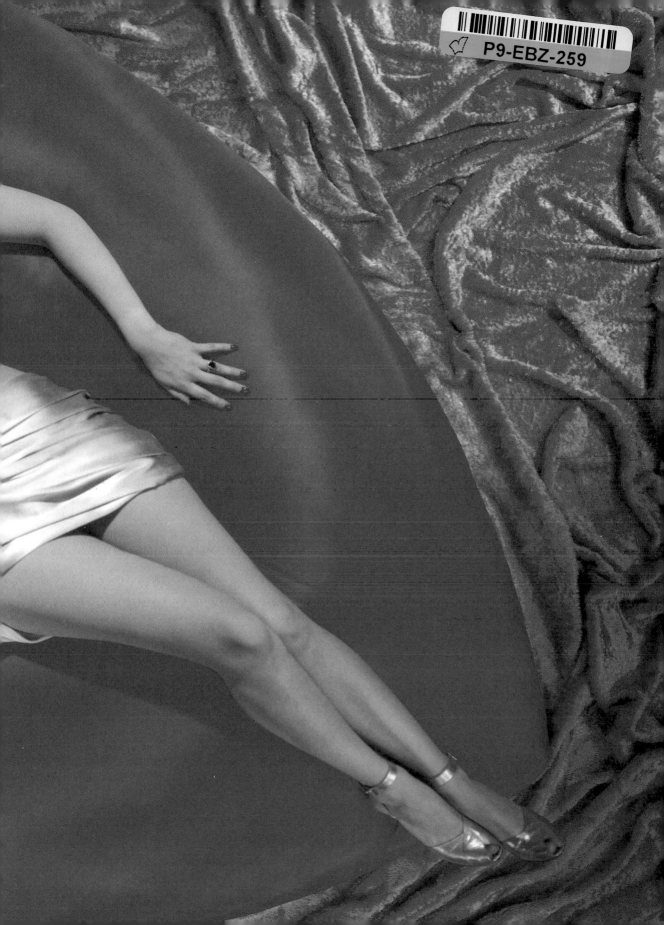

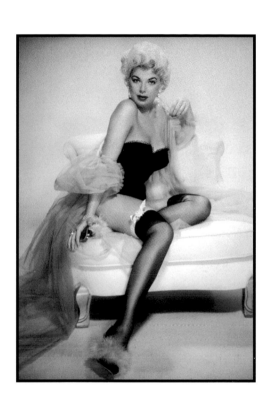

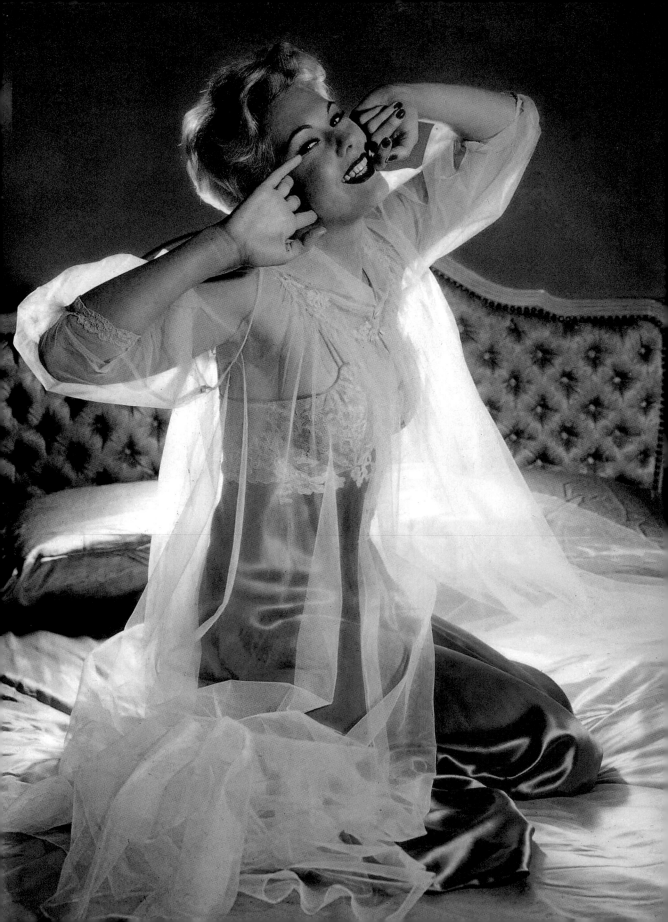

Va-Va-Voom!

★

CLASSIC HOLLYWOOD PIN-UPS

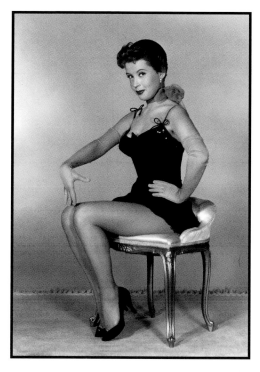

CHRIS CHANG

Foreword by Mamie Van Doren

FALL RIVER PRESS

New York

FALL RIVER PRESS

New York

An Imprint of Sterling Publishing
387 Park Avenue South
New York, NY 10016

COVER: JANE MANSFIELD, 1957
BACK COVER: BARBARA STANWYCK, C.1949
PAGE 1: BARBARA NICHOLS, 1957
PAGE 2: KIM NOVAK, 1955
PAGE 3: GLORIA DEHAVEN, 1954
PAGE 5: MAMIE VAN DOREN, 1954
PAGES 6-7: GLORIA DEHAVEN, 1944

Design by Jeff Batzli and Suraiya Hossain

ISBN 978-0-7607-9199-8

Manufactured in China

6 8 10 9 7 5

www.sterlingpublishing.com

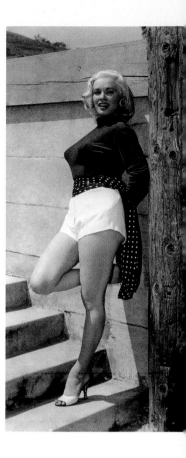

It's very flattering to be asked to pen a preface for a wonderful collection like this. The publishers did, however, choose the right person. I think I can say without exaggeration that no other actress, living or dead, has been photographed more than I have. My collection at home is awash with photographs of me early on, mid-career, and just last month. After 50-plus years in the business, fans will still send me a picture of myself that I've never seen before.

I'm not sure that anyone sets out to be a pin-up. Girls want to be beautiful, of course. They want to be fashion models and they want to be movie stars. But a pin-up? There are modeling schools and acting schools, but there are, as far as I know, no pin-up schools.

No one taught me to be a pin-up. Since I was a little girl, I knew instinctively how to pose for pictures. There are shots of me at age five with one foot in front of the other, hip cocked, a big toothy smile charming away at the lens.

Describing being sexy, or being a pin-up, is kind of like describing nirvana. Whatever you say nirvana is—that's not it. It's the same with being sexy. Set yourself to describe it—to be it—and you miss it by a mile.

There is one surefire way to define the sexy pin-up: see it. And that's what these pages do, presenting you a staggering, lush, palm-sweating collection of the beauty of the pin-up.

—**Mamie Van Doren**
Newport Beach, California
February 2008

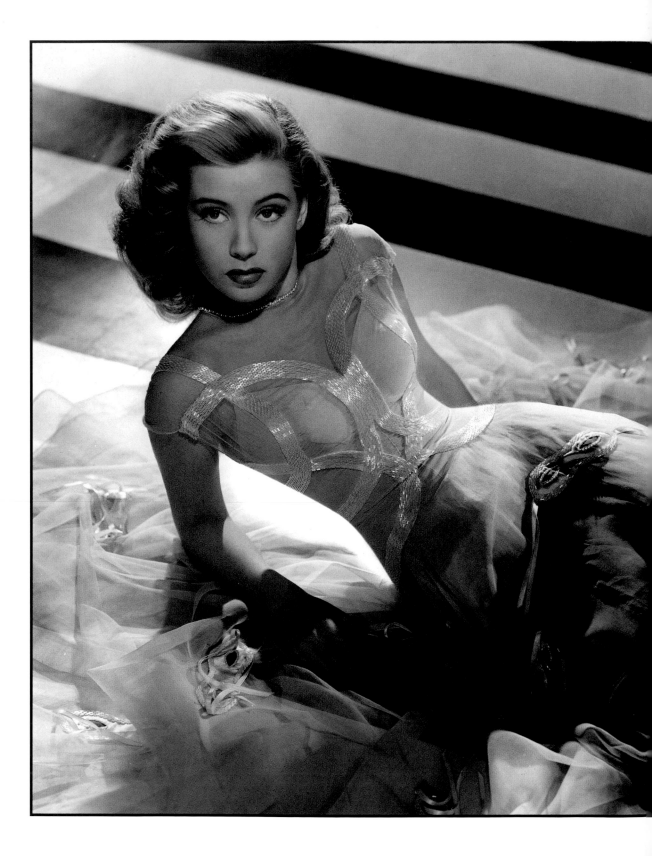

GIRLS ON FILM

Poised somewhere between portraiture and pornography, the Hollywood pin-up sits pretty. The phrase "pin-up," in most minds, conjures a certain style of ultra-vivid illustration, associated with a certain type of magazine, catering to a specifically male clientele. From an etymological standpoint, however the word has its roots in World War II barracks, where photos of a particularly glamorous breed of woman—usually cut from the pages of publications that trafficked in such things—were pinned to walls or inside lockers. According to the *Oxford English Dictionary*, "pinup" first appeared as a noun in the pages of *Yank* magazine, which provided millions of GIs with a weekly dose of Hollywood beauties in provocative poses. It was one more thing that the folks back home could do "for the boys" overseas. As the legendary French film critic André Bazin put it: "As a wartime product created for the benefit of the American soldiers swarming to a long exile at the four corners of the world, the pin-up girl soon became an industrial product, subject to well-fixed norms and as stable in quality as peanut butter or chewing gum." Hence the well-established nomenclature: Pin-up. An old story, perhaps, but a good one all the same.

Contra Bazin, the aesthetic lineage of the pin-up extends much further back in time than the 1940s. Depending on who you ask, it can be traced to: 1) The rise of the Hollywood star system; 2) mid-to-late nineteenth-century photographs of female stage performers; and 3) the fifteenth century, Mr. Guttenberg, and the birth of print media itself. (At some point, someone with a lot of time on his hands will take the argument back to 24,000 BC, when that small, curvaceous stone artifact, the Venus of Willendorf, was lovingly created. It's a readily portable and highly suggestive pebble that more than a few scholars have deemed pornographic.)

While it can be as hard to locate the beginning of any genre as it is to designate its conclusion, in these pages we are able to lay out some broad parameters for the rise, golden age, and ultimate decline of the pin-up girl in all her multitudinous guises. Although the pictorial contents contained herein are culled from one singular source—the

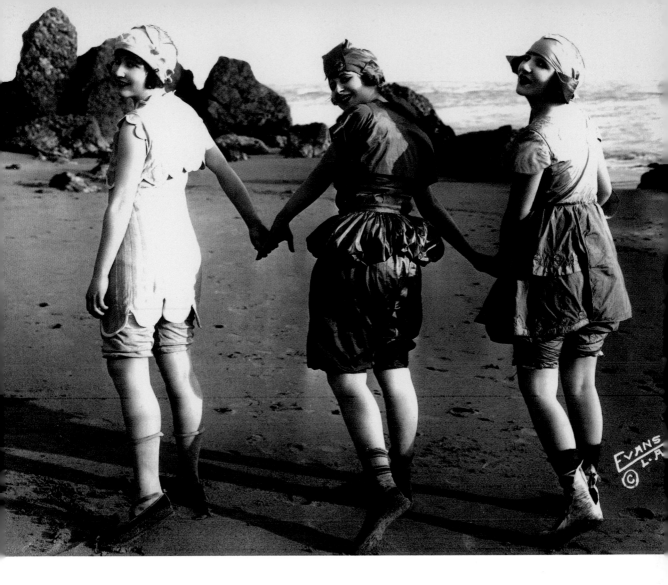

Kobal Collection, founded over thirty years ago by writer and historian John Kobal—that hardly proves a limitation, as today the archive contains more than a million images from some 40,000 films. As with so many things American, the pin-up starts with the movies.

The earliest of this book's images include Hollywood pioneers, such as Mack Sennett's Bathing Beauties (1915) and Theda Bara (1916), predating the pin-up's formative period by over a quarter-century. An editorial decision was made to conclude the survey in the 1970s, an end point that will raise a few eyebrows. Anyone who cares, or who has recently looked at a magazine stand or inside a schoolboy's locker, knows that the pin-up—in a variety of formats—continues to exist and shows no signs of going away anytime soon. But the 1970s makes for a more than apt terminus for this project. The "Me Generation," so

★ Sennett Girls, 1915: These three (and their risqué calves) were part of an ever-changing troupe often billed as "Mack Sennett's Bathing Beauties" (which included the likes of Gloria Swanson), whom the silent filmmaker employed as eye candy in his Keystone Cops shorts.

dubbed by Tom Wolfe, saw the nation begin to seriously shift its focus from the collective impulses engendered by a succession of defining crises (the Great Depression, World War II, the Cold War) toward distinctly individual pursuits of happiness. The change was apparent in everything from global politics (the Vietnam War's demoralizing spectacle inspired practically an entire generation to rebel against its government's policies), social reality (continued sexual revolutions on multiple fronts), and popular culture (from the standpoint of American cinema, the 1970s stubbornly remains a golden age and creative benchmark).

Who are the last iconic pin-ups that we can remember? Has there been anyone from the 1980s to the present day who had anything like the indelible guilty-pleasure resonance of such 1970s endgame pin-up girls as Suzanne Somers, Bo Derek, or Farrah Fawcett? They're out there, but they just don't seem to occupy the same liminal space that they use to. (It might simply be a product of the specific age of this particular writer, but I believe there's more to it than that.) The 1980s saw Brooke Shields turn legal, and in the 1990s, there was the brief nadir of heroin chic, but honestly, you would certainly not call Kate Moss an actor. (To be fair, Somers, Derek, and Fawcett were never exactly renowned for their thespian gifts.)

The beginning of the end for pin-up culture was 1972. That year, *Cosmopolitan* published its first male pin-up, and Gloria Steinem's *Ms.* was launched (*Playgirl* would follow in early 1973). The times were definitely changing. However, it's erroneous to think that the feminist movements of the 1960s and 1970s were the first time that women's rights and interests were addressed in regard to media imagery. Since its inception at the dawn of Hollywood (or wherever one happens to pinpoint the event), the pin-up has sparked fiery debate: Does the form represent female empowerment, or female objectification? Just as the seemingly polarized positions of portraiture and pornography can be seen, under scrutiny, to collapse into each other, the pin-up ethos continues to constantly move between various definitions. As this book wends its way through the decades, different aspects of the pin-up's innate bipolarity (empowering, objectifying, or some glossy admixture of the two?) will come to light. Words, of course, will eventually fail. But in a way, that's what photography books are all about. To state the obvious: You can pin her up, but you can never pin her down.

★ Hedy Lamarr, 1940: One of the most popular World War II–era pin-ups, Lamarr (born Hedwig Eva Maria Kiesler in Austria in 1913) was often billed as the world's most beautiful woman—no one argued with much conviction.

★ OPPOSITE: Farrah Fawcett, 1976: Arguably the last of the great pin-ups, Fawcett graced the bedroom walls of countless teenage boys during the 1970s, a decade during which this poster reportedly sold 12 million copies, a record yet to be matched.

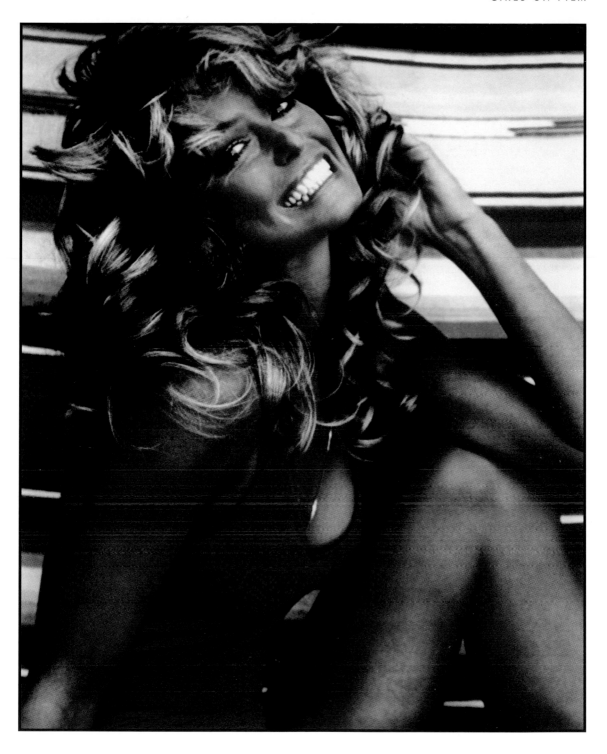

The Early Years: What the Girl Wants

W/hether viewed as trash or art, empowering or objectifying, good or bad, the pin-up has always had a split personality, which can be seen with the appearance of cinema's earliest leading lights. First, there's the virginal Good Girl, exemplified by actresses such as Lillian Gish or Mary Pickford (aka "Our Little Mary"). Then there's the antithesis, the not-quite-so-nice Bad Girl, or Vamp, incarnated by openly sexual creatures such as Pola Negri or Theda Bara—the latter sometimes fiendishly referred to as "Arab Death" or "Death Arab" (depending on how you prefer to parse your anagrams).

Goodness, as demonstrated by the parts Pickford plays in her films, generally involves a free-spirited child or childlike woman—with, more often than not, some hint of a future "domesticated" private life. (Ironically, Pickford started acting in theater when she was a child, and then became so beloved for her later film portrayals of children that she was forced by public perception to remain forever young—which, in effect, led her to become a child impersonator. She would subsequently claim that she never had a real childhood.) Pickford's screen (and photographic) persona was a facade concealing a force to be reckoned with. Extremely shrewd and a bit of a control freak, she, along with Charlie Chaplin, Douglas Fairbanks, and D.W. Griffith, formed United Artists in 1919; in 1927, she helped create the Academy of Motion Picture Arts and Sciences—not-too-shabby for an angelic guttersnipe.

Badness, as reprented by the Vamp, calls for a *public* woman: a predatory female whose visibility—especially if she happens to be a streetwalker—allows for her sins to take on a greater scale and dimension, not to mention the subsequent destruction of the unfortunate men who get in her way. One of the earliest and best films showcasing this type of savage persona is Frank Powell's 1915 Theda Bara vehicle, *A Fool There Was*. Here, desire for the Vamp is manifested through physical harm inflicted on the bodies of foolish

★ Mary Pickford, 1918: Although twenty years old when this picture was taken, Pickford was perhaps doomed by the Hollywood system to a perpetual case of arrested development.

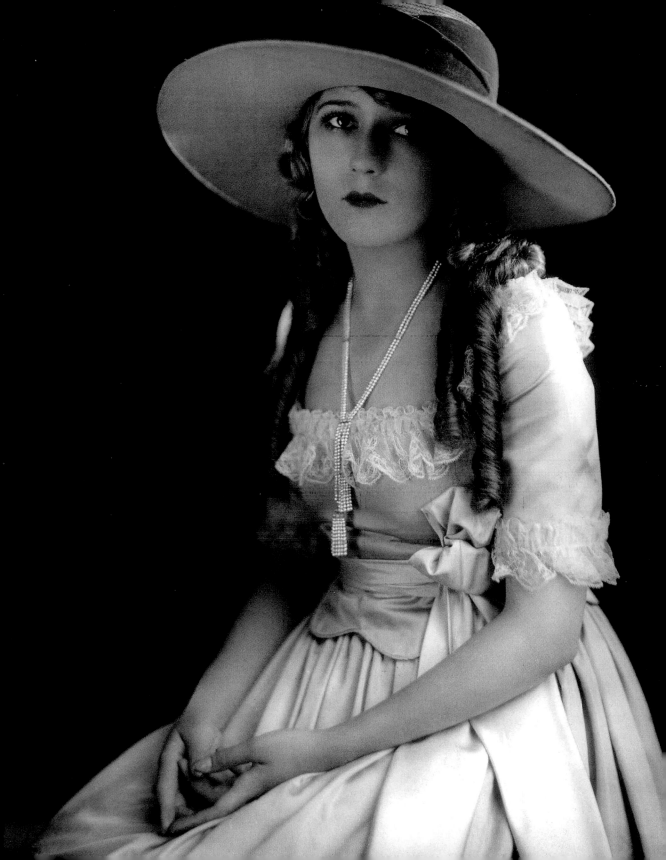

★ LEFT: Theda Bara, 1916: Not only did Bara personify the Vamp in *A Fool There Was*, she also originated the term in a role based on the title character from Kipling's poem "The Vampire."

★ OPPOSITE: Anita Page, 1930: When this shot was taken, Page (who specialized in playing hard-drinking party girls) was the most popular actress in Hollywood, next to Greta Garbo. She received bags of fan mail, including many love letters from a besotted Benito Mussolini.

men. The femme fatale is, by definition, "fatal"—but what is so disturbingly memorable in this Bara film is the depiction of men literally wasting away as they writhe within her web-like thrall. The image of Bara above is extraordinary, both for its camp melodrama and the obvious question it begs—namely, what type of person would pin this up?

The eventual synthesis of the Good Girl and the Vamp resulted in a creature more recognizable to contemporary eyes: The Flapper. Clara Bow was the first officially designated It Girl, and you can still detect remnants of her in the postmodern landscape—in, say, Chloë Sevigny, and Uma Thurman in *Pulp Fiction*. Although popular perception of the modern woman had been in flux ever since the first superstar actresses, Bow introduced a new level of sexuality—not just in terms of the New

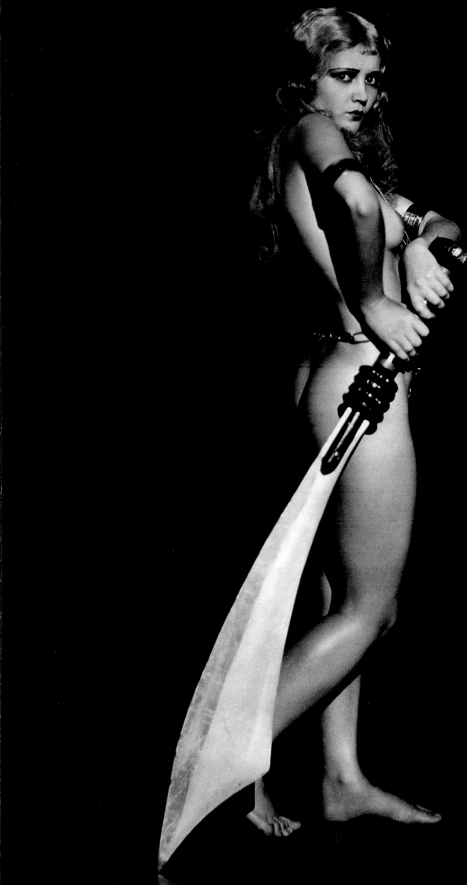

Woman's emerging ability to frankly acknowledge (and even demand) sexual pleasure, but also in the gender blur that the flapper style heralded. Boyishness and manliness could now be publicly equated with sexiness—for both men and woman.

Pin-up shots of Hollywood actresses were not just byproducts of movies—they also played significant and often symbolic roles within the movies themselves. In Wesley Ruggles's *The Plastic Age* (1925), a college frat boy explains his collection of pin-ups to a new roommate: "If she kisses me twice, she ends up on the wall." One of the trophies in question is the film's vibrant and frenetic star, Clara Bow. Louise Brooks, an American girl from Wichita, was memorably chosen by G.W. Pabst to play the bewitching yet bedeviled prostitute Lulu in *Pandora's Box* (1929). In that film, one of Lulu's clients paws through a handful of photos of available girls, among which is a picture of Brooks, "The Girl in the Black Helmet." The image is enough to make him drool in carnal anticipation. Greta Garbo's character in Jacques Feyder's

★ Clara Bow, 1930: The "It Girl" is pictured here on the verge of losing her career to sound. Her Brooklyn accent didn't translate well to the talkies she started filming in 1929.

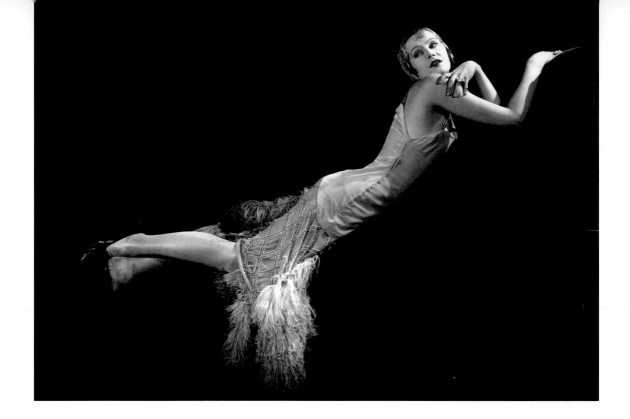

The Kiss (1929) promises a photo of herself to a paramour. When he arrives at her home to collect the memento their encounter is interrupted by the unexpected arrival of her husband. A confrontation ensues, a shot is fired, and one man is left for dead. (Photography can be fatal.)

Perhaps the strangest pin-up anecdote in onscreen history (in terms of its off-screen ramifications) occurs in Lowell Sherman's *She Done Him Wrong* (1933). Mae West plays Lady Lou (a modern Lulu), a fast-and-loose gin-mill queen who, in one scene, displays a photo collage of the assorted men in her life. One of the studs happens to be a black man. In real life, gossip swarmed around Mae West with the same blind intensity that the men in her films display toward her characters. The lurid rumors claimed that she was, in fact, a man; that the levels of camp and kitsch in "her" work proved she was a gay man; that she was, in fact, black—or at least of African-American descent. Is it possible to put two and two together and declare Mae West a gay black man? (For anyone interested in pursuing this thread, Jill Watt's aptly titled biography *Mae West: An Icon in Black and White* definitely sheds light.)

★ Greta Garbo, 1926: Just "Garbo" to the rest of us, the Swedish beauty was a pin-up from the very start (she began as a model) but quickly became famous for her icy, and particularly un-pin-up-like, hauteur.

The point here is that we are looking at not just mere images but iconographic history. The more you know, the more you will see; and what you know changes what you see. If this is true, you will never be able to look at Mae West the same way again. Indeed, the founder of the collection of photographs used in this book, John Kobal himself, once questioned West about her racial background.

Joan Crawford appears in this book multiple times, and one of the most resonant pictures (at least to these eyes) appears on the opposite page. The layers of significance within the image are legion. Although it's a publicity still from Tod Browning's psycho-circus flick *The Unknown* (1927), and it relates directly to a scene in the film, this particular shot was completely restaged. The circus background in the film's original scene has been replaced by an eerie makeshift void-space. Affixed to a plank by knives, Crawford is literally pinned up. Since her character in the film performs her role in the act with come-hither glee, the look of terror in the photo can either be perceived as value-added or bait-and-switch publicity (promotional imagery—i.e., pin-up imagery—often misleads, often on purpose.)

To appreciate the image, it helps to know a bit of the film's story: Lon Chaney plays an armless knife thrower (he uses his feet) who's secretly in love with Crawford. She, in turn, is very fond of him because he's both a nice guy and—in a perverse twist of narrative logic—*she hates to be touched by men*. Knowing that to Chaney she is untouchable (like a person in a photograph) she can comfortably display herself to him with flirtatious affection.

The entire history of the pin-up genre can be found embedded in this singular specimen: its origins in the traveling sideshow and burlesque; the objectification of women; and the potential that that objectification has to empower women through the fabrication and control of their own images. In other words: You can make an image of me—but you can't make an image without me.

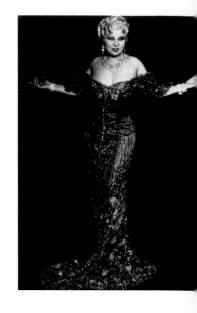

★ Mae West, 1933: Unlike many pin-ups, West was actually known for *what* she said, not just how she said it; in fact, those double entendres got her thrown in jail on obscenity charges after her Broadway show, *Sex*.

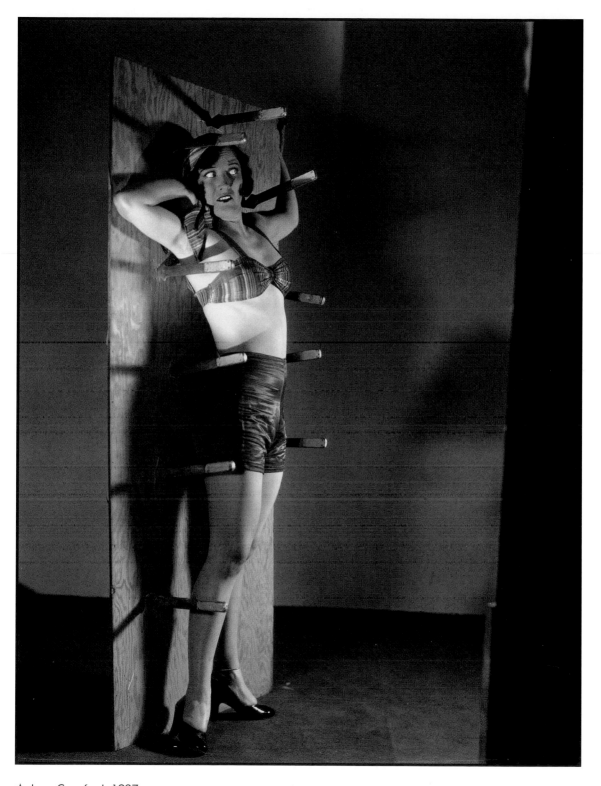

★ Joan Crawford, 1927

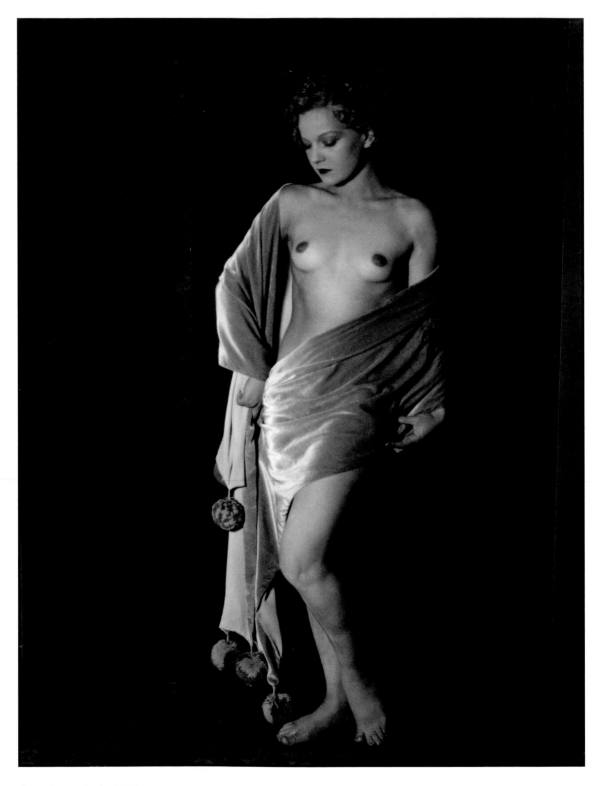

★ ANONYMOUS, 1928

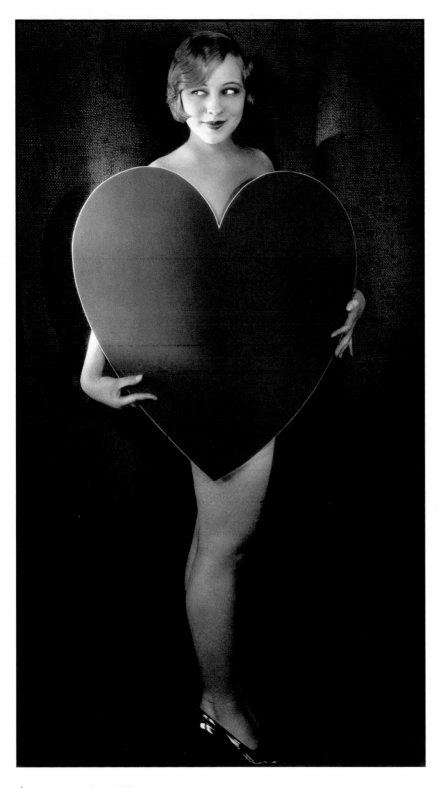

★ SALLY RAND, 1927

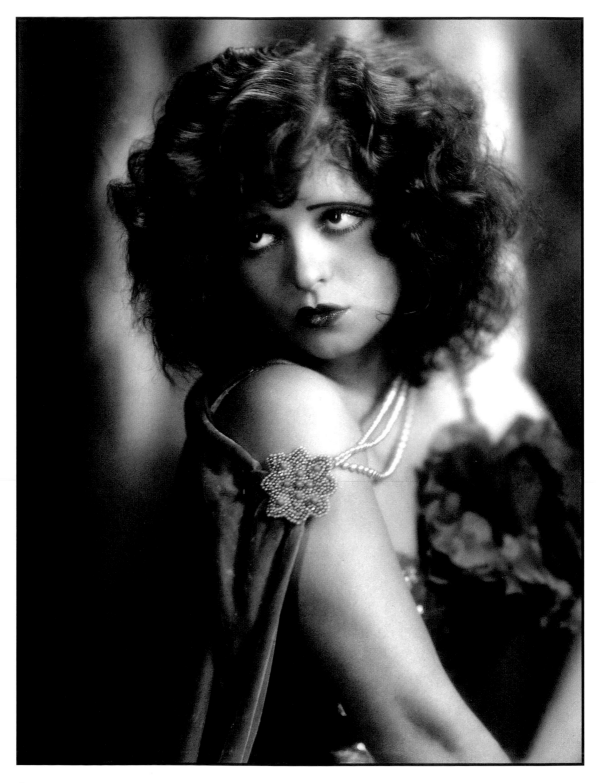

★ CLARA BOW, 1924

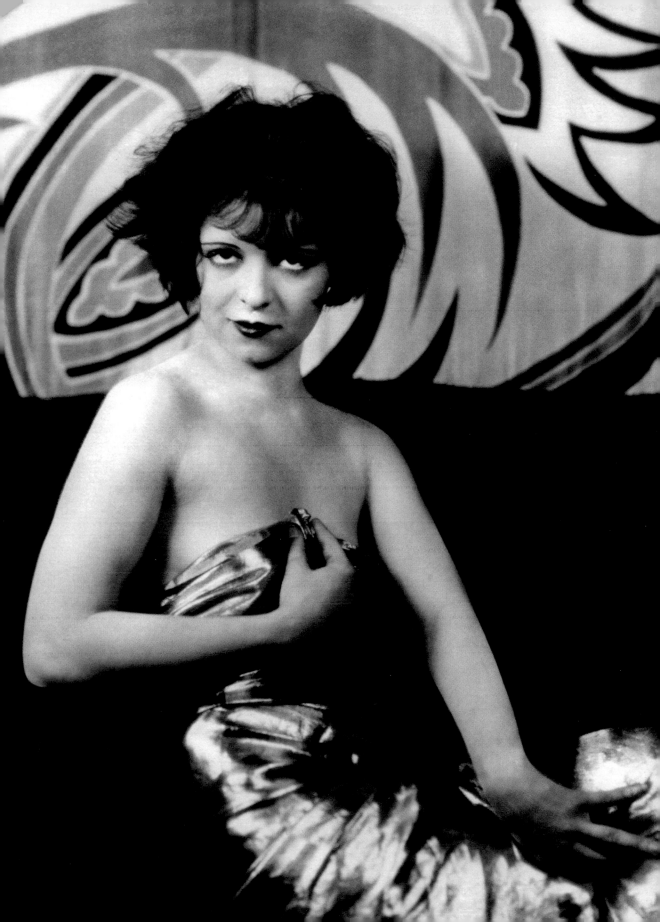

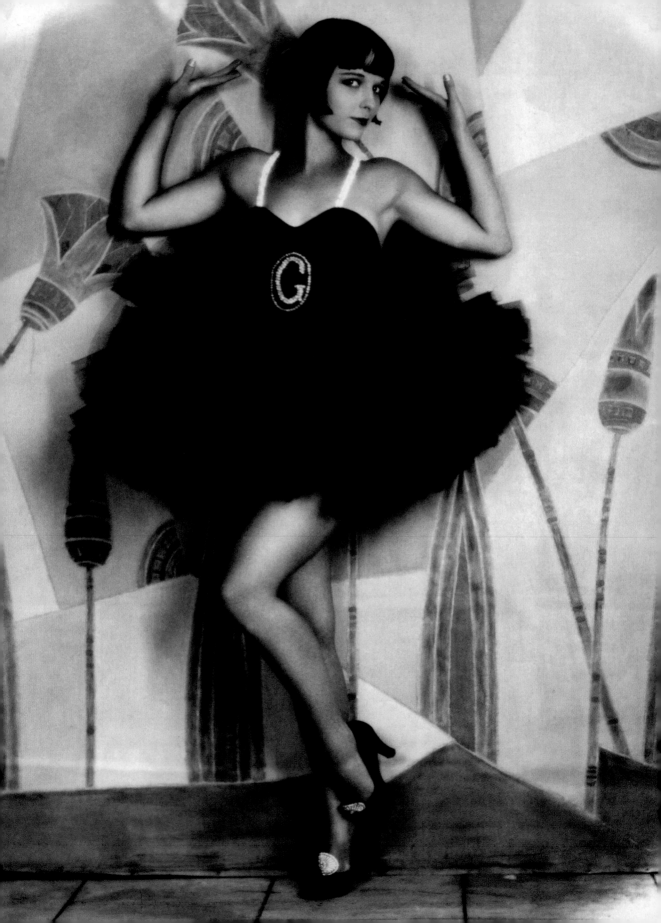

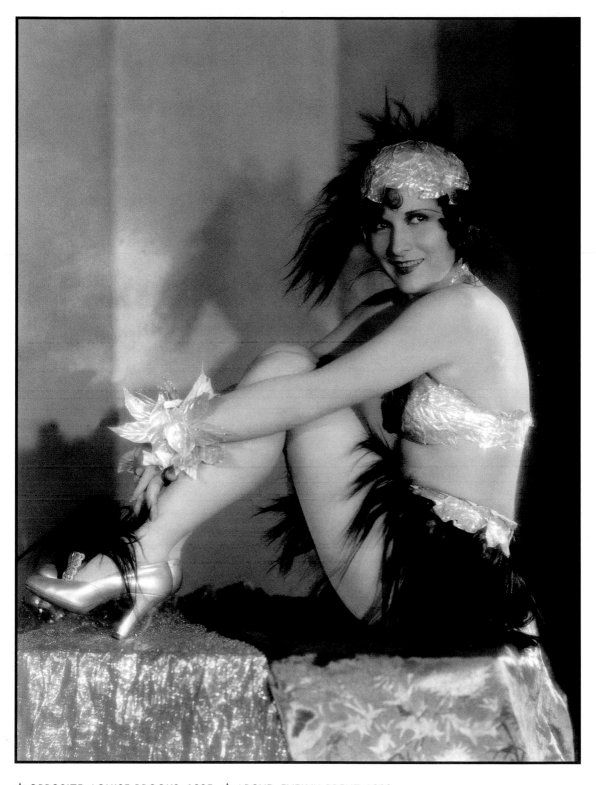

★ OPPOSITE: LOUISE BROOKS, 1925 ★ ABOVE: EVELYN BRENT, 1929

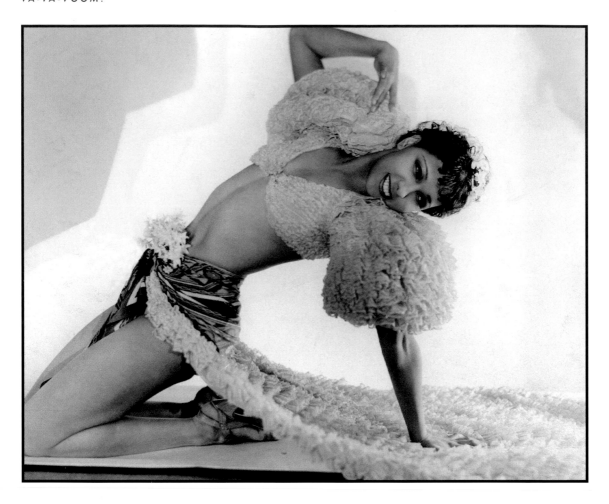

★ ABOVE: JOSEPHINE BAKER, 1927 ★ OPPOSITE: ANNA MAY WONG, 1929

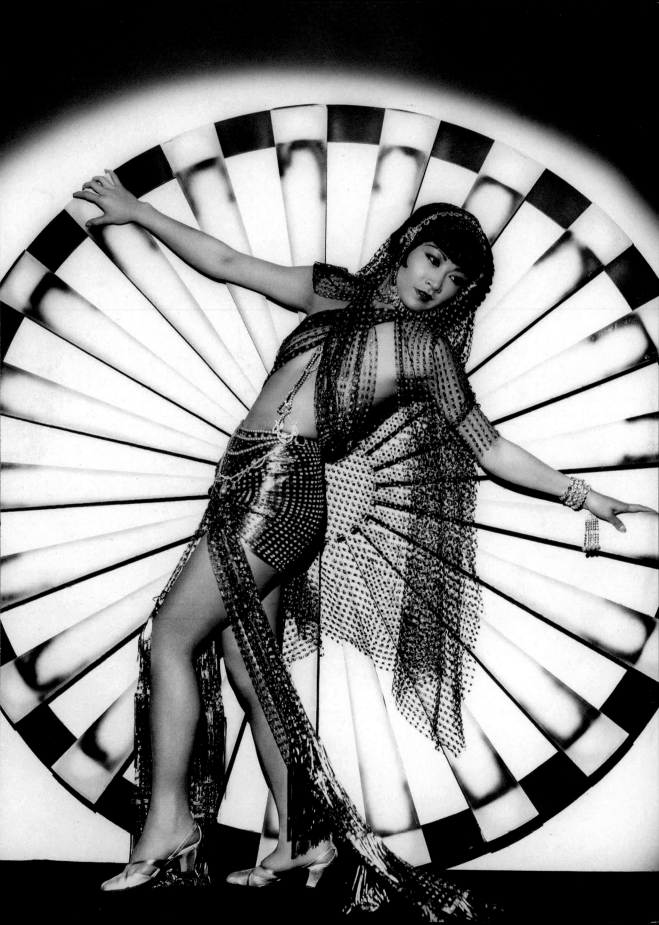

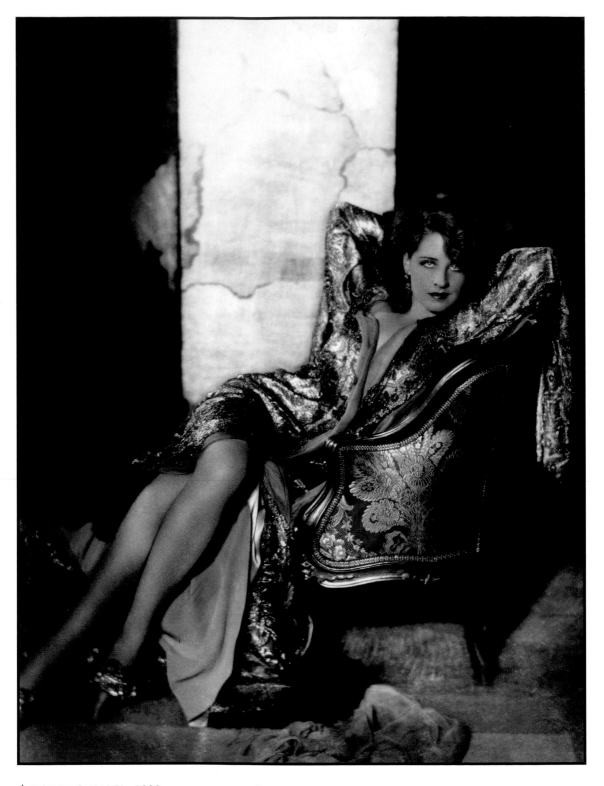

★ NORMA SHEARER, 1930

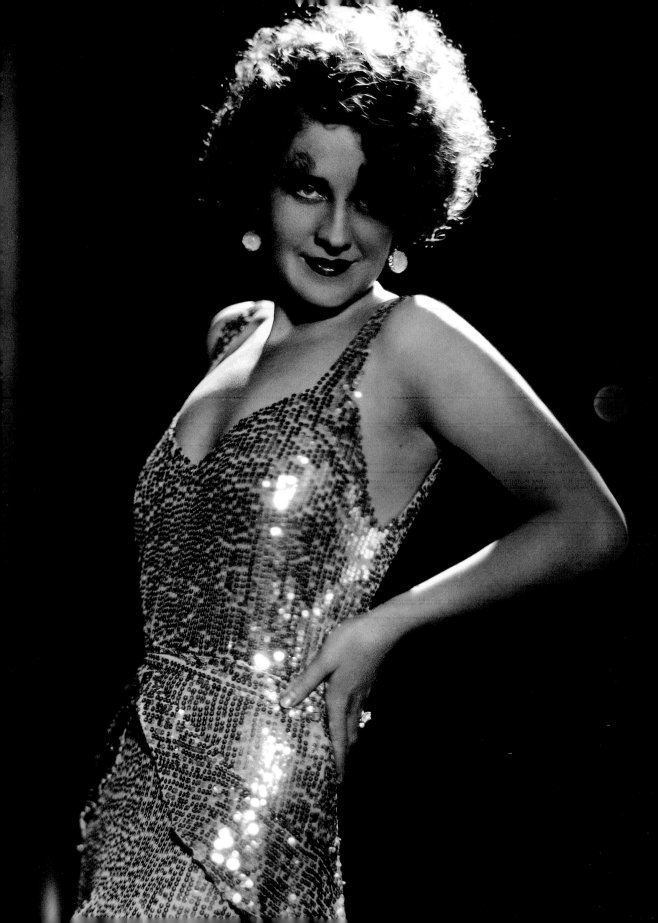

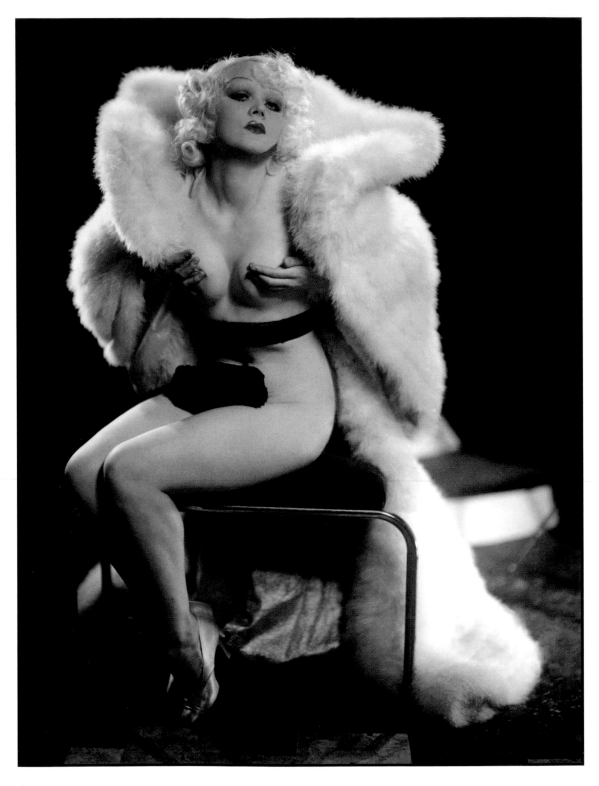

★ MARION MARTIN, 1930

★ GINGER ROGERS, 1933

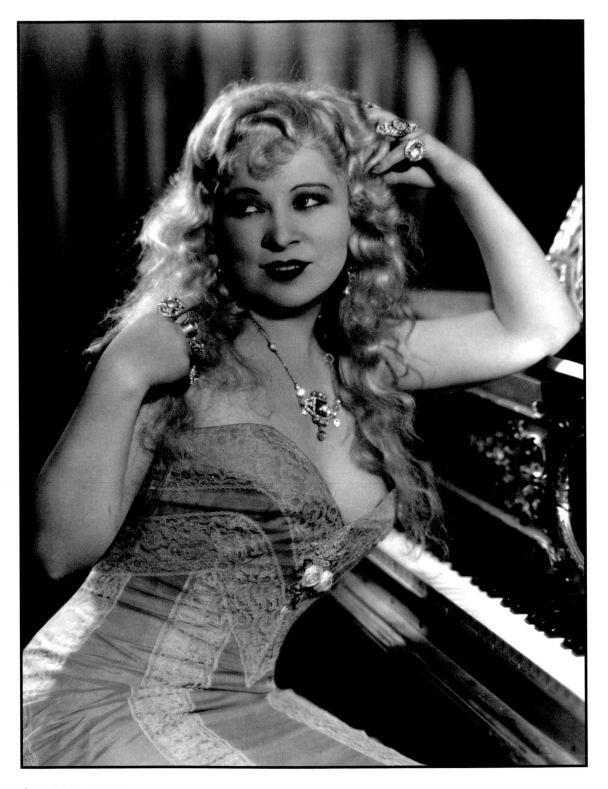

★ MAE WEST, 1933

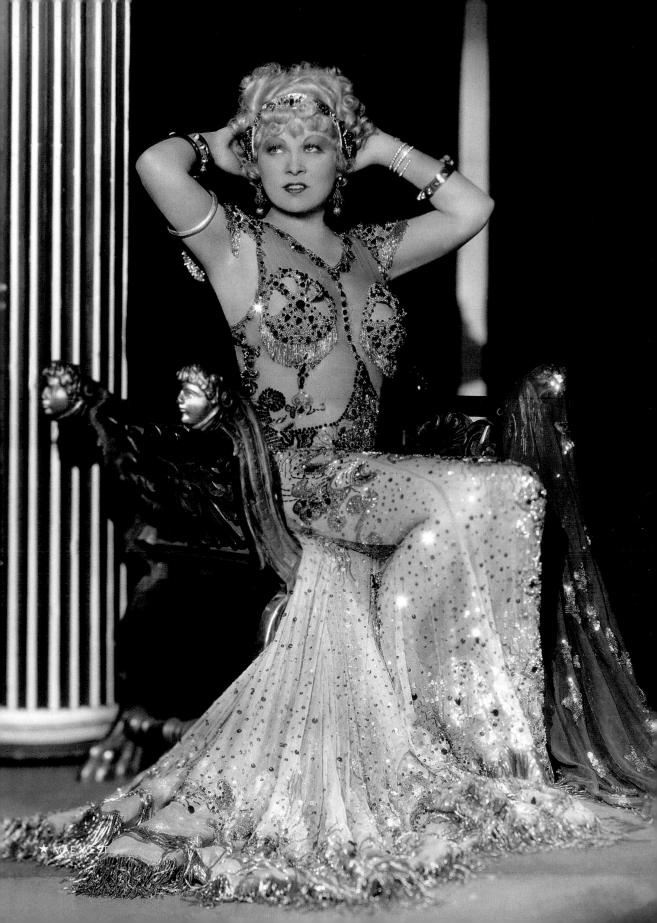

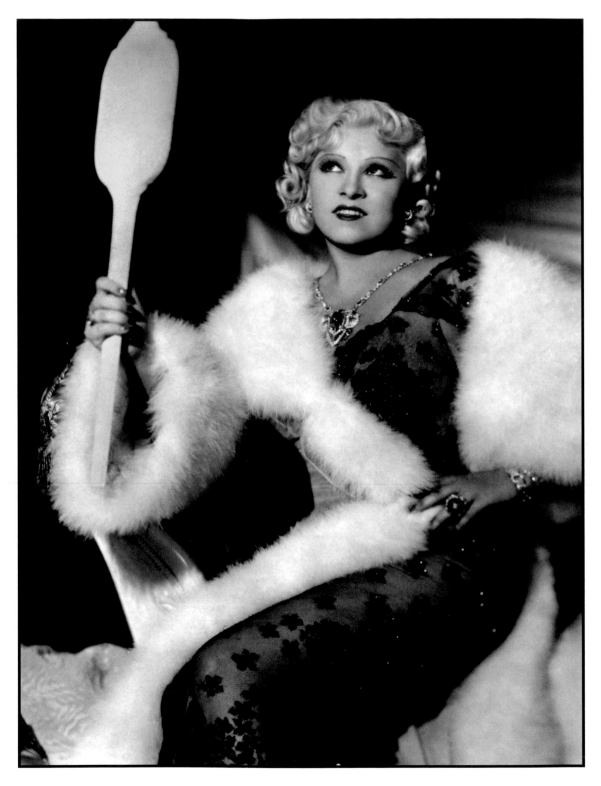

★ MAE WEST, 1931

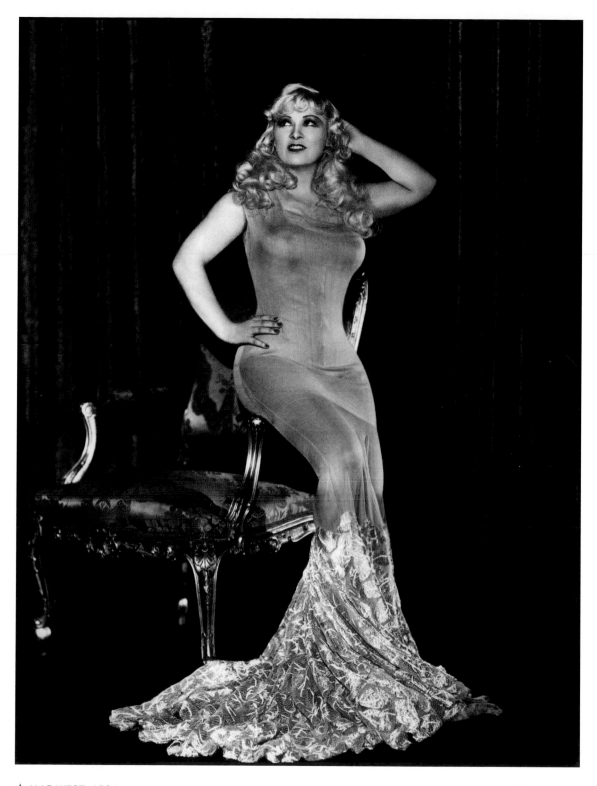

★ MAE WEST, 1934

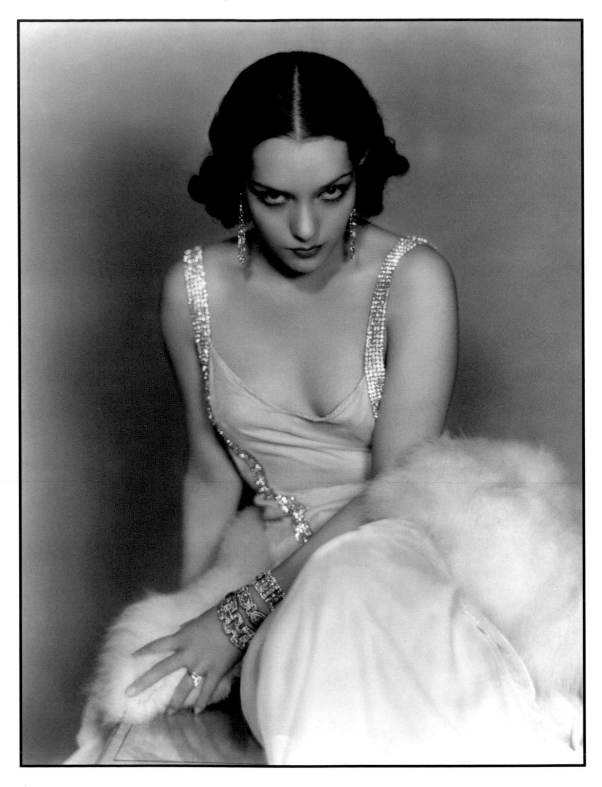

★ LUPE VELEZ, 1934

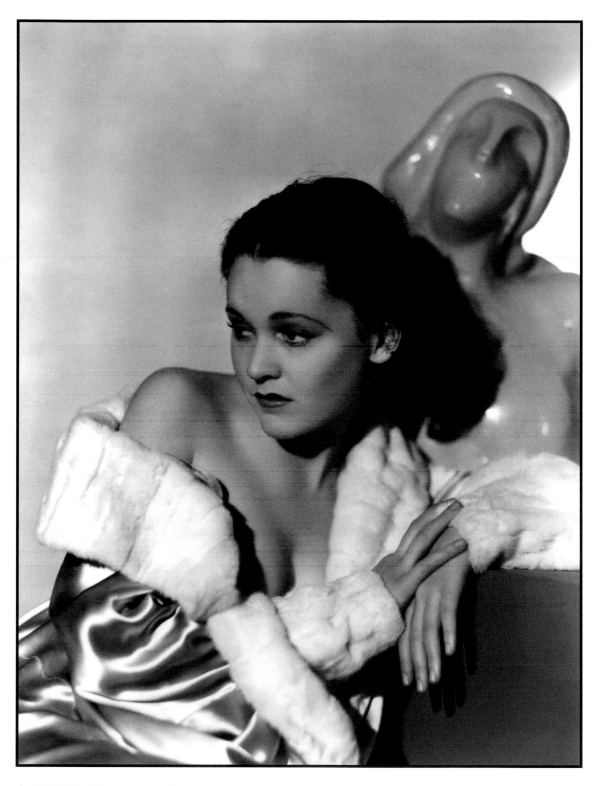

★ MAUREEN O'SULLIVAN, 1931

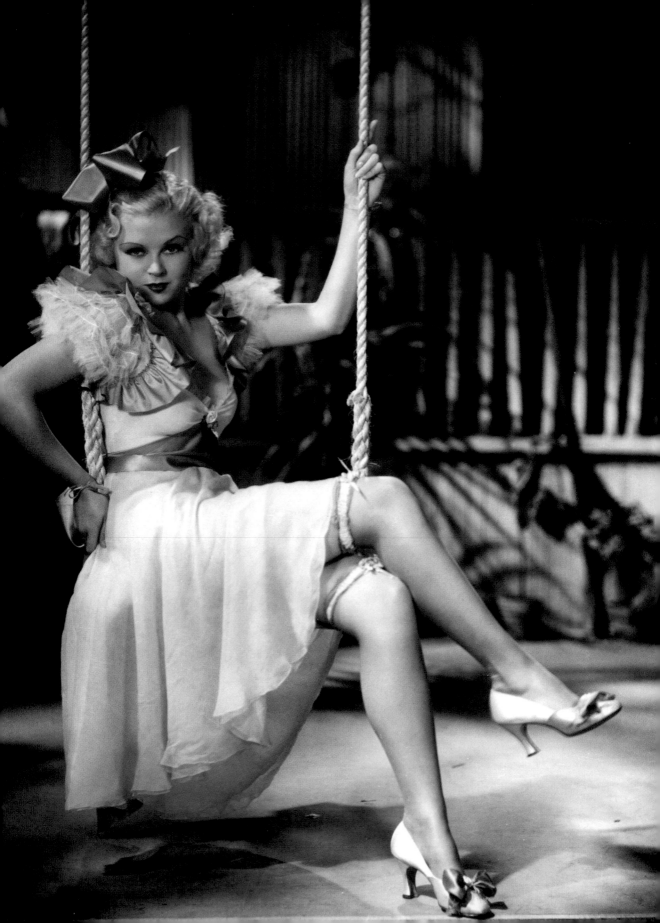

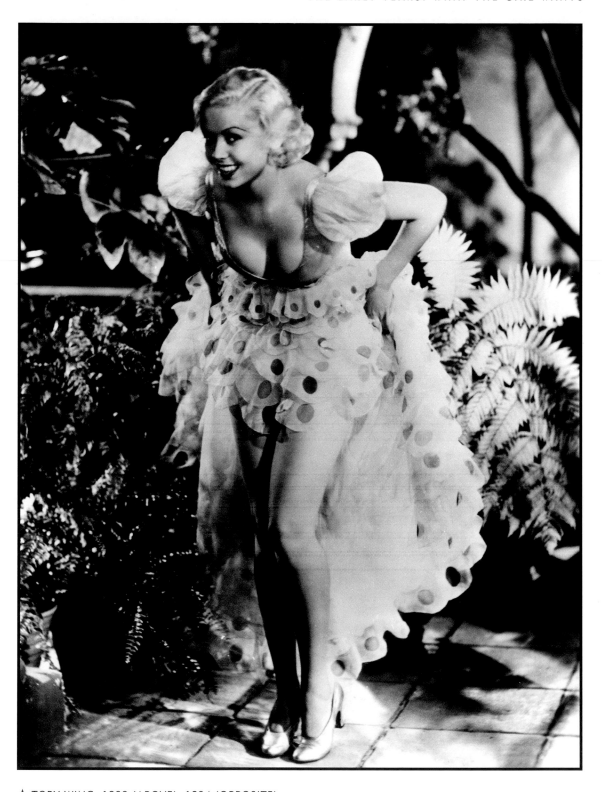

★ TOBY WING, 1932 (ABOVE), 1934 (OPPOSITE)

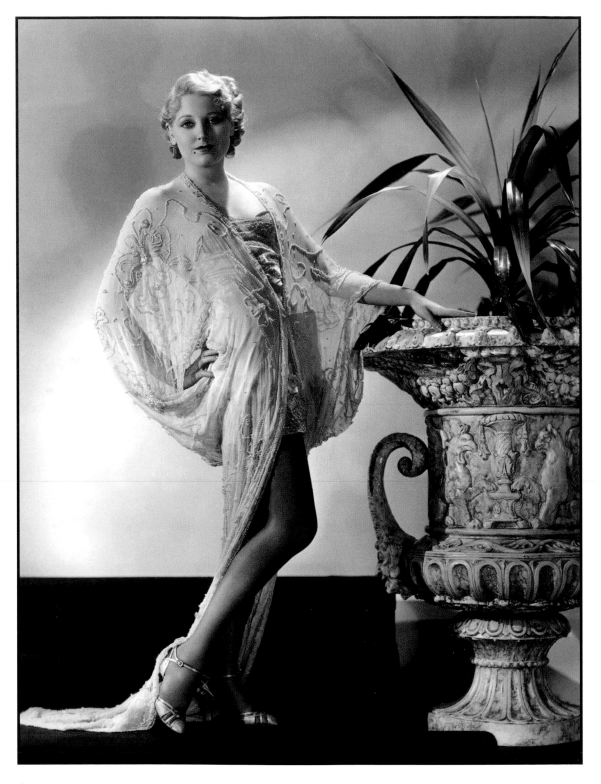

★ THELMA TODD, 1931

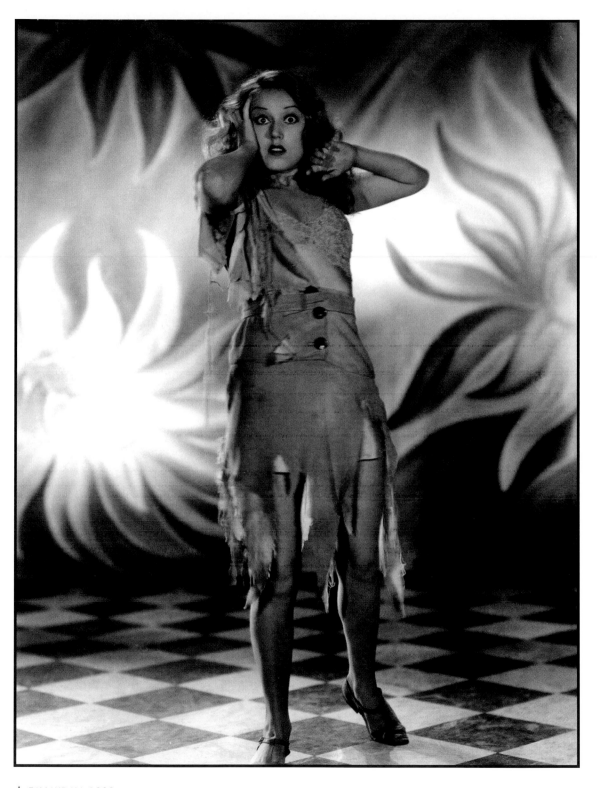

★ FAY WRAY, 1933

It Came Upon a Midnight Clear

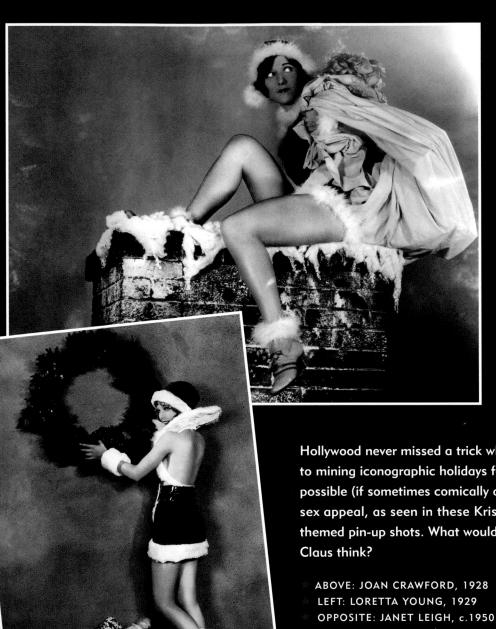

Hollywood never missed a trick when it came to mining iconographic holidays for all of their possible (if sometimes comically awkward) sex appeal, as seen in these Kris Kringle-themed pin-up shots. What would Mrs. Santa Claus think?

✳ ABOVE: JOAN CRAWFORD, 1928
✳ LEFT: LORETTA YOUNG, 1929
✳ OPPOSITE: JANET LEIGH, c.1950

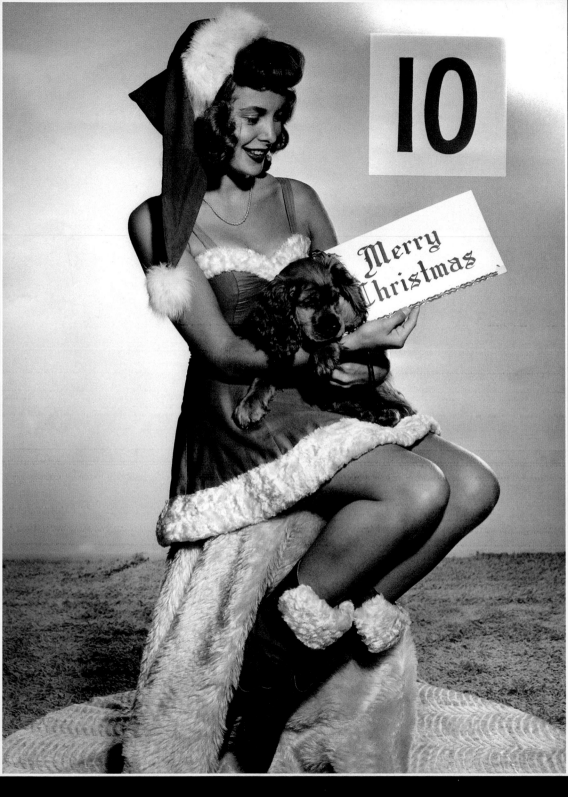

43

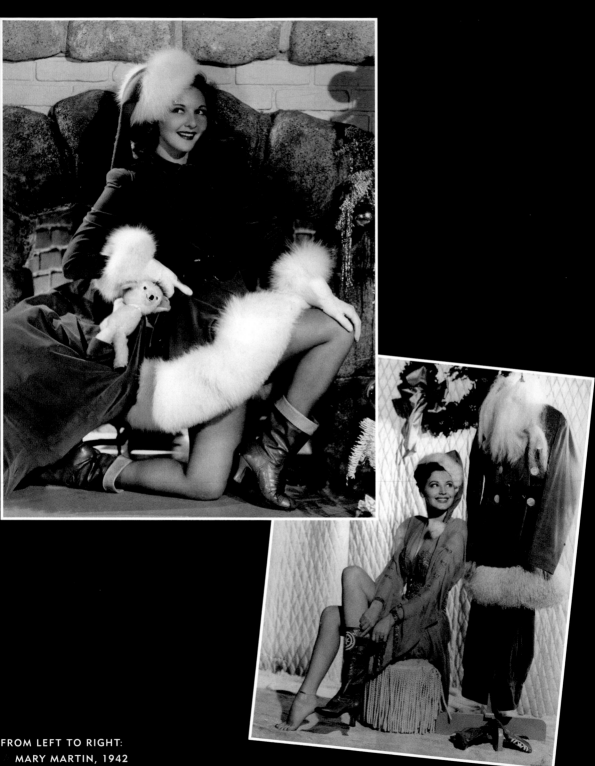

FROM LEFT TO RIGHT:
MARY MARTIN, 1942
AVA GARDNER, c.1944
MARIE DEVEREUX, 1959

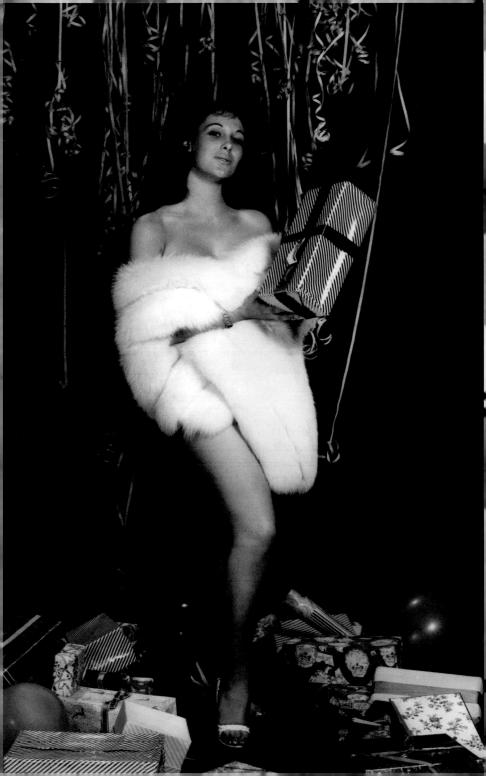

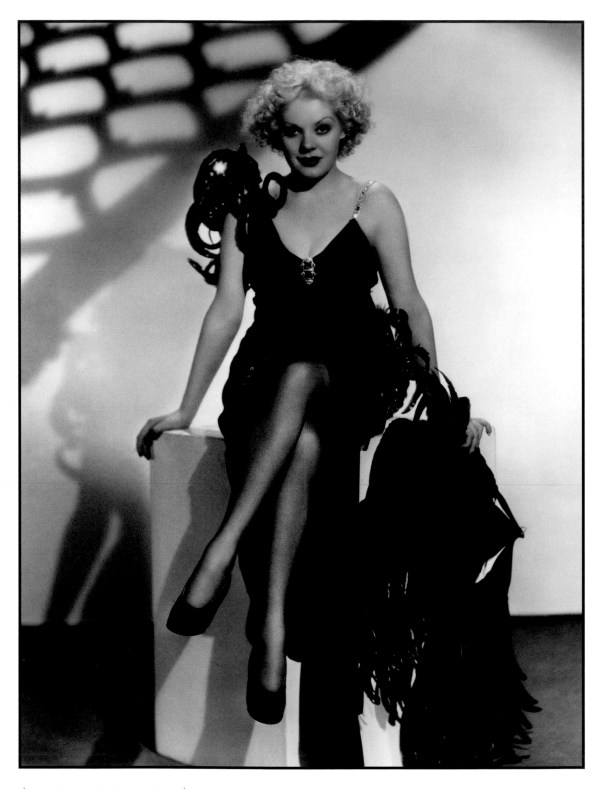

★ ABOVE: ALICE FAYE, 1934 ★ OPPOSITE: CONSTANCE BENNETT, 1934

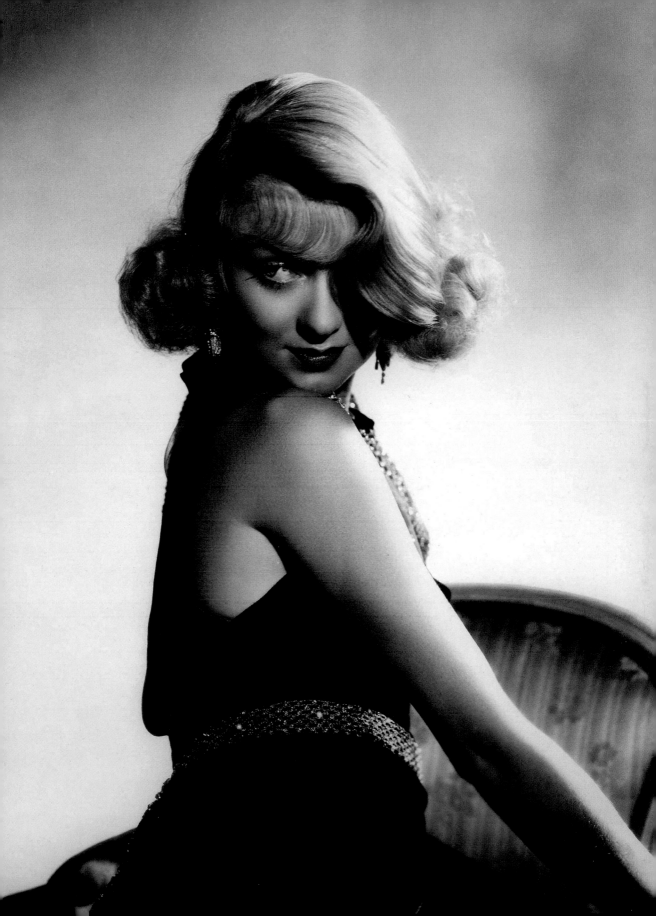

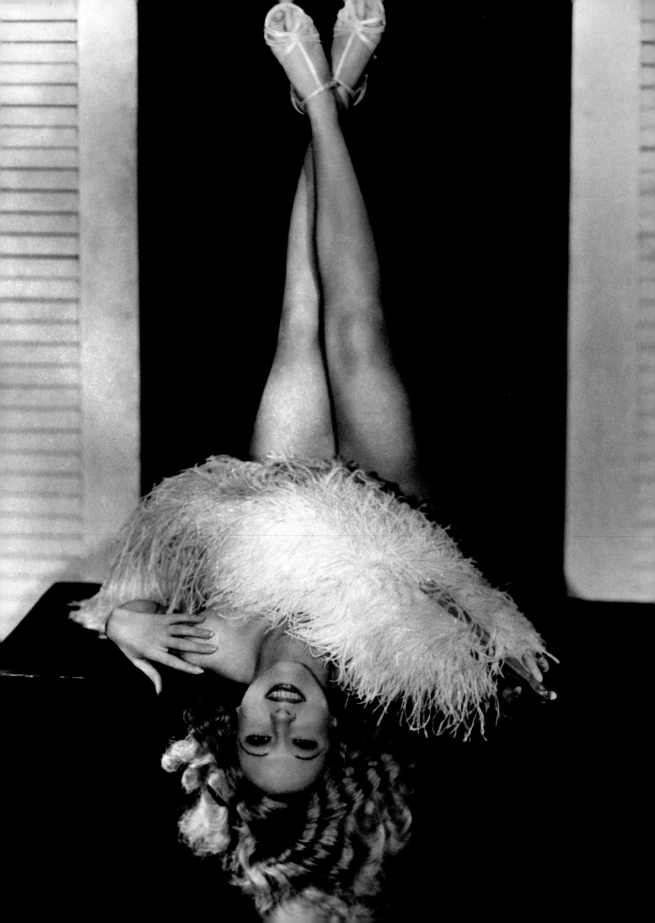

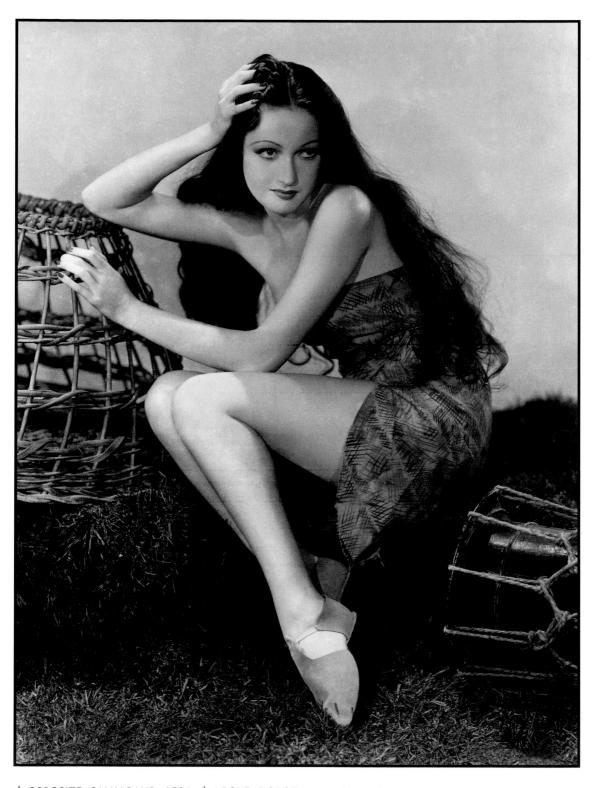

★ OPPOSITE: SALLY RAND, 1934 ★ ABOVE: DOROTHY LAMOUR, 1938

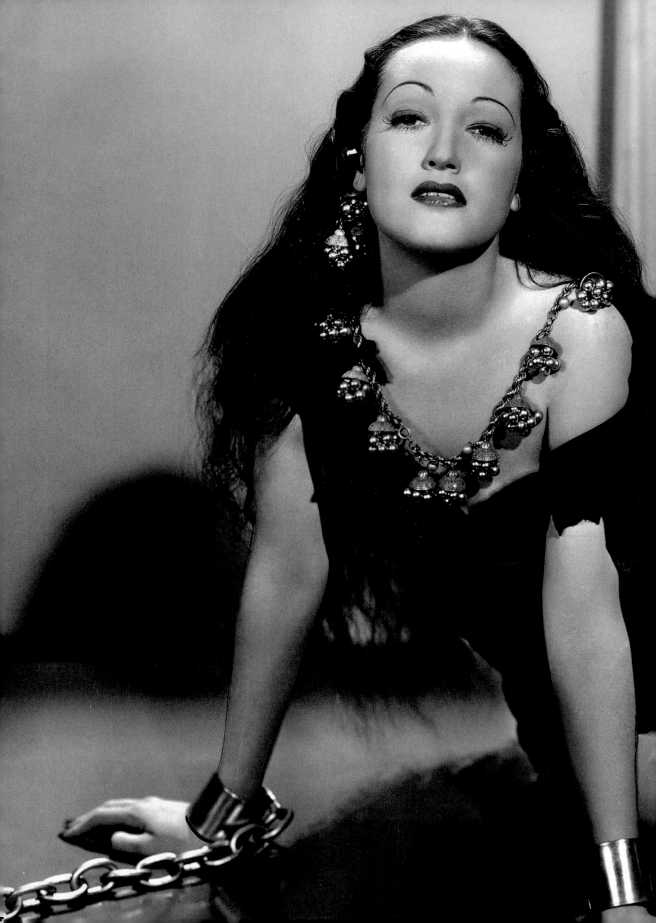

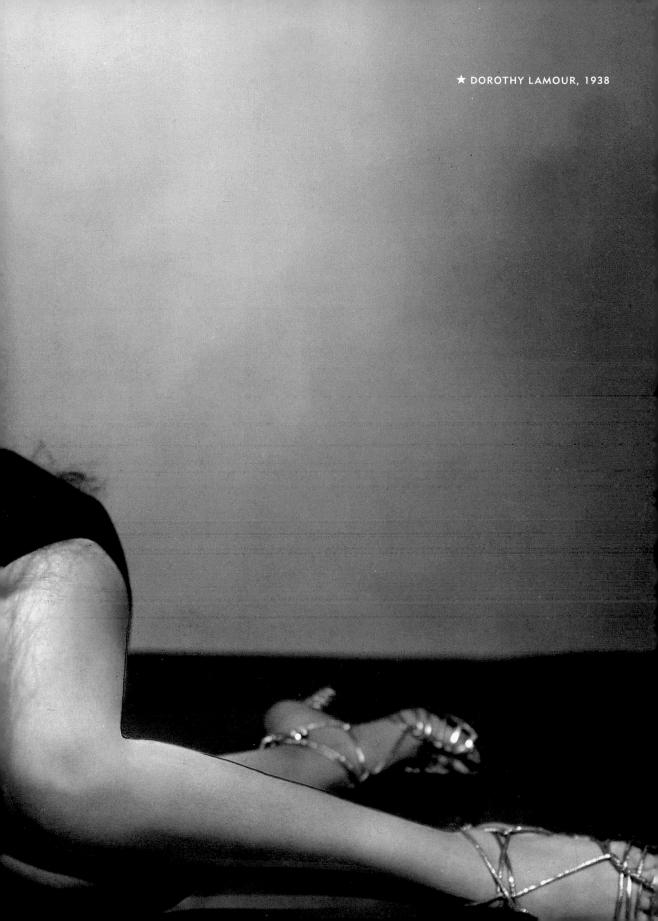

★ DOROTHY LAMOUR, 1938

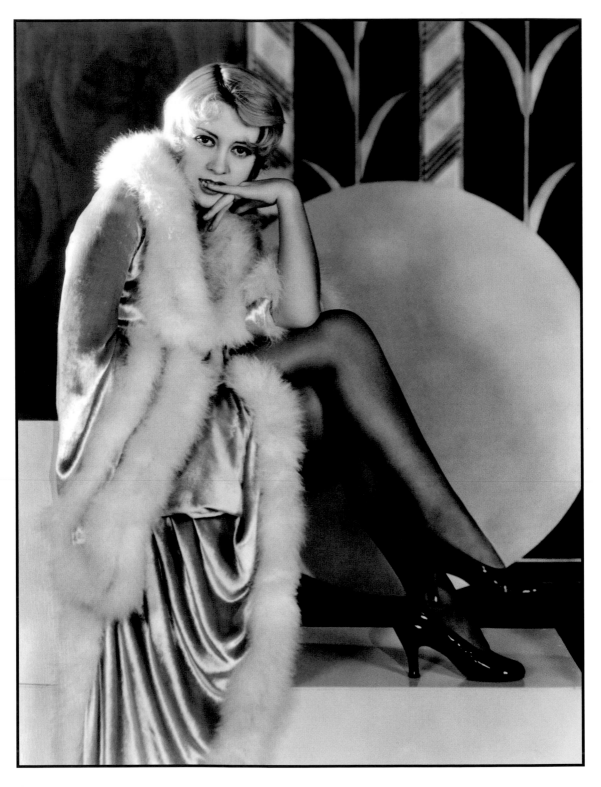

★ JOAN BLONDELL, 1933

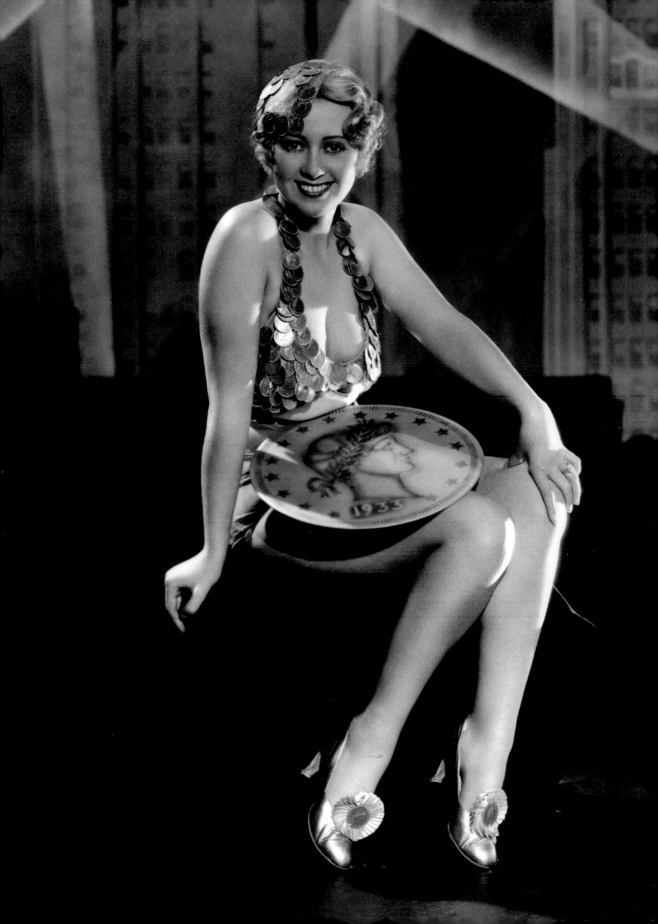

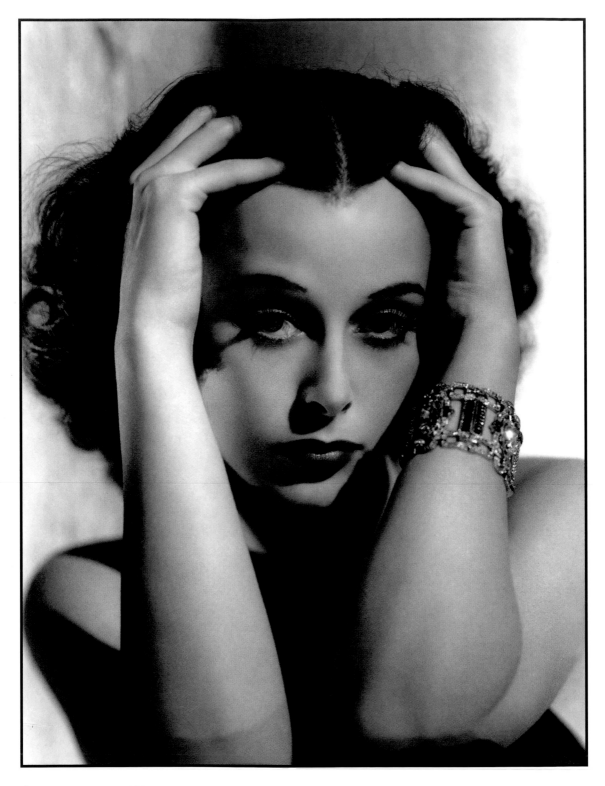

★ HEDY LAMARR, 1938

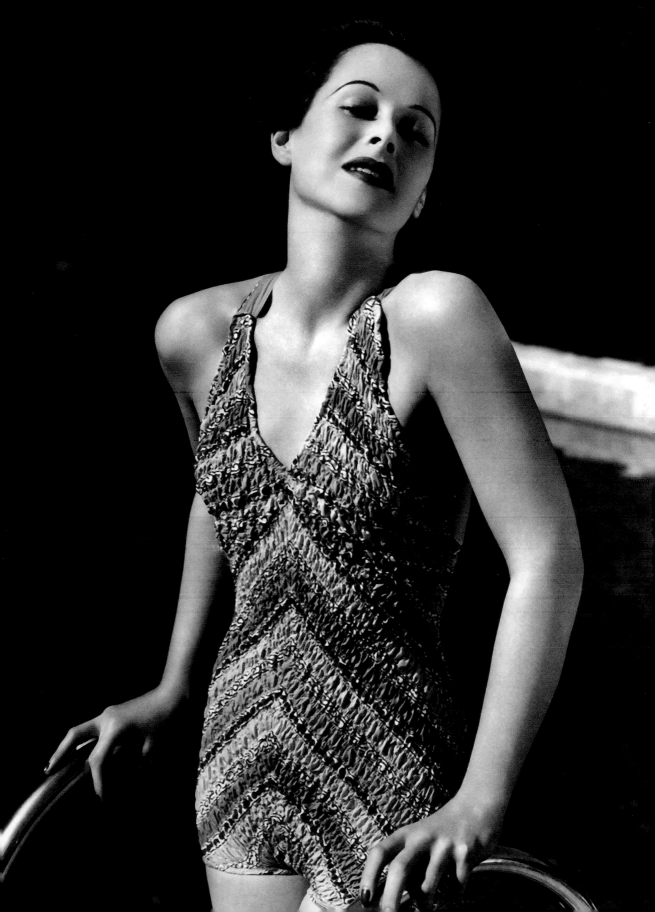

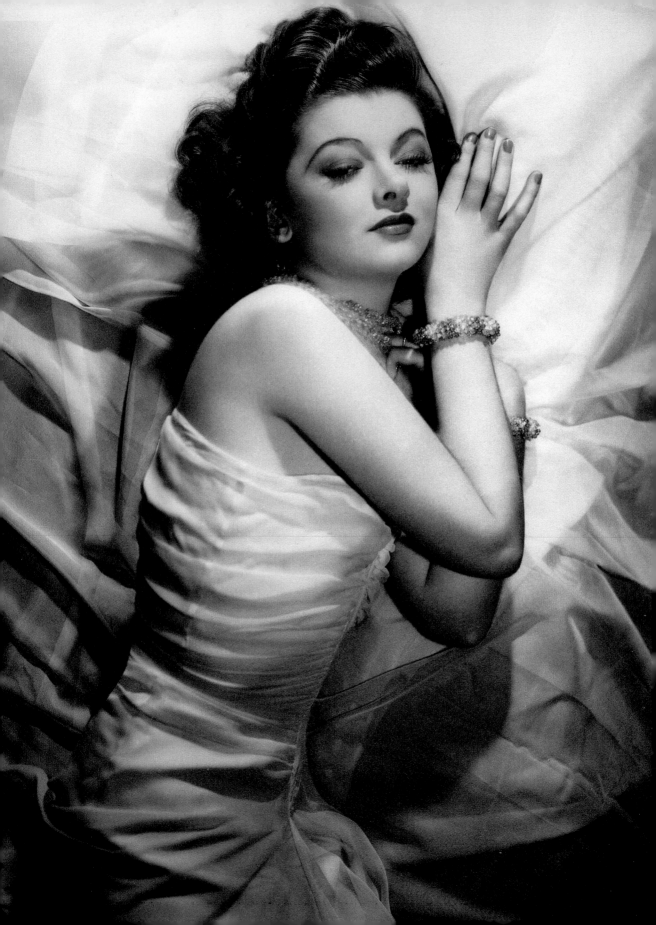

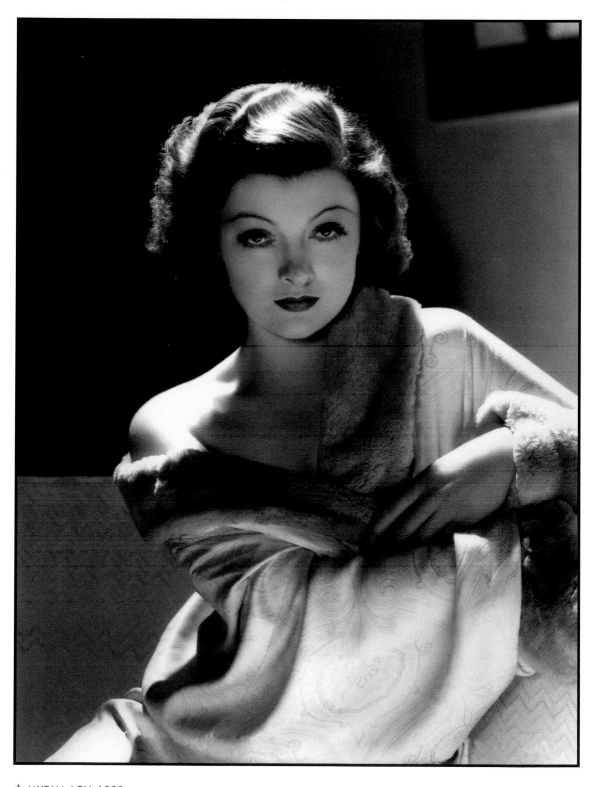

★ MYRNA LOY, 1938

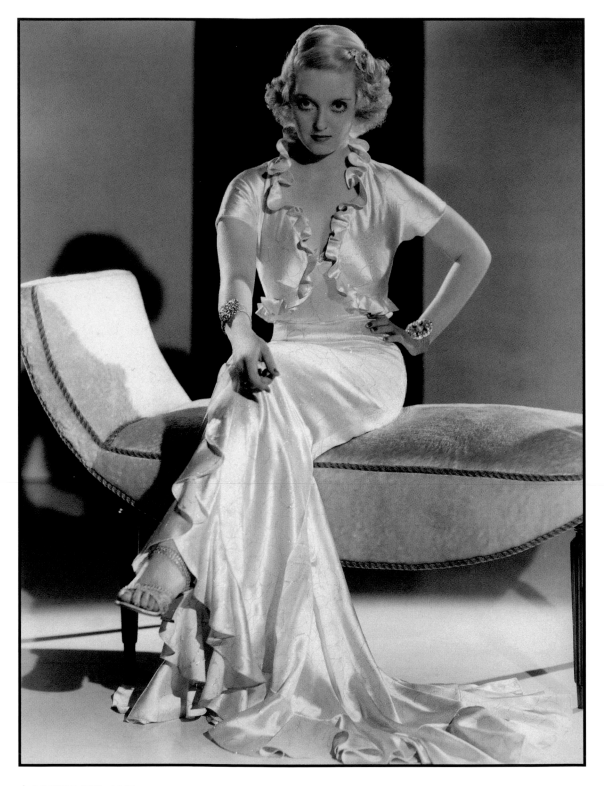

★ BETTE DAVIS, 1933

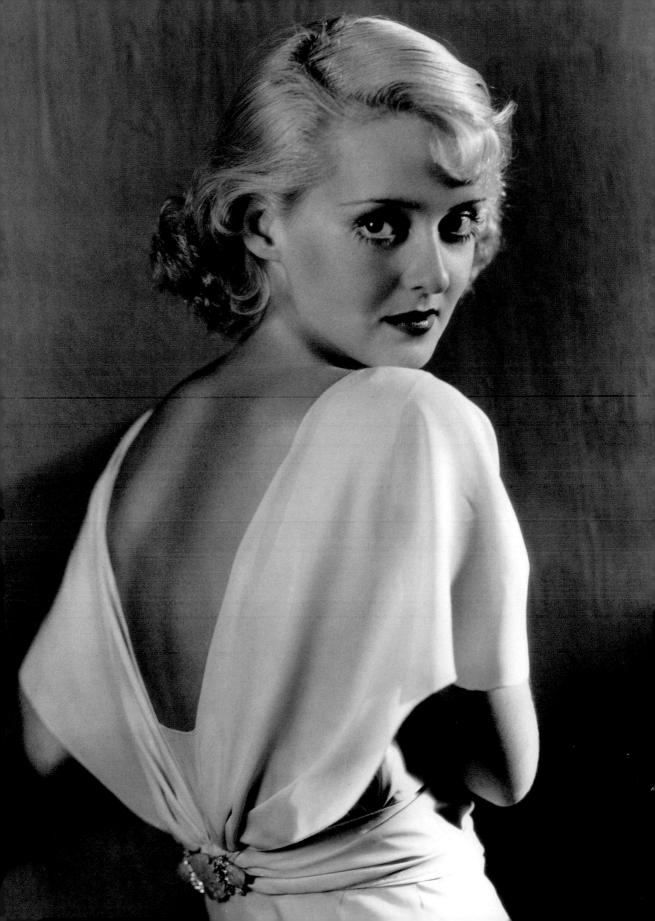

Turkey Shoot

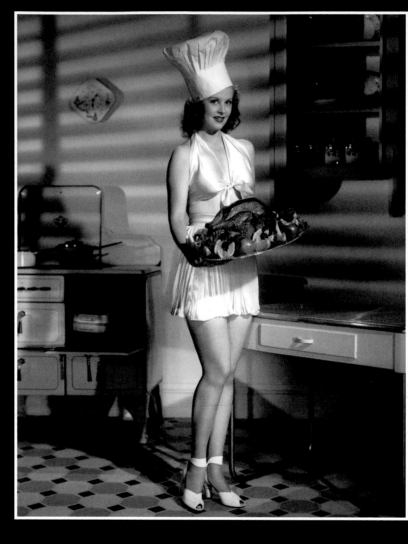

In addition to posing with big holiday birds,
Marilyn Monroe and Arlene Dahl had other
points of convergent interest (aside from being
close friends). Both graced the pages of
Playboy—and both, at one point or another,
were in the good graces of JFK.

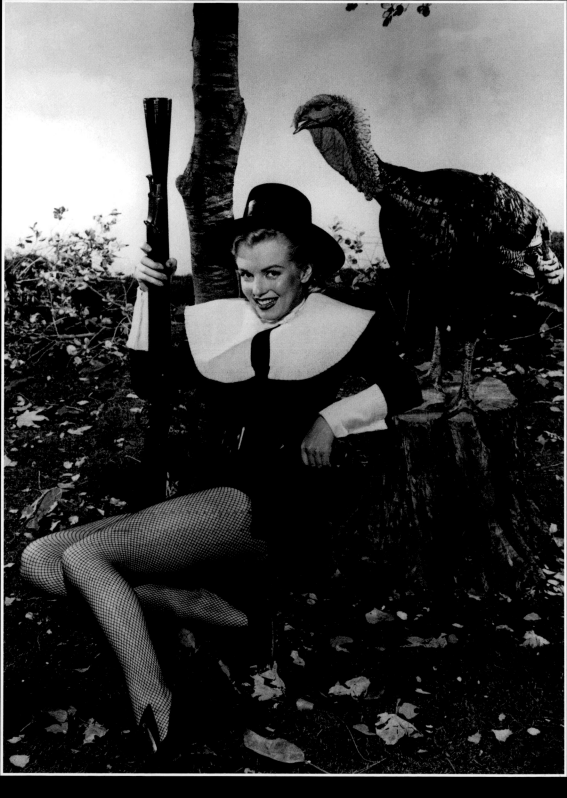

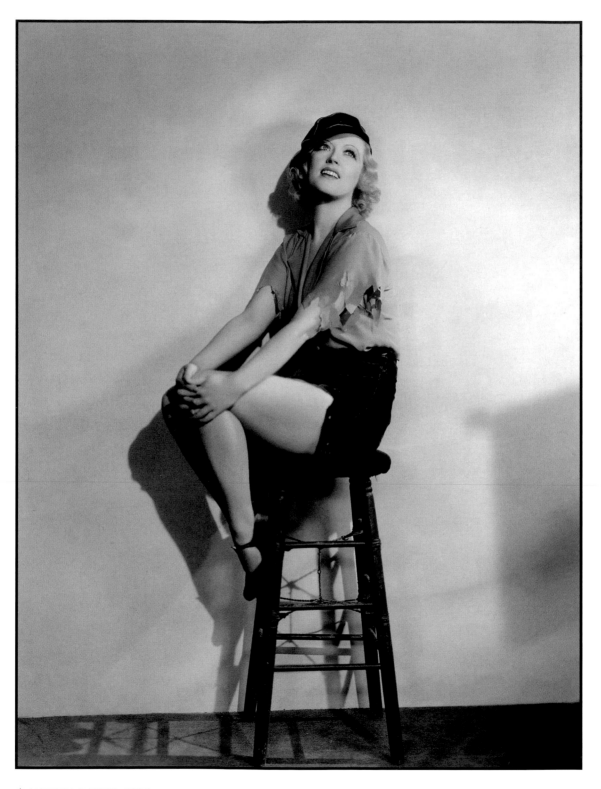

★ MARION DAVIES, 1933

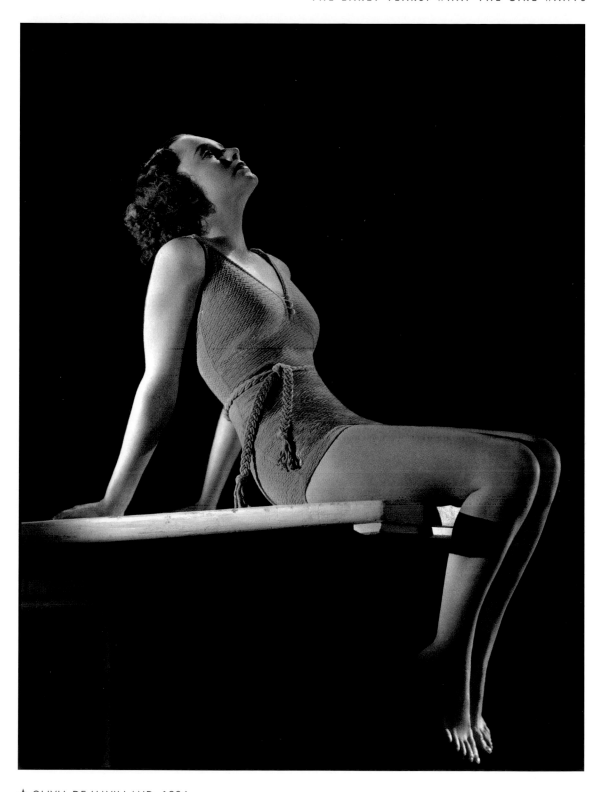

★ OLIVIA DE HAVILLAND, 1936

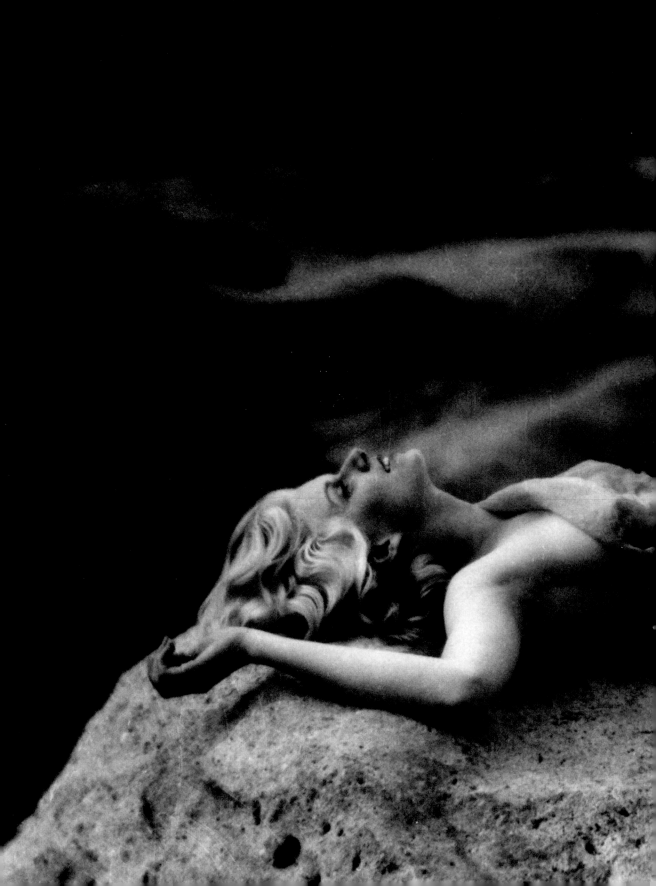

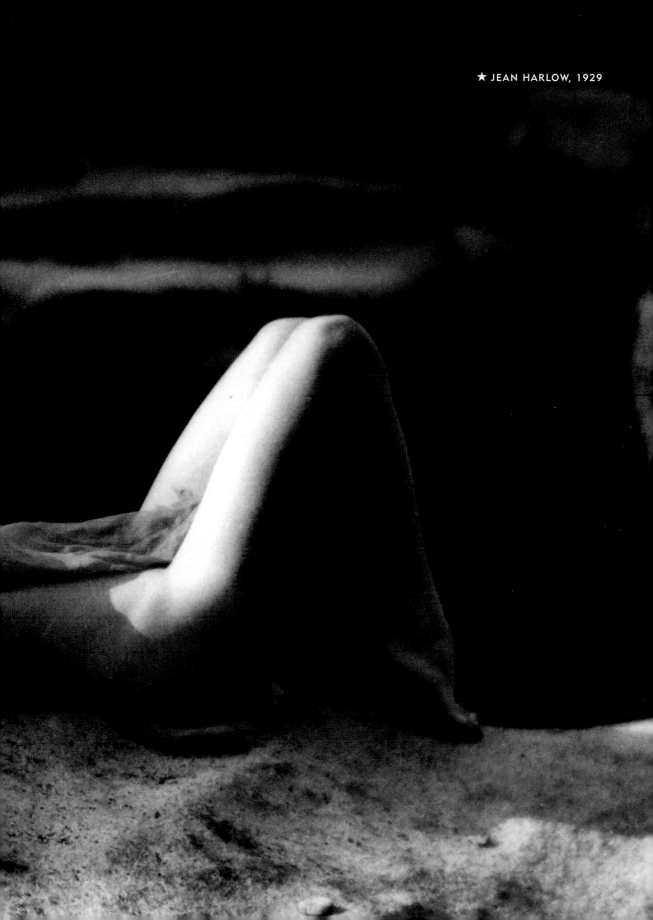

★ JEAN HARLOW, 1929

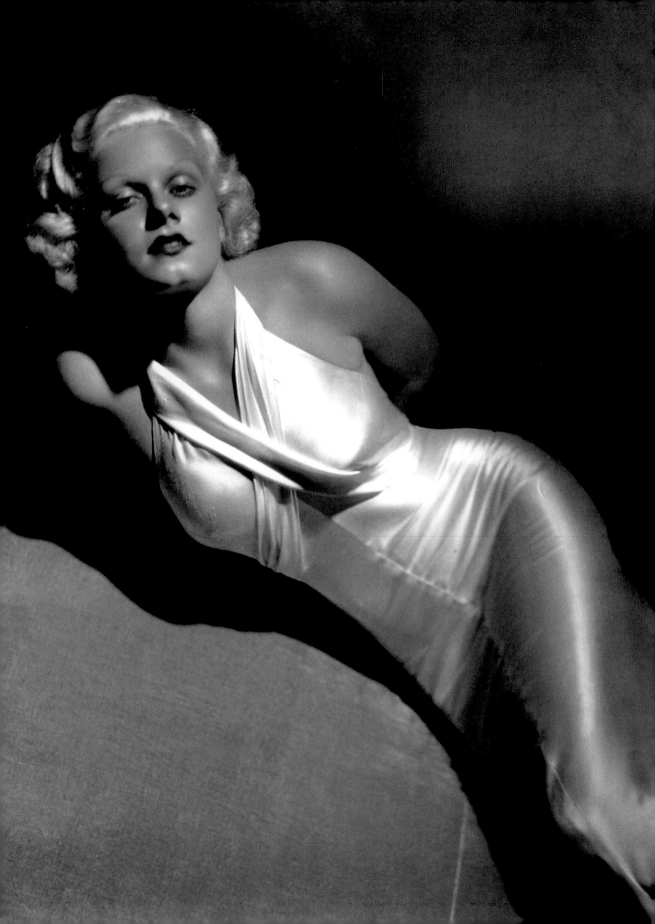

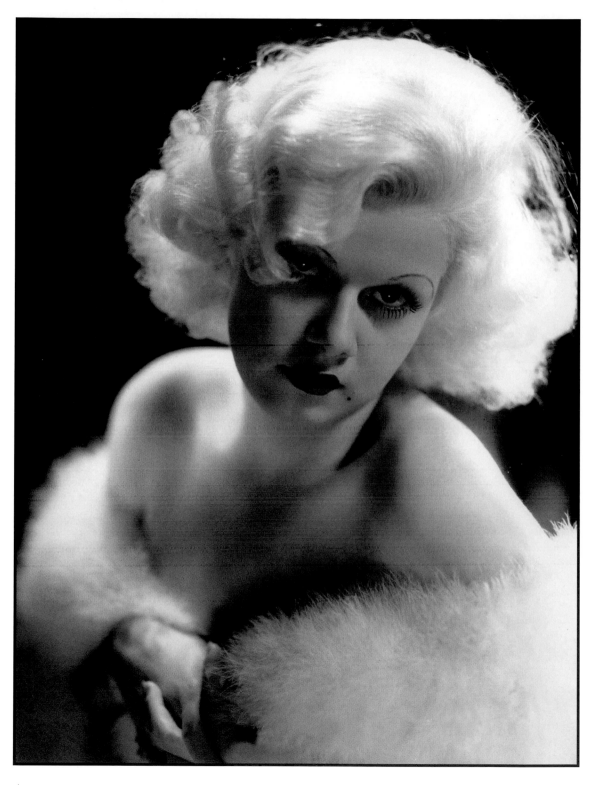

★ JEAN HARLOW, 1934

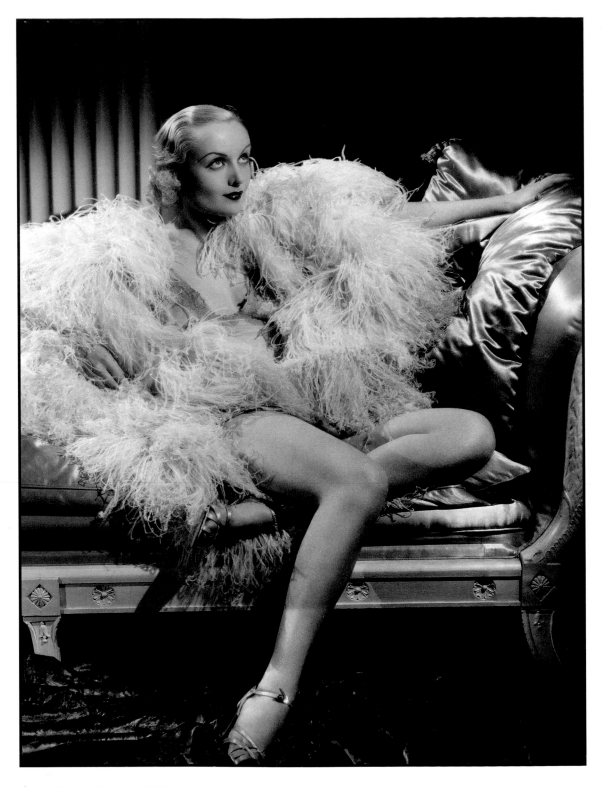

★ CAROLE LOMBARD, 1933

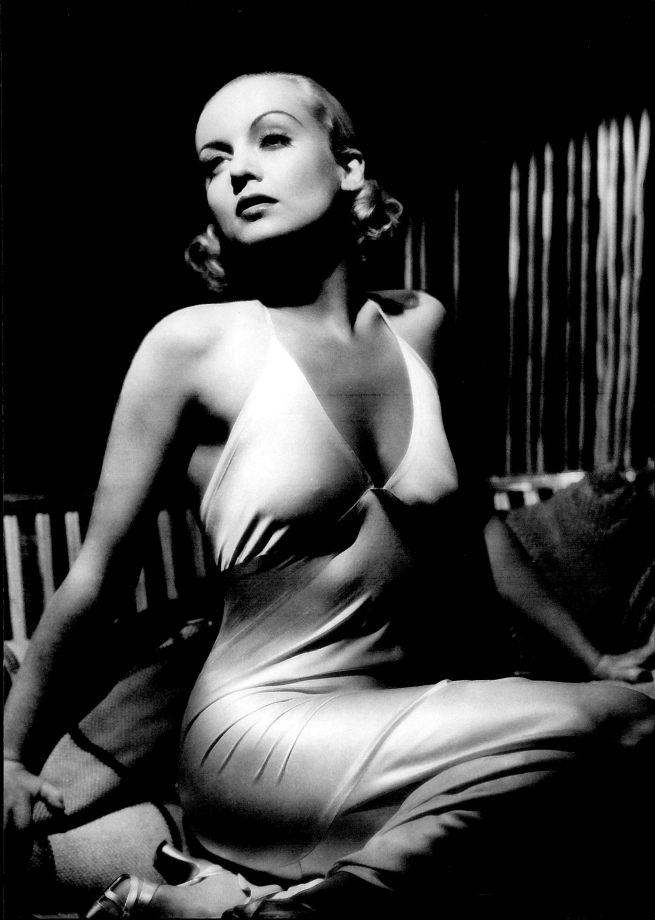

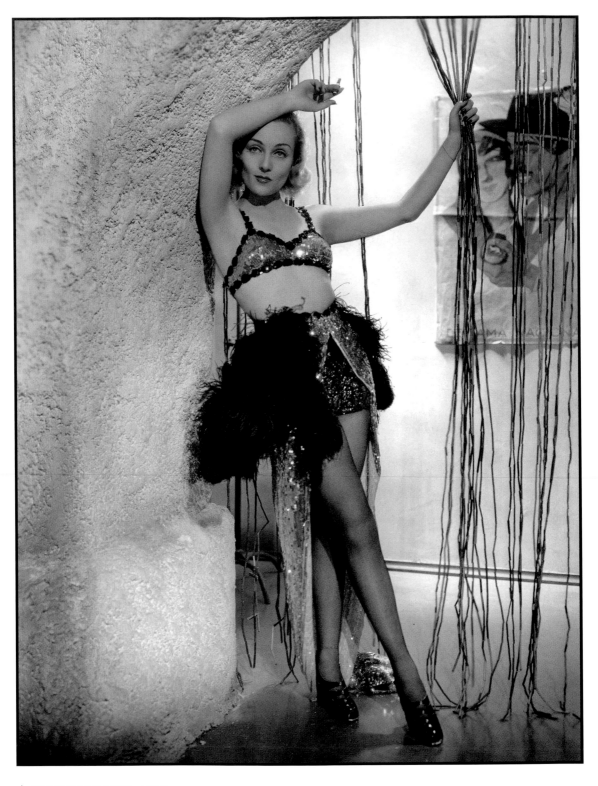

★ CAROLE LOMBARD, 1937

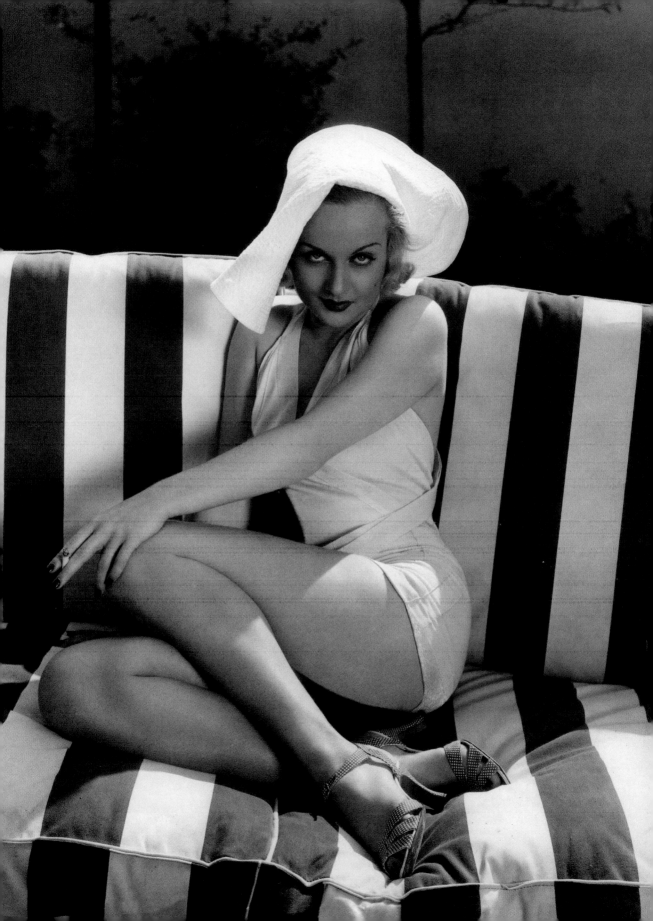

★ JOAN CRAWFORD, 1925

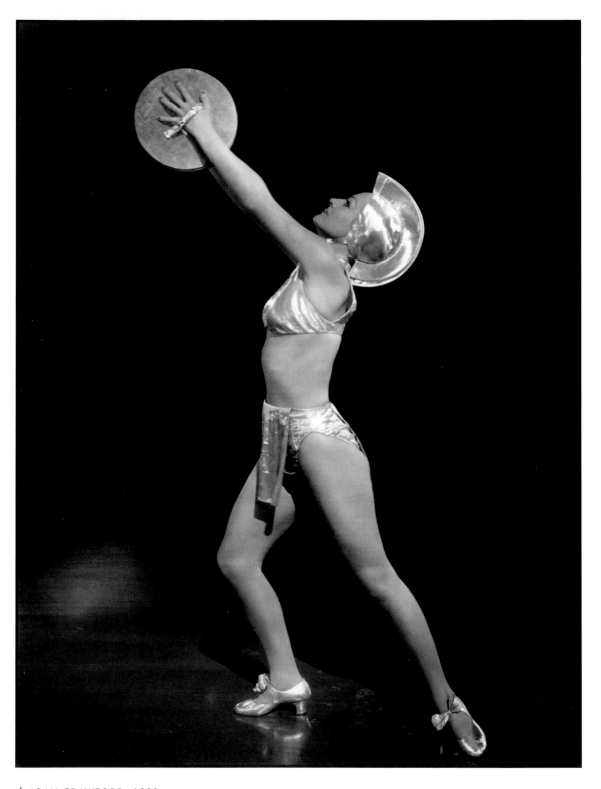

★ JOAN CRAWFORD, 1933

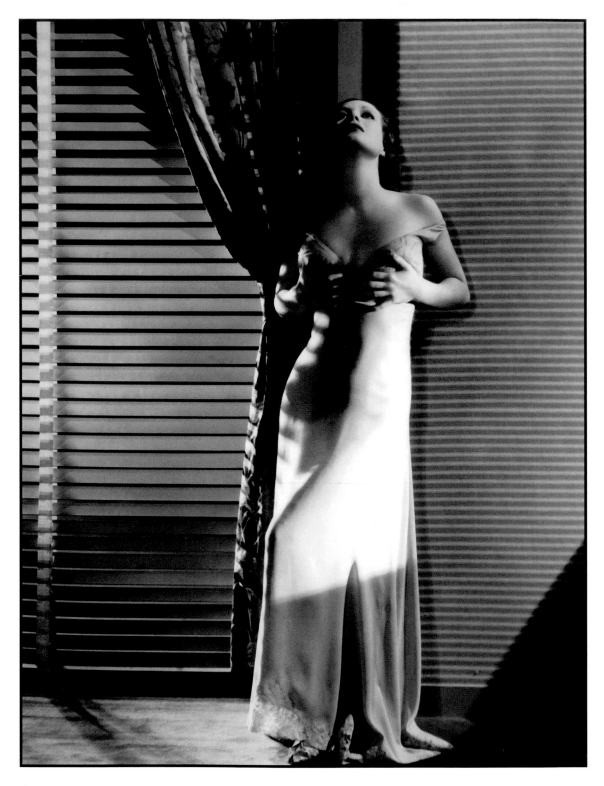

★ JOAN CRAWFORD, c.1930

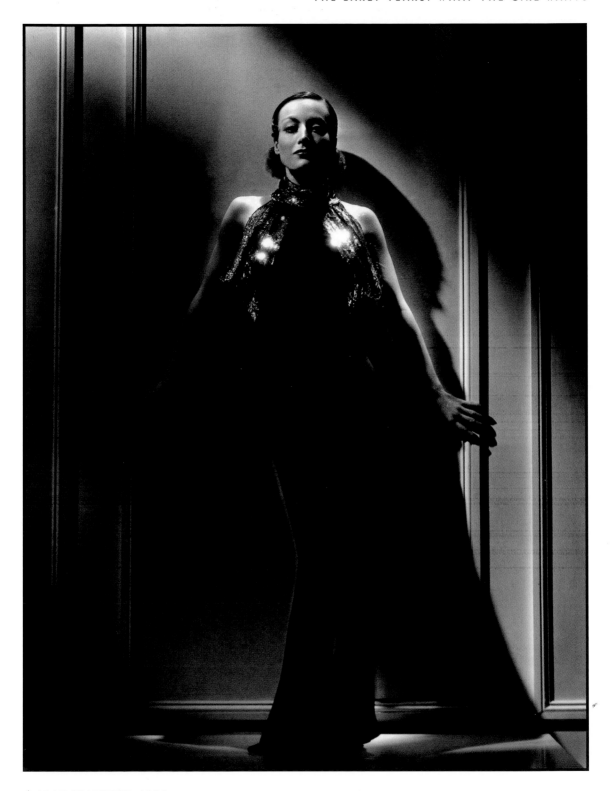

★ JOAN CRAWFORD, 1934

Trick or Treat!

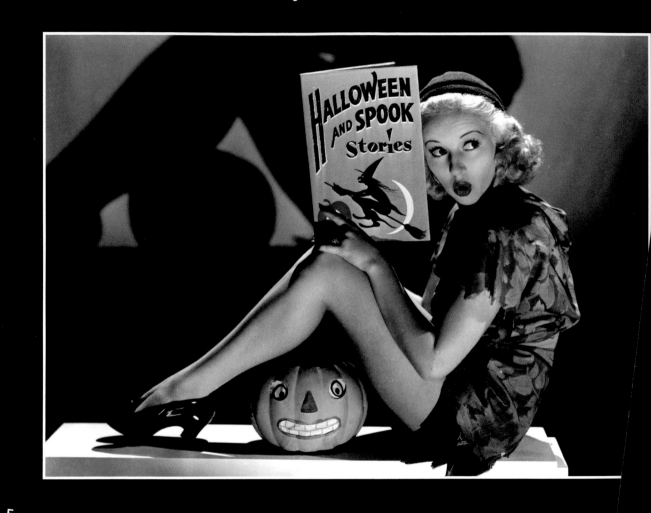

From pagan rituals to party nights, the pin-ups in these Halloween-themed shoots appear game for just about anything involving costumes, pumpkin accessories, and a chance to switch identities. According to Mark Twain: "Clothes make the man. Naked people have little or no influence on society." His opinion on the semi-clad pin-ups of the night remains unknown.

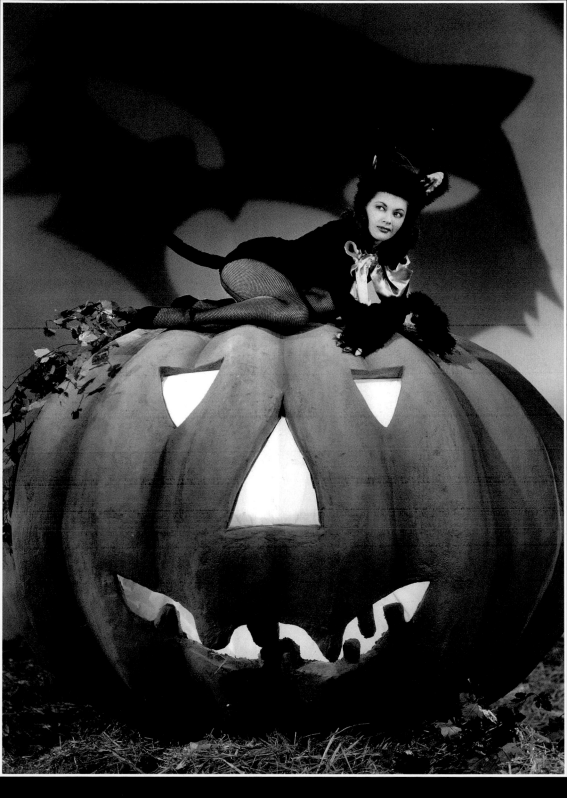

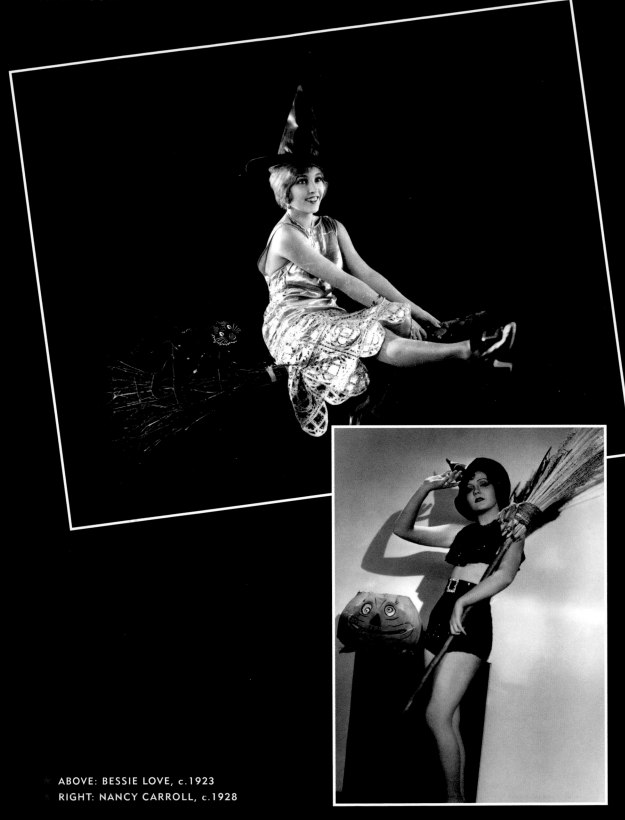

ABOVE: BESSIE LOVE, c.1923
RIGHT: NANCY CARROLL, c.1928

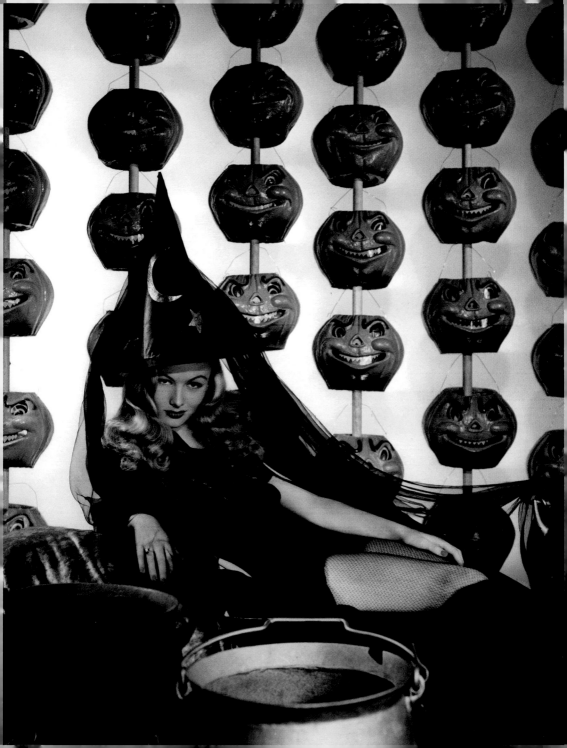

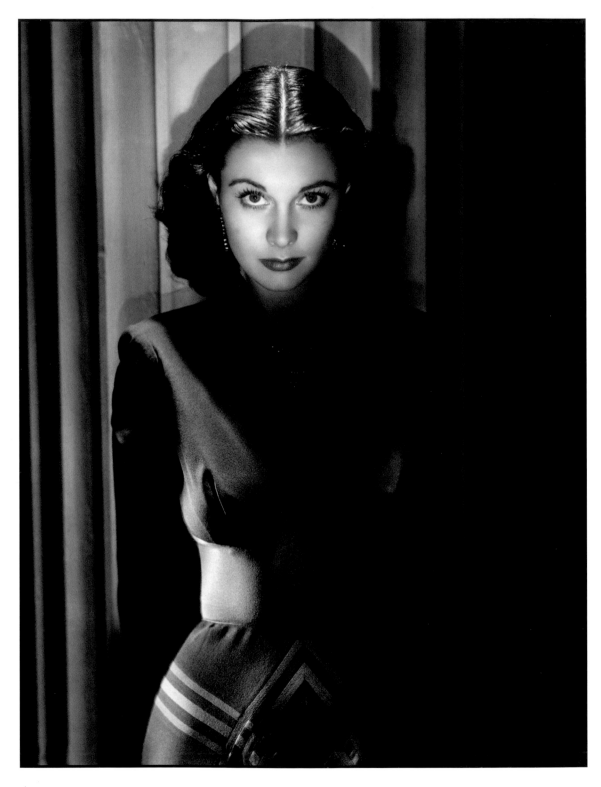

★ VIVIEN LEIGH, 1939

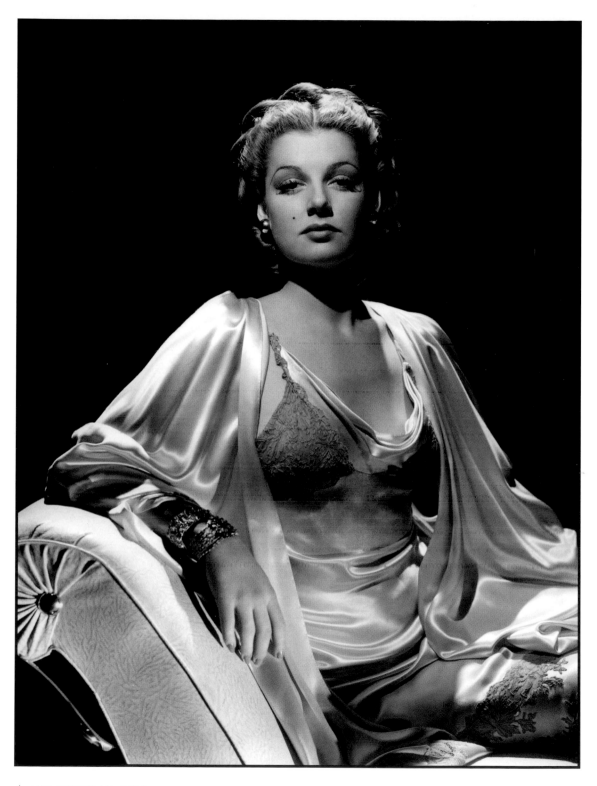

★ ANN SHERIDAN, 1939

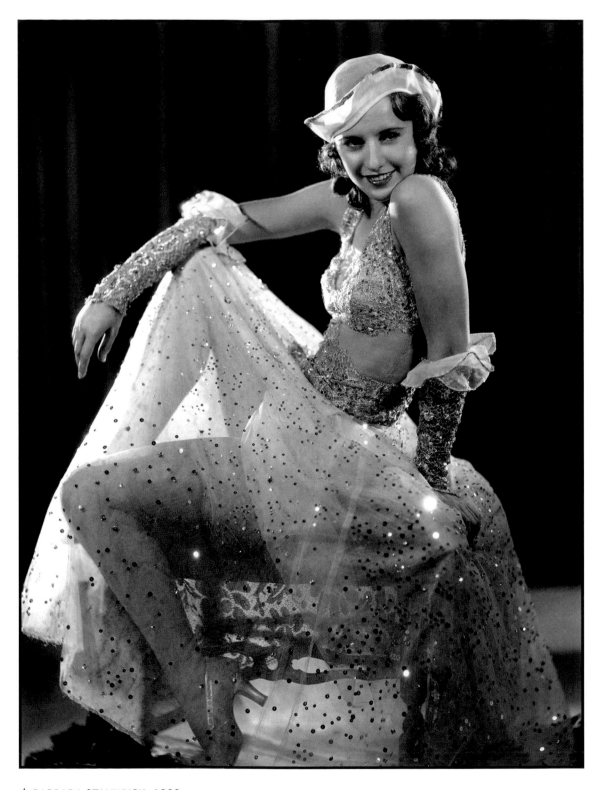

★ BARBARA STANWYCK, 1932

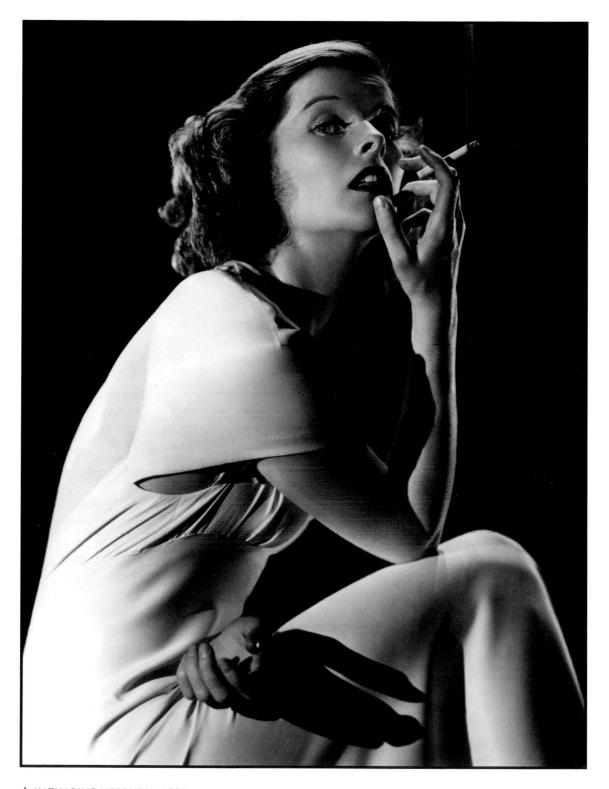

★ KATHARINE HEPBURN, 1935

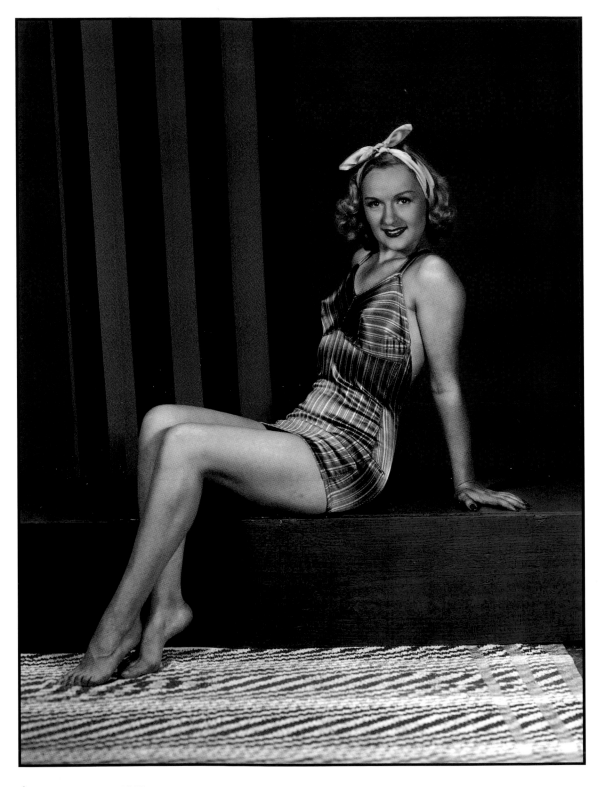

★ VIRGINIA DALE, 1938

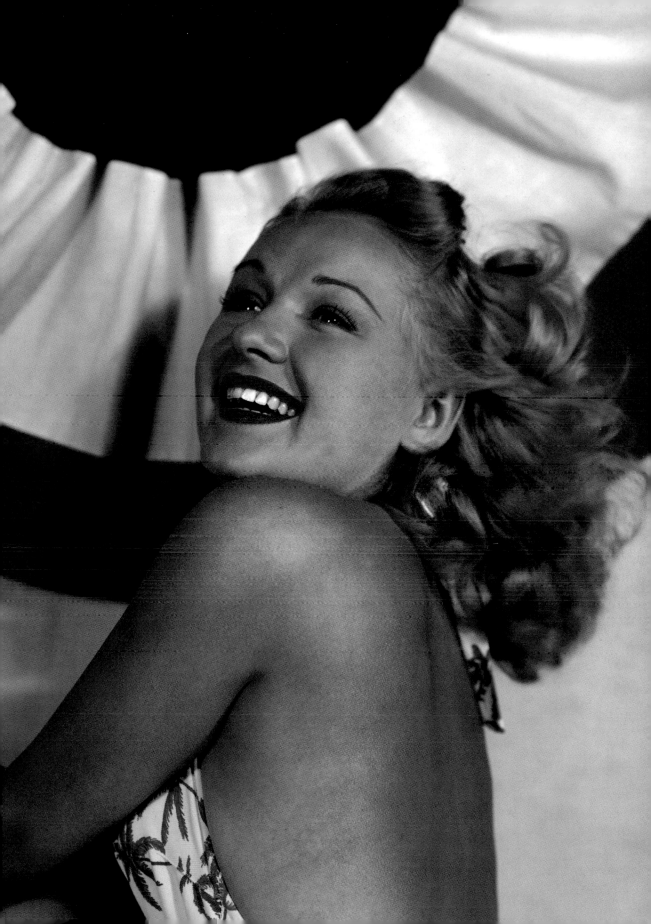

The 1940s: Over There

O n September 1, 1939, the end of the decade arrived slightly ahead of schedule. Germany invaded Poland, World War II officially began, and the pin-up was quickly conscripted for active duty. What people most likely do *not* remember about this particular day is the U.S. premiere of George Cukor's *The Women*. This extremely odd (and totally twisted) film may very well be the ultimate "women's picture." Although completed prior to the outbreak of war, the film can be seen as encapsulating the range of women's concerns that would spring up during the war and immediately afterward—and as such it serves as a perfect springboard for a discussion of the pin-up.

One would be hard-pressed to find a film with a more pin-up-heavy cast than *The Women*, most of whom can be found within these pages. The stars include: Rosalind Russell, Norma Shearer, Joan Crawford, Joan Fontaine, Virginia Grey, and Paulette Goddard. While the film's tagline—"It's all about men!"—is essentially correct, the central artistic device is that no male actors ever appear on screen (nor are their voices ever heard). The absence of men in the film was a prescient analogue for what would happen in many American households during the war. And the escalated levels of female agency—not to mention the film's focus on rampant promiscuity and infidelity—anticipates the changing of women's roles "over here" while their men were "over there."

The parallel irony of this interpretation is that at the end of both the actual war and the film, there is a regression to a gender status quo: The women of the real world—i.e., the individuals who were given greater freedom, job opportunities, and gender equality during the war—were told it was now time to return to their former roles as homemakers. Correspondingly, the lead actor in *The Women*, Norma Shearer, foregoes her seemingly new found freedom to gleefully return to the arms of the bimbo-seeking letch who abandoned her at the film's beginning. Needless to say, the film is not exactly a revolutionary feminist tract.

★ Paulette Goddard, 1942: This former Ziegfeld girl caught the eye of Charlie Chaplin, who cast her in his WWII satire, *The Great Dictator* (1940).

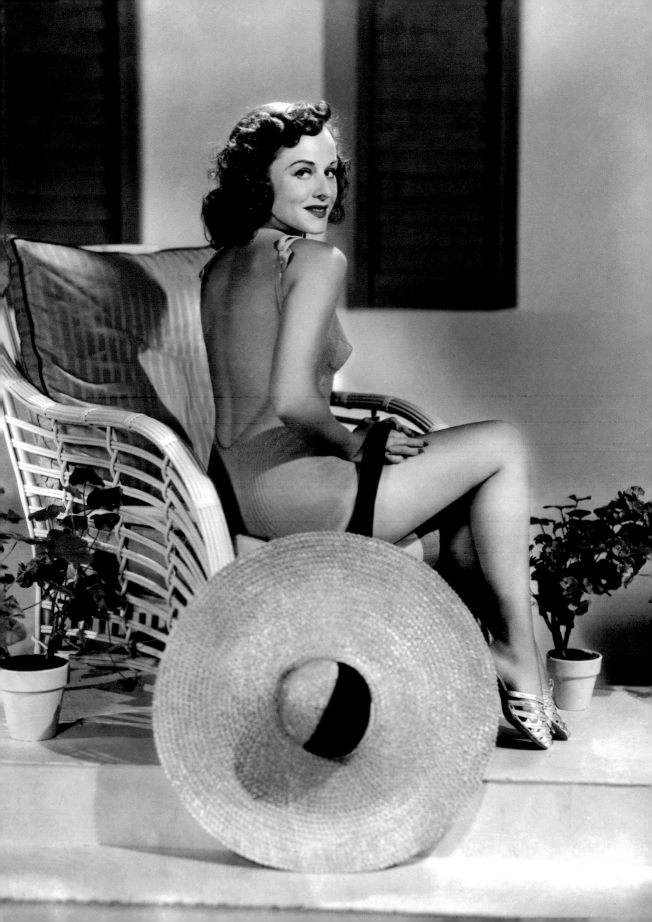

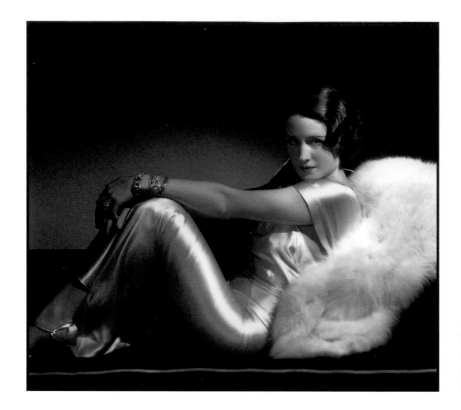

★ Norma Shearer, 1933: Shearer's high-glam but sultry look bridged the pin-up style of the 1930s and '40s.

By war's end, however, the title of the Most Significant Pin-up went not to the glamazons of *The Women*, but instead to the sweet-seeming Betty Grable. Proliferating throughout American barracks worldwide, her iconic image—a coy, over-the-shoulder peek-a-boo while clad in a most curvaceous one-piece swimsuit—was nothing less than ubiquitous (see opposite). From today's vantage point it's easy to comprehend not just the image's place in history, but also how much the times have changed. The appeal, however, remains forever ambiguous. As film historian David Thomson aptly put it: " . . . her body was too pert to be disturbing, too thoroughly healthy to be interesting." And yet for American servicemen Grable definitely had allure. In *Wing and a Prayer* (1944), her appeal was summed up by a bit of cinematic self-reflexivity: In the movie, soldiers stationed overseas are taking a break from combat to watch the 1940 Grable vehicle *Tin Pan Alley*. The screening turns into a screamfest. The men hoot and holler at Grable's screen image. When the projector breaks down, the crowd goes berserk.

Photographs, unlike films, don't make sounds. But they can surely evoke them. This is especially true when dealing with subjects whose voices are so memorable they seem virtually embedded in any still

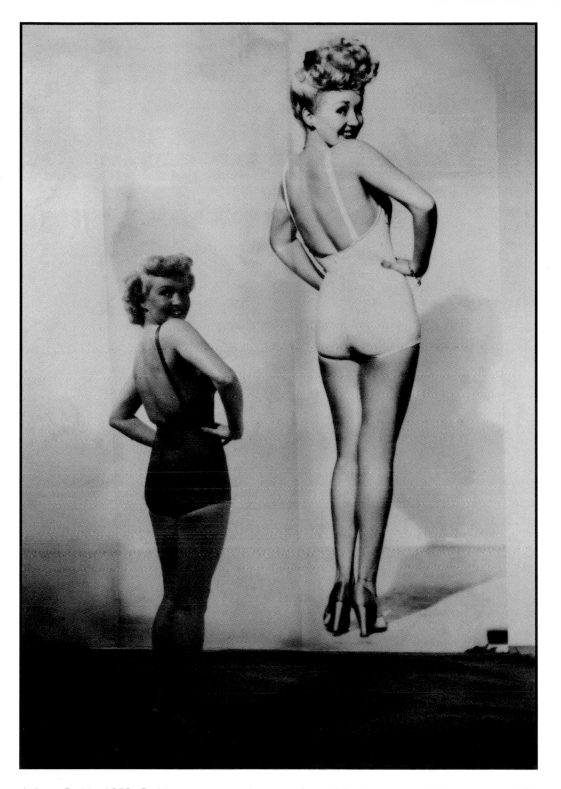

★ Betty Grable, 1950: Grable re-creates and poses in front of the shot that made her an icon in 1944.

image that's been made of them. Consider the shots of Lauren Bacall here and on page 155. Or Marilyn Monroe on page 171. You can practically hear them growl and purr. Can the pin-up push the sensual envelope? Take a look at the aura that seems to surround Marlene Dietrich (opposite). One could argue that in this particular image a woman can be seen, the echoes of her voice heard, and even the fragrance of her presence detected. Indeed, Dietrich looks like she's inhaling it herself.

The pin-up genre is not always driven by the needs of Hollywood or the media-personality star system. Many of the women in so-called men's magazines are not exactly household names, and most of the hybrid creations of painters such as Alberto Vargas and Gil Elvgren don't even exist. As it happens, a small handful of the women who appear in this book are in fact unknown and unidentified. (For example, who *is* the topless beauty on page 20?) There's also a subcategory of real-people pin-ups: the wives and girlfriends of men at war who took it upon themselves to create homegrown pin-up imagery that they would pose for, photograph, and then mail to loved ones.

Art historian Maria Elena Buszek, an academic titan when it comes to all things pin-up-able, persuasively argues that the wartime homegrown pin-up demonstrates an active agency on the part of some women. "The pin-up," states Buszek, "provided an outlet through which women might assert that their unconventional sexuality could coexist with conventional ideals of professionalism, patriotism, decency, and desirability—in other words, suggesting that a woman's sexuality could be expressed as part of her whole being." For certain female practitioners, and for thinkers like Buszek, the old-school hard-line argument—that this type of imagery objectifies and degrades women—belittles the fact that the pin-up artform opens a field in which female empowerment can come into its own and flourish. It is hard indeed to behold many of the images on the pages that follow and regard them as anything but powerful.

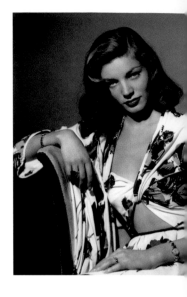

★ Lauren Bacall, 1946: With a voice like a purr of smoke, which she used to exchange brainy badinage on screen with her husband Humphrey Bogart, Bacall was the thinking-man's pin-up of the '40s.

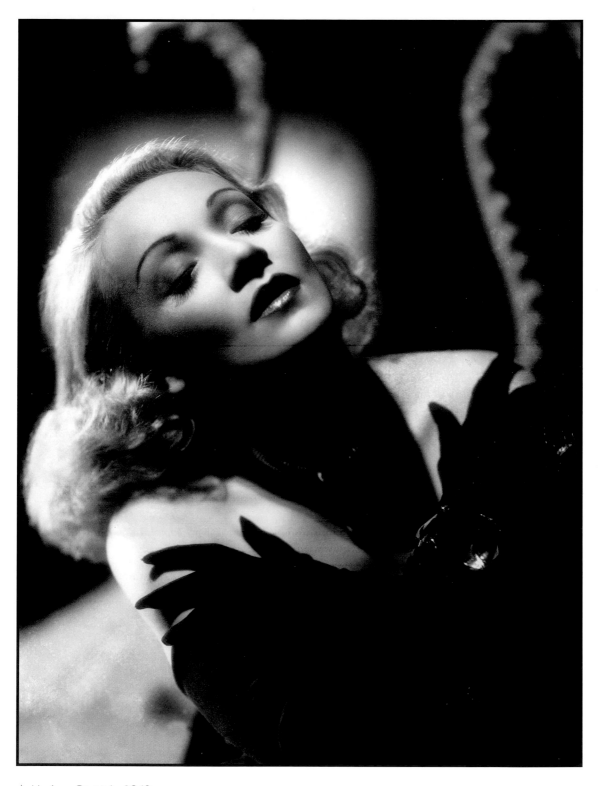

★ Marlene Dietrich, 1942

★ PAULETTE GODDARD, 1941 (ABOVE), 1946 (OPPOSITE)

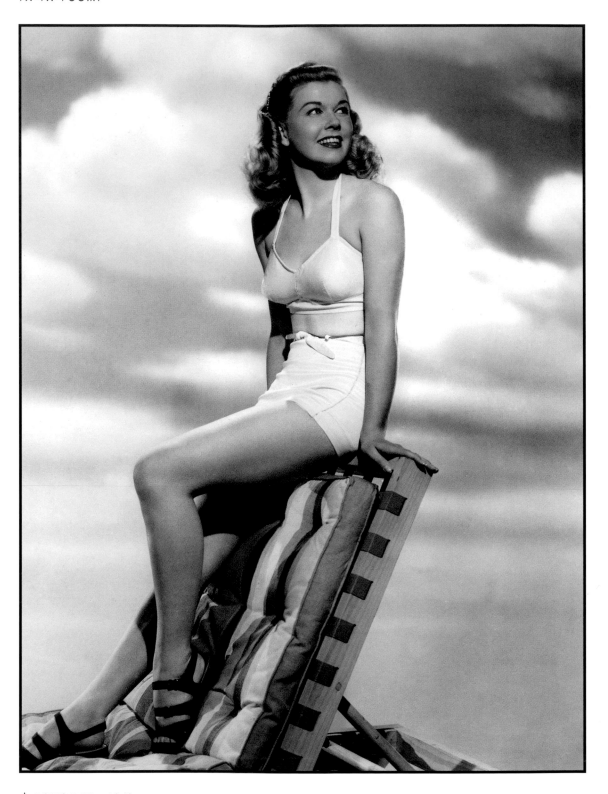

★ DORIS DAY, c.1940

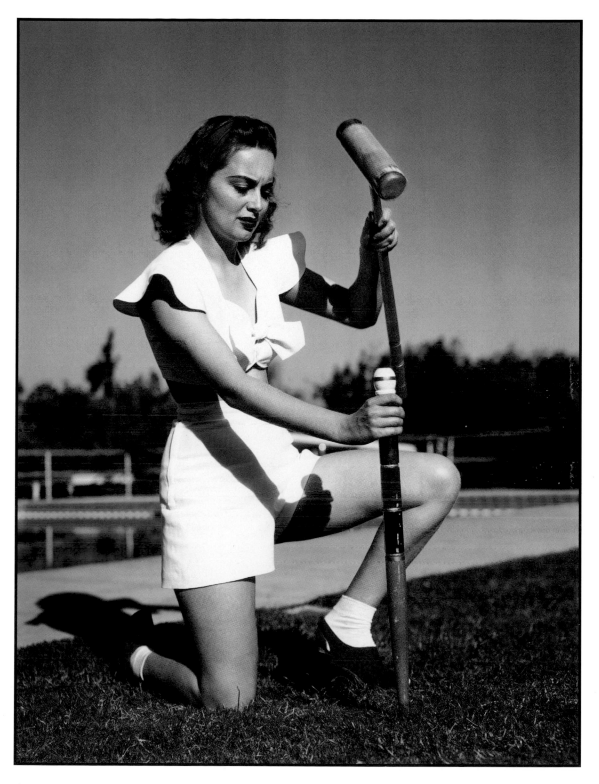

★ OLIVIA DE HAVILLAND, 1945

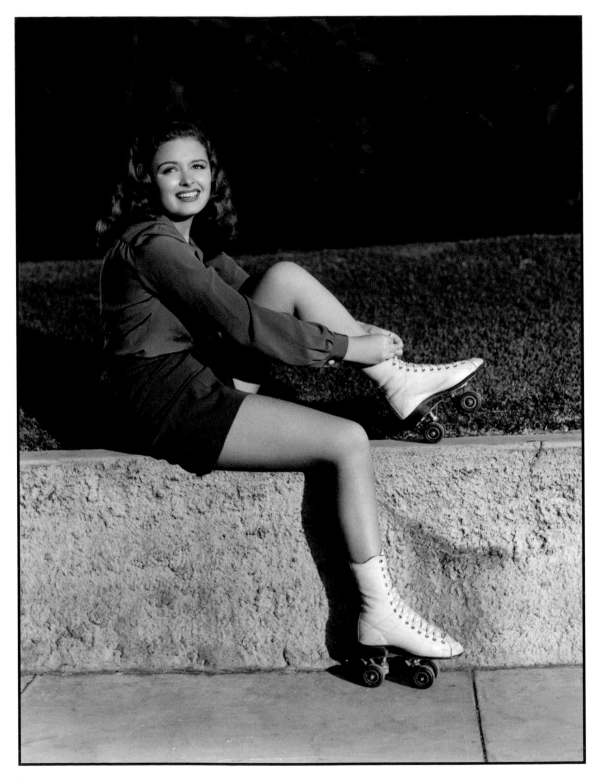

★ DONNA REED, 1941

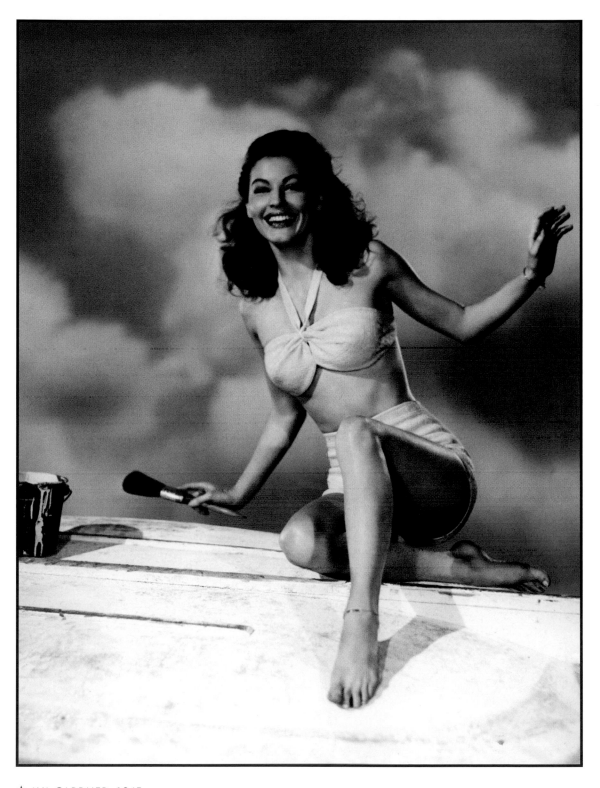

★ AVA GARDNER, 1945

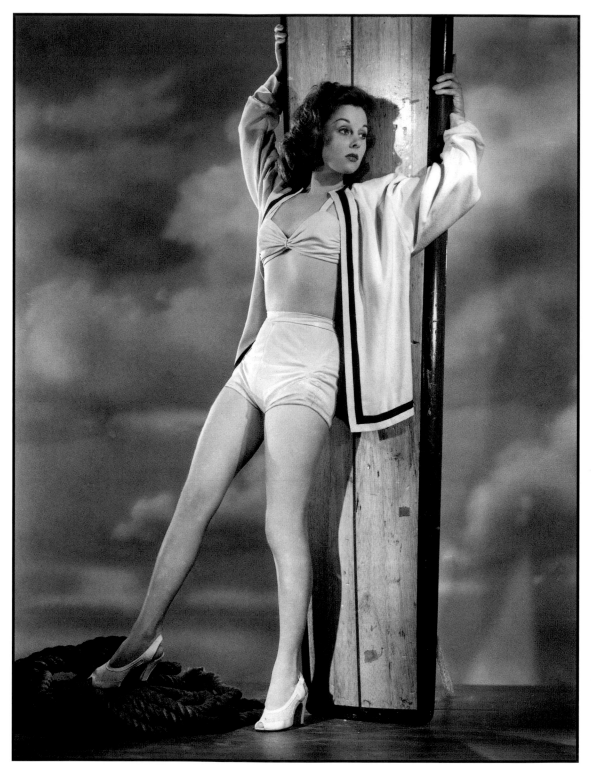

★ SUSAN HAYWARD, 1947

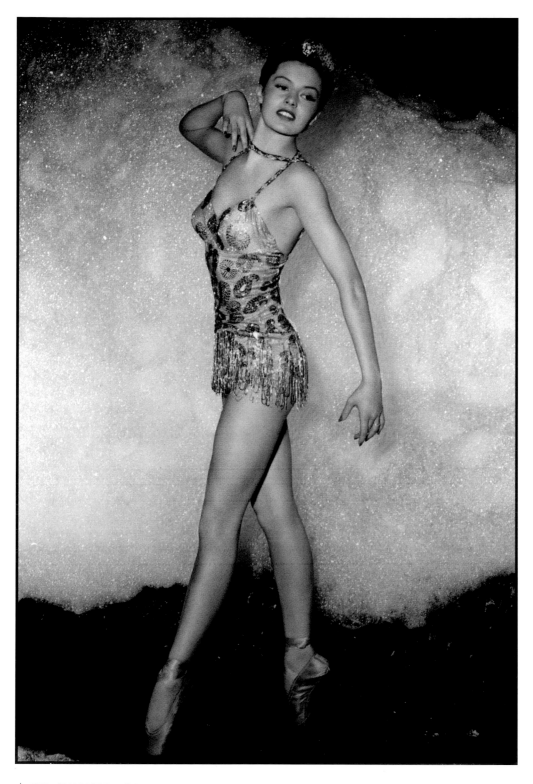

★ CYD CHARISSE, 1946

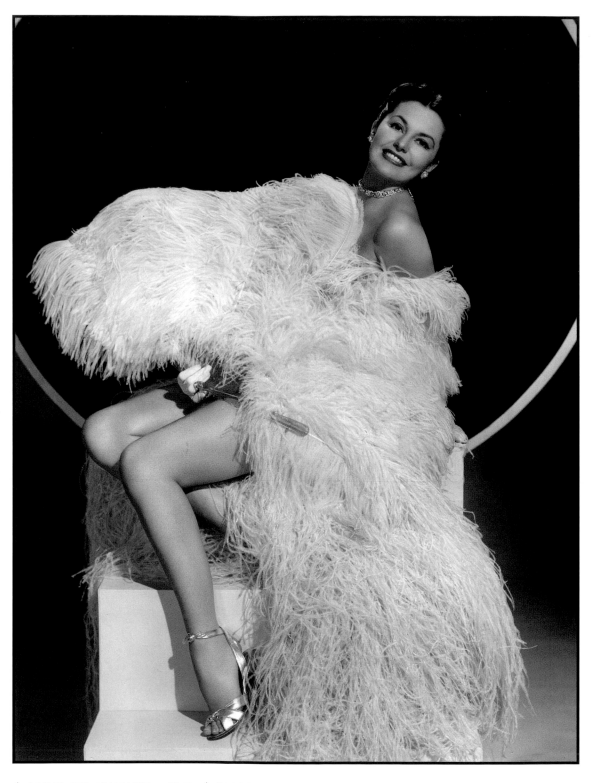

★ ABOVE: CYD CHARISSE, c.1948 ★ OPPOSITE: GLORIA DEHAVEN, 1954

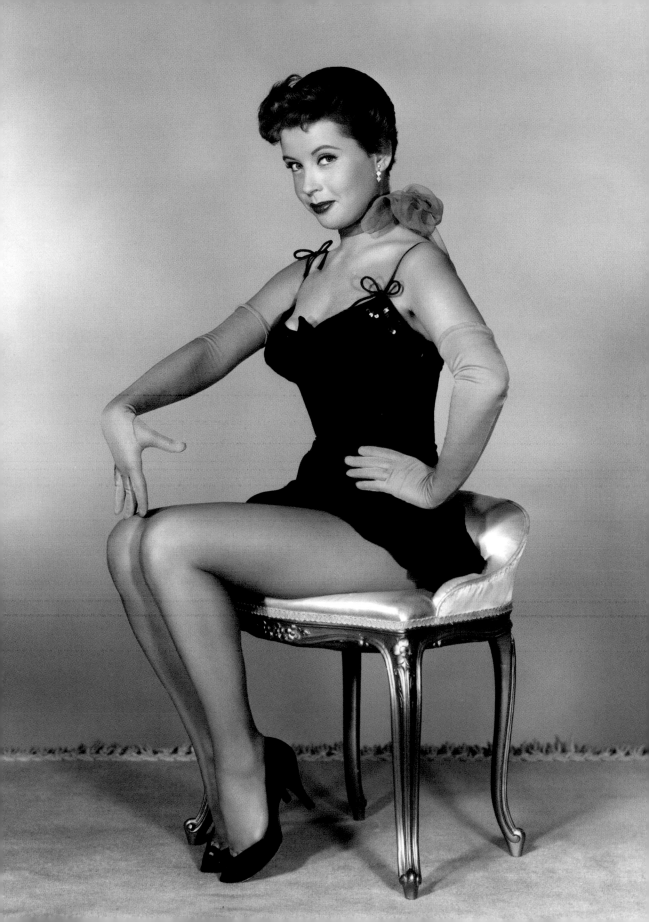

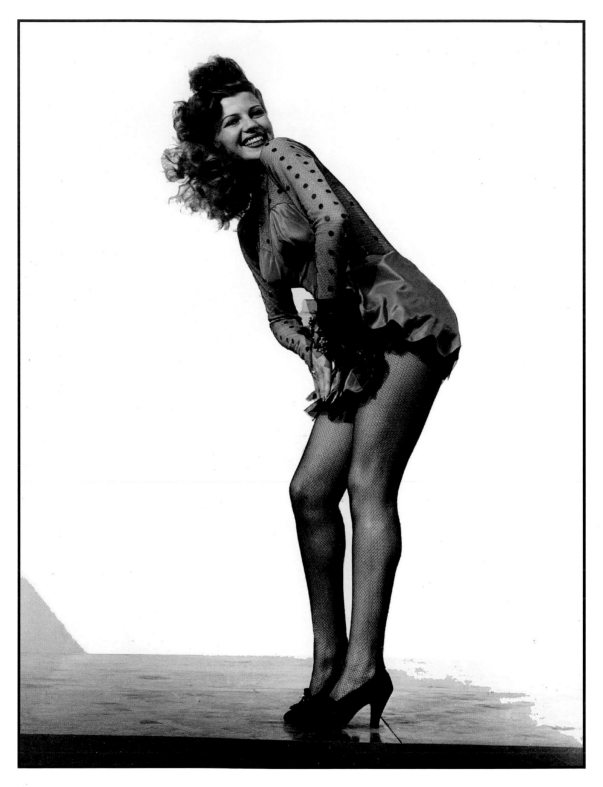

★ RITA HAYWORTH, 1944

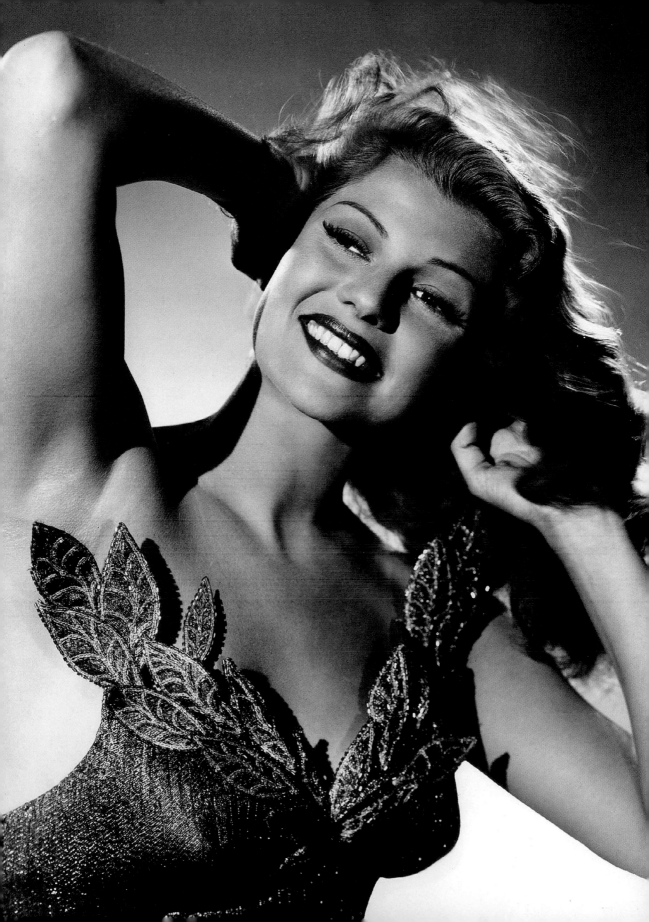

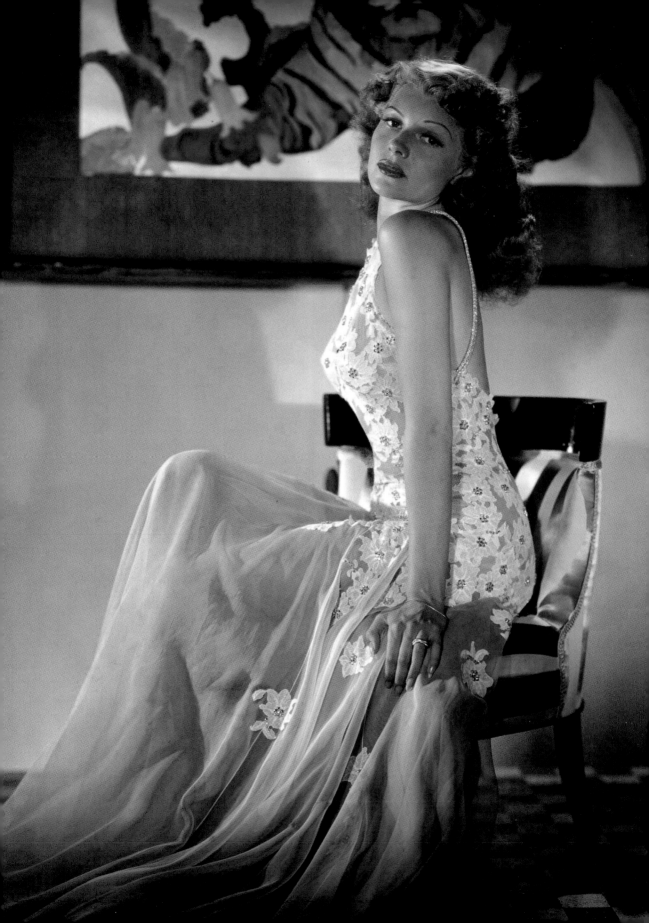

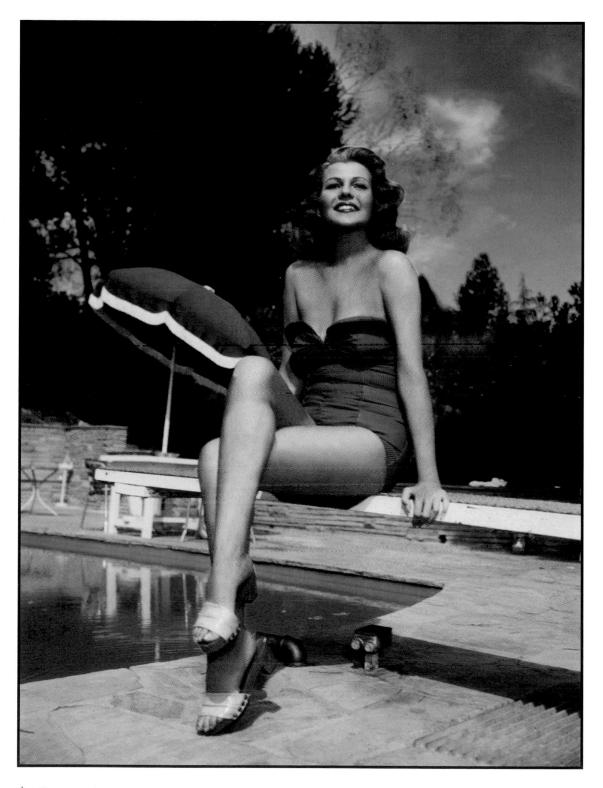

★ RITA HAYWORTH, 1944

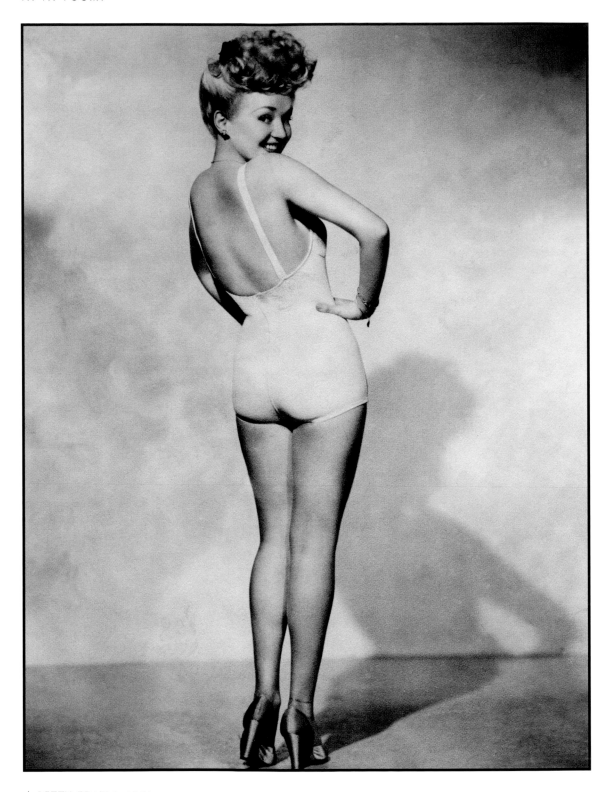

★ BETTY GRABLE, 1944

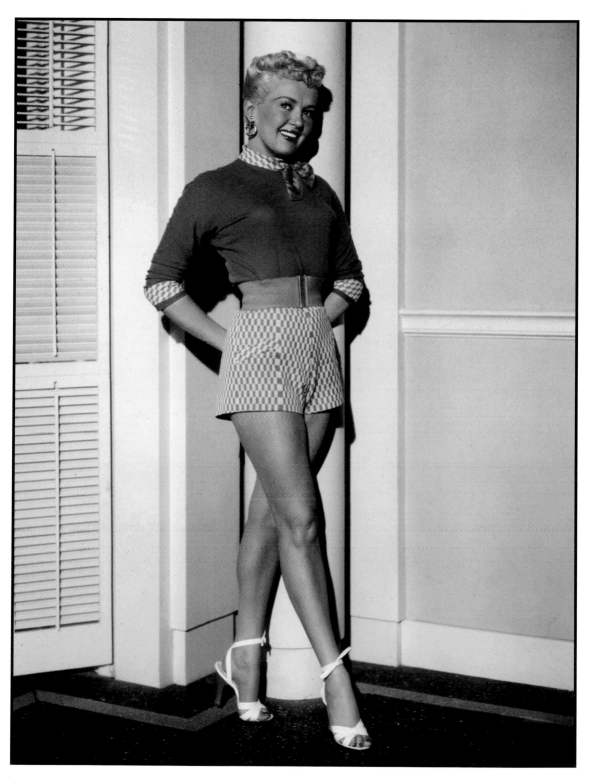

★ BETTY GRABLE, 1953

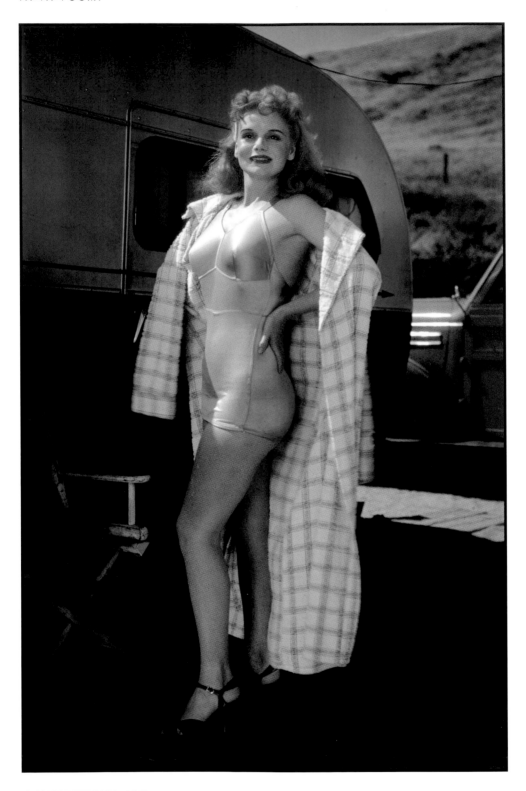

★ MARIE WILSON, 1945

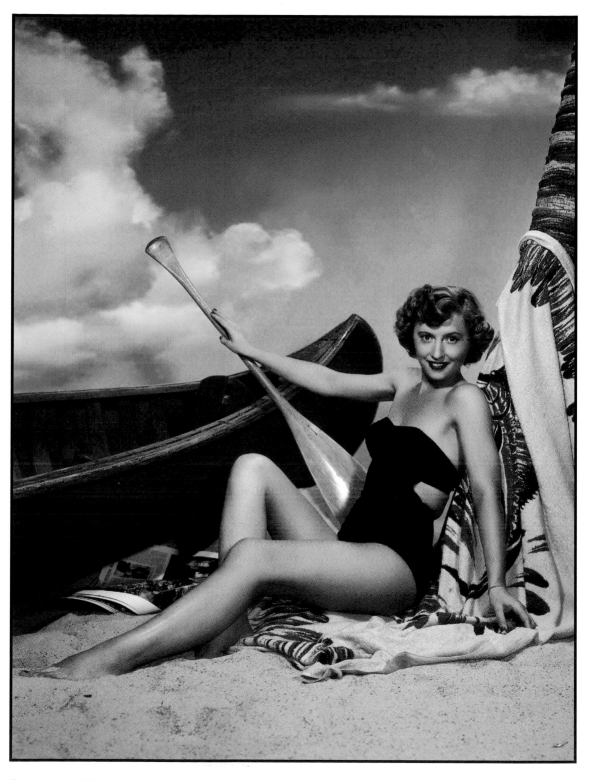

★ BARBARA STANWYCK, 1949

Time Marches On

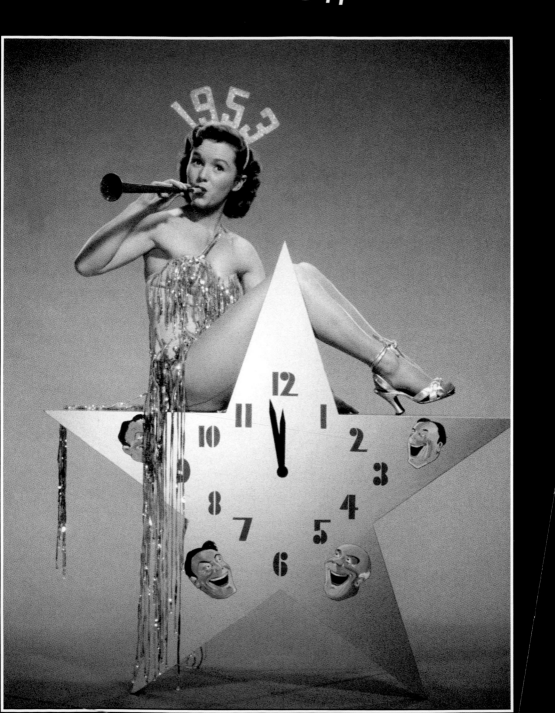

Although festive, New Year's doesn't provide nearly as many easily identifiable props to build a pin-up photo shoot around. Apparently, though, clocks, party streamers, and revealing dresses were all that were required for the pin-ups to celebrate the transition from old annum to new.

OPPOSITE:
 DEBBIE REYNOLDS, 1953

CLOCKWISE FROM TOP LEFT:
 JEAN PETERS, 1947
 JAYNE MANSFIELD, 1957
 EDY WILLIAMS, 1968

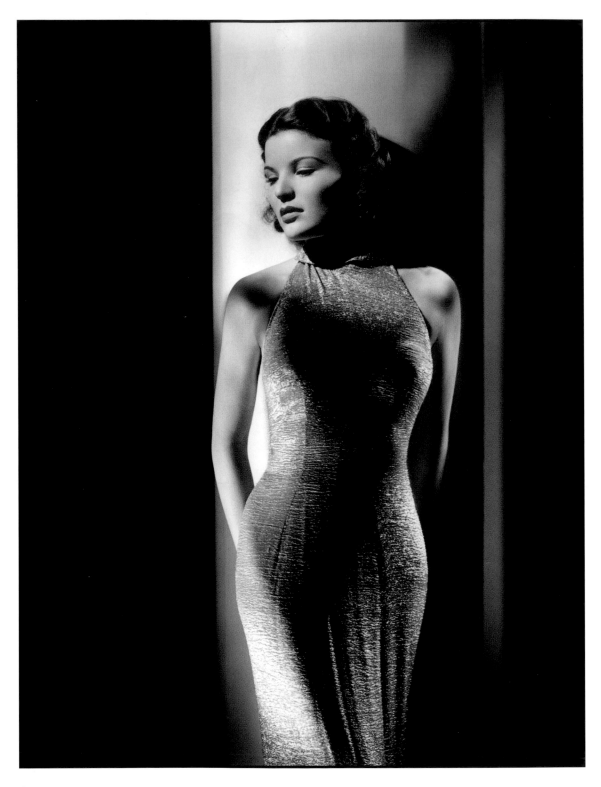

★ NANETTE FABRAY, 1949

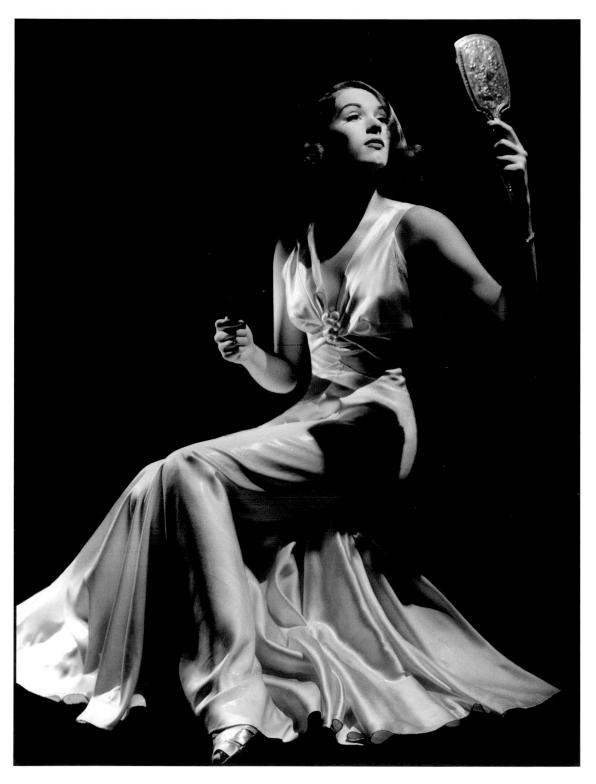

★ JINX FALKENBURG, 1940

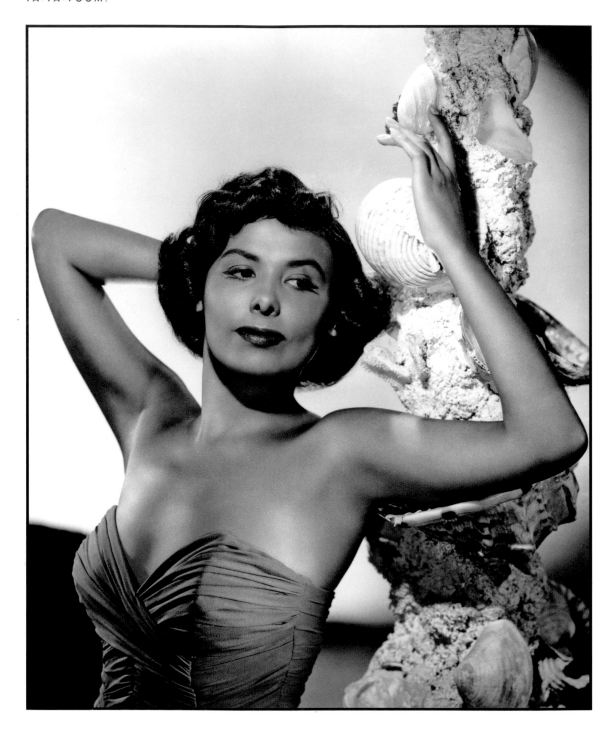

★ ABOVE: LENA HORNE, c.1948 ★ OPPOSITE: ANN MILLER, 1943

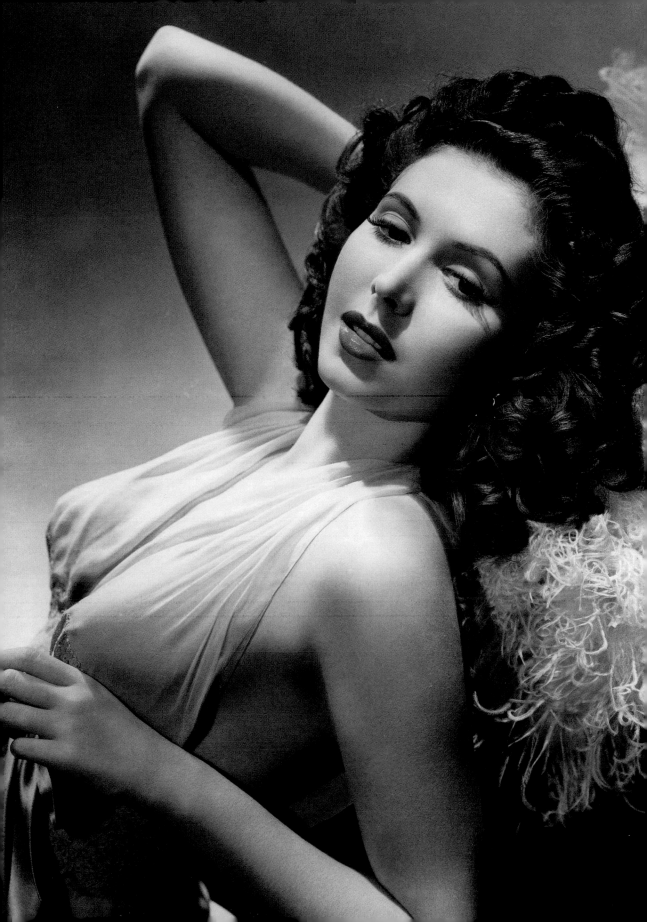

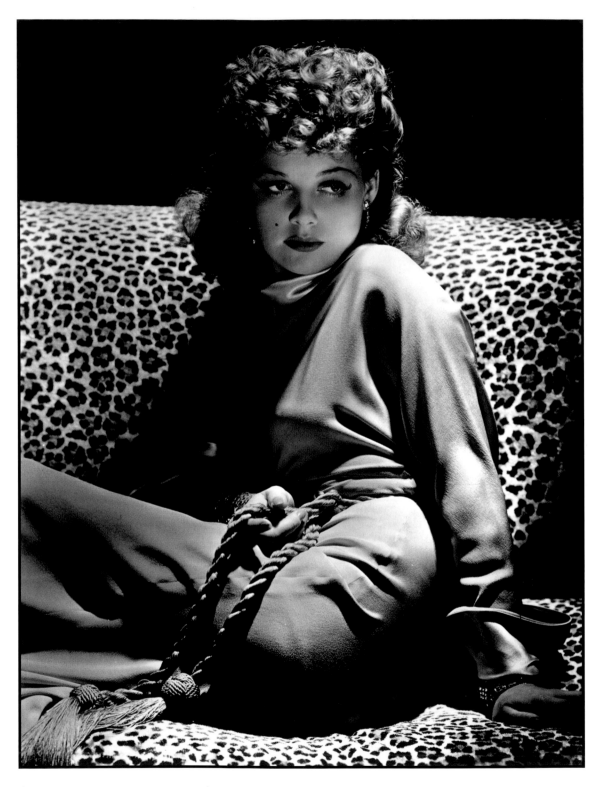

★ ABOVE: ANN SHERIDAN, 1941 ★ OPPOSITE: SUSAN HAYWARD, 1939

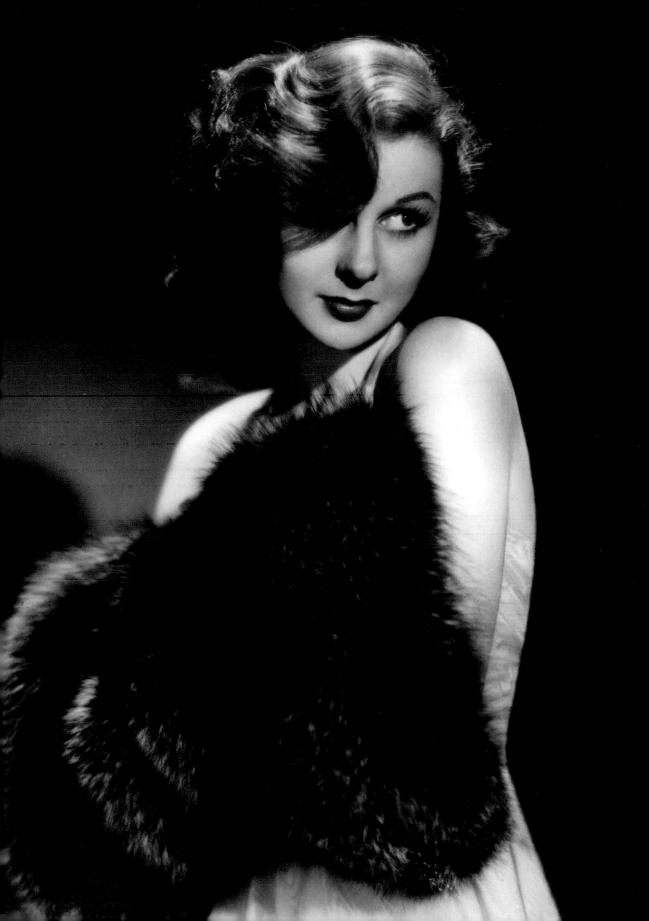

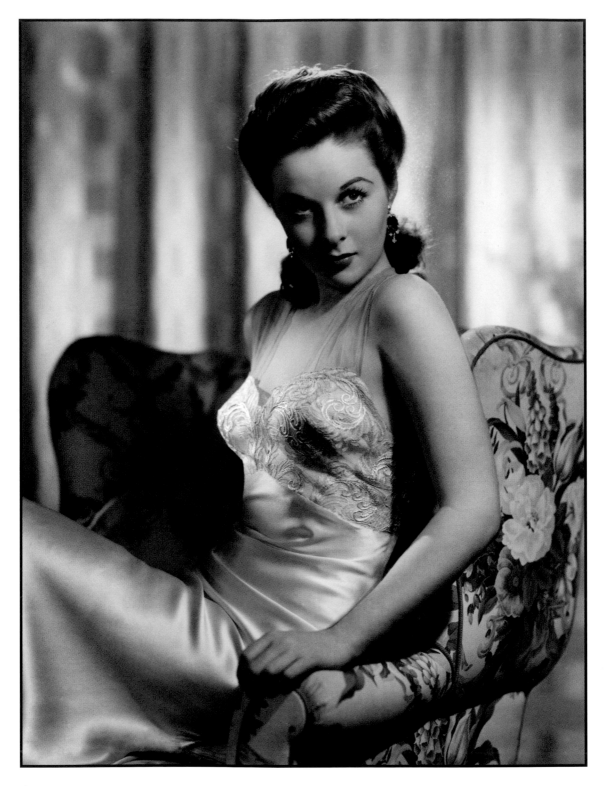

★ SUSAN HAYWARD, 1941

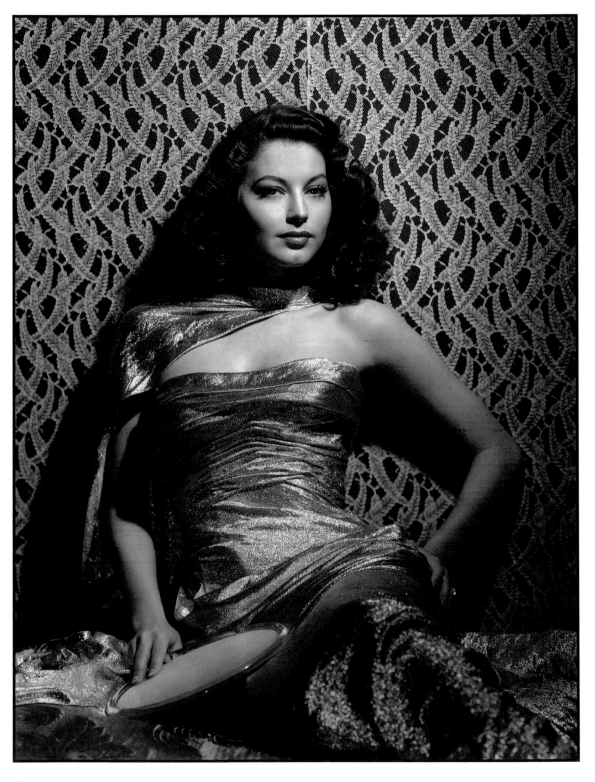

★ AVA GARDNER, 1944

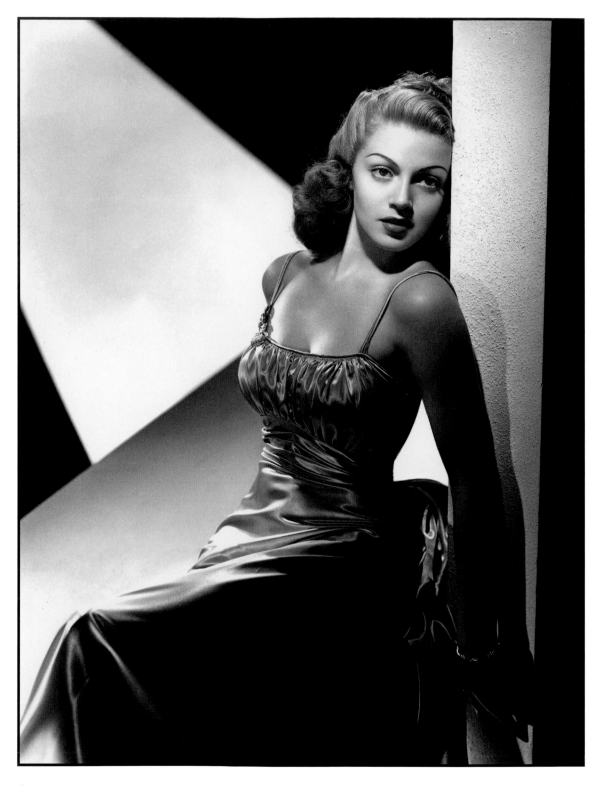

★ LANA TURNER, 1940 (ABOVE), 1943 (OPPOSITE)

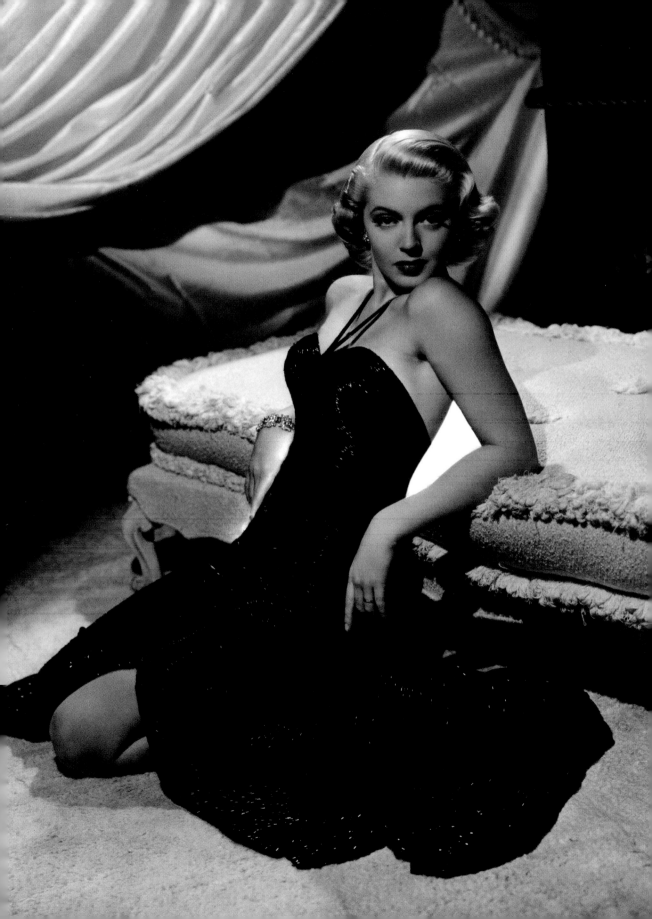

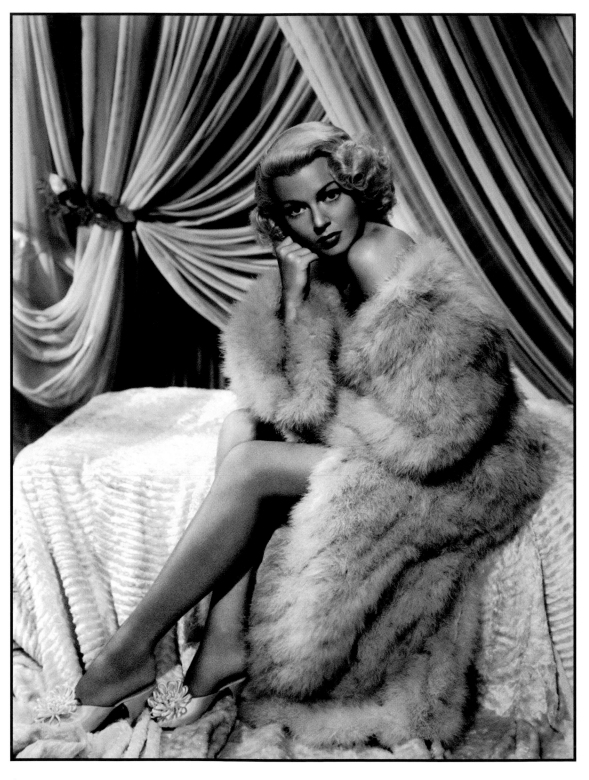

★ LANA TURNER, 1942

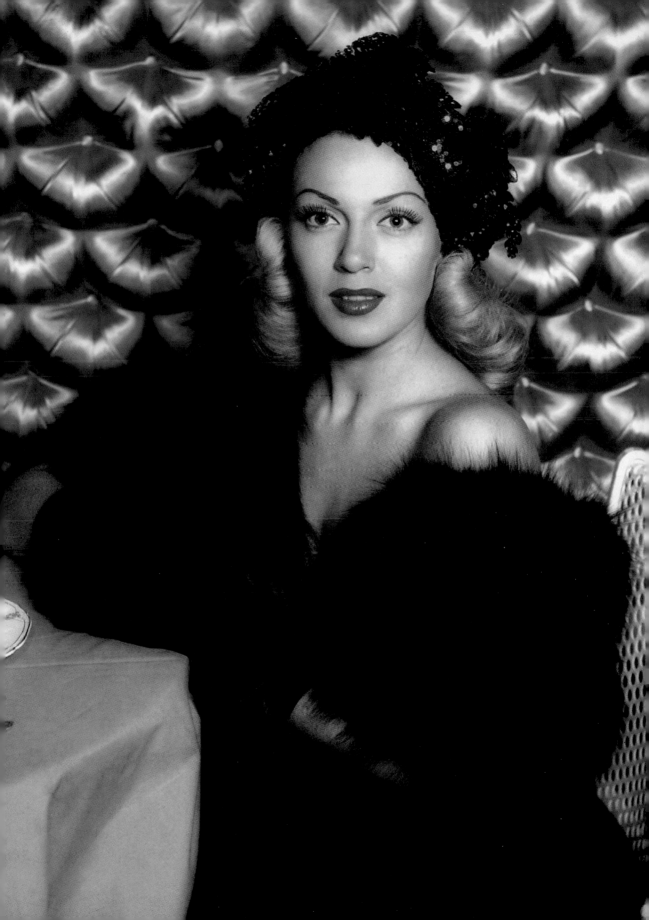

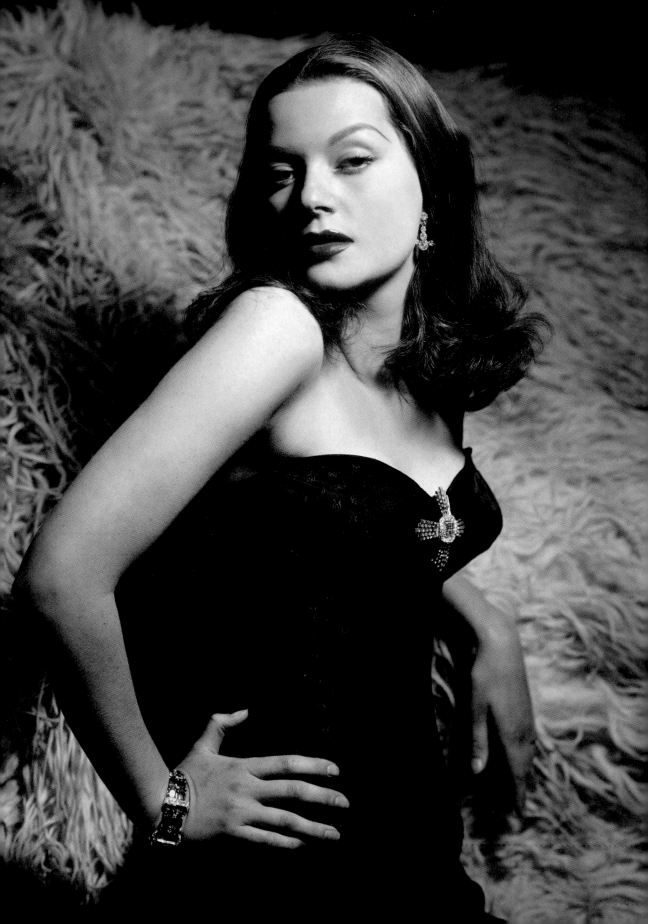

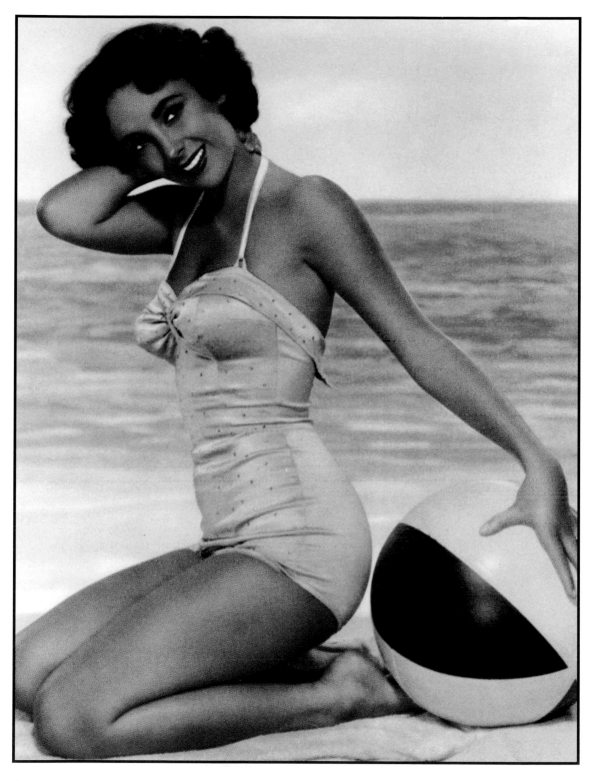

★ OPPOSITE: HAZEL BROOKS, 1943 ★ ABOVE: ELIZABETH TAYLOR, 1948

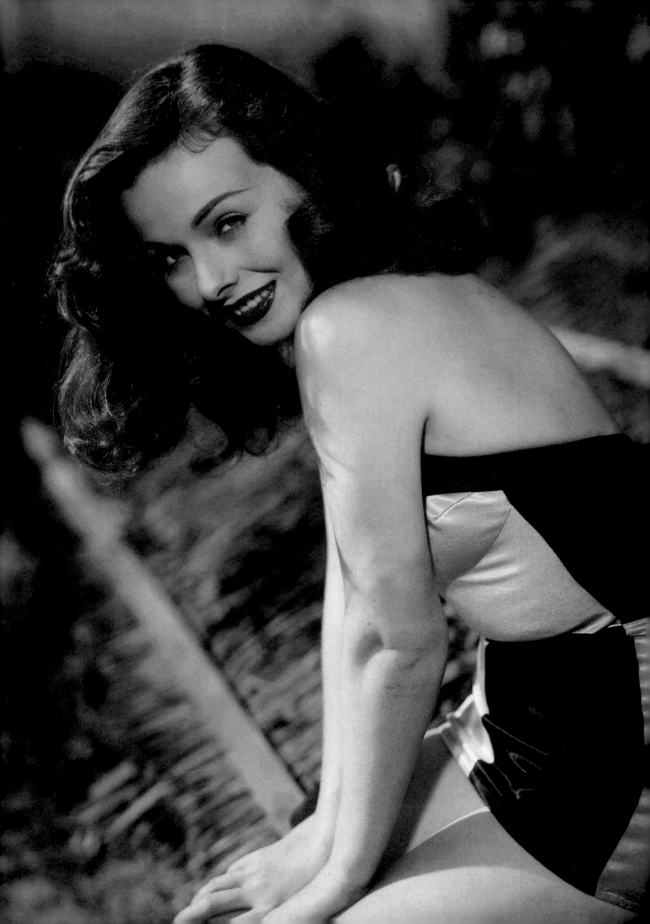

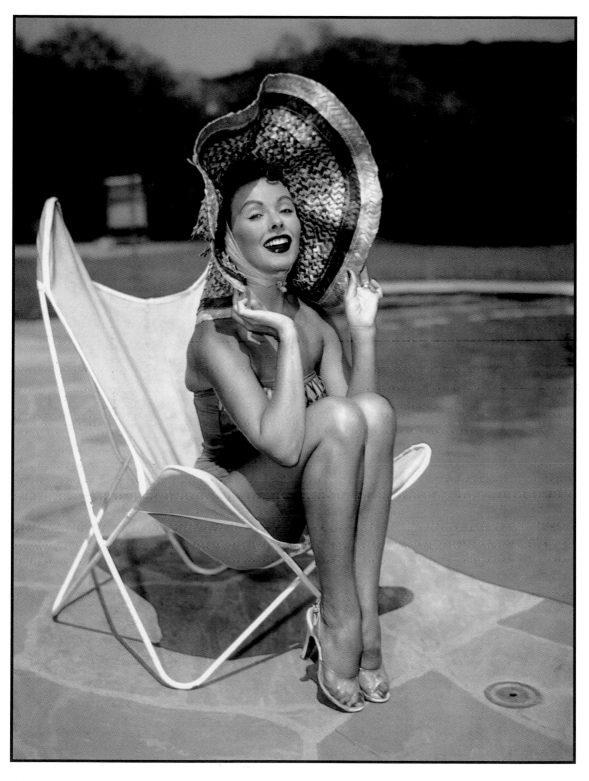

★ JEANNE CRAIN, 1944

Girl on a Diving Board

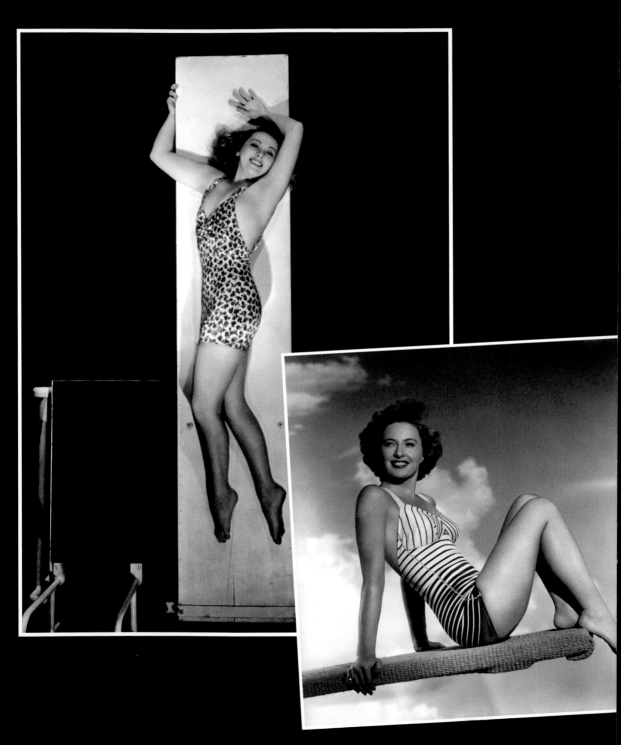

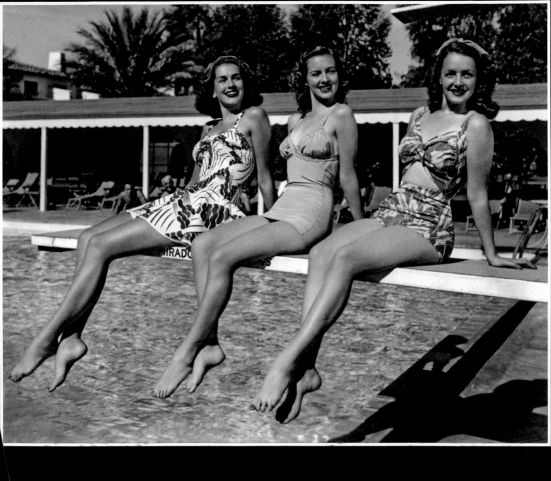

This ubiquitous poolside device can be used as a place for pin-ups to pose or as a metaphor for inspiration or imminent rise to success—i.e., a "springboard." It also provides the photographer with an eminently viable excuse for putting these pin-ups into swimsuits.

LEFT TO RIGHT:
JOAN BLONDELL, 1933
BARBARA STANWYCK, c.1949
LEFT TO RIGHT: JINX FALKENBURG, EVELYN KEYES, UNKNOWN, 1945

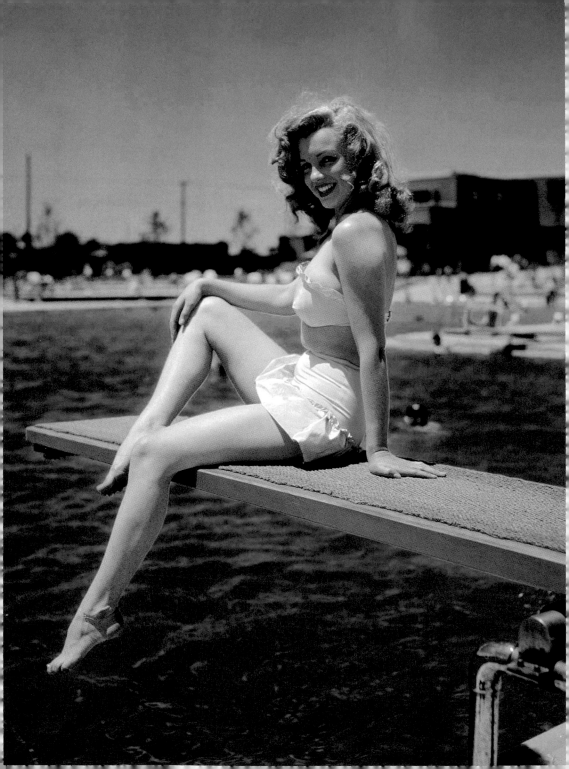

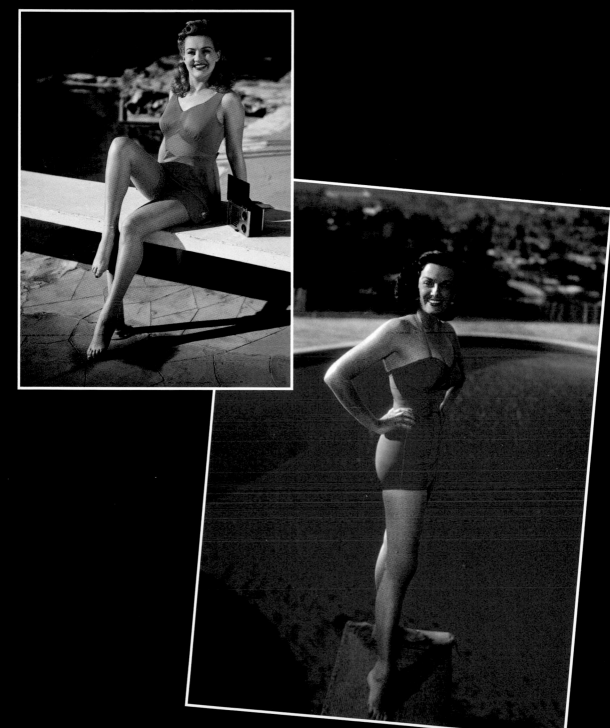

LEFT TO RIGHT:
MARILYN MONROE, 1949
BETTY GRABLE, 1945

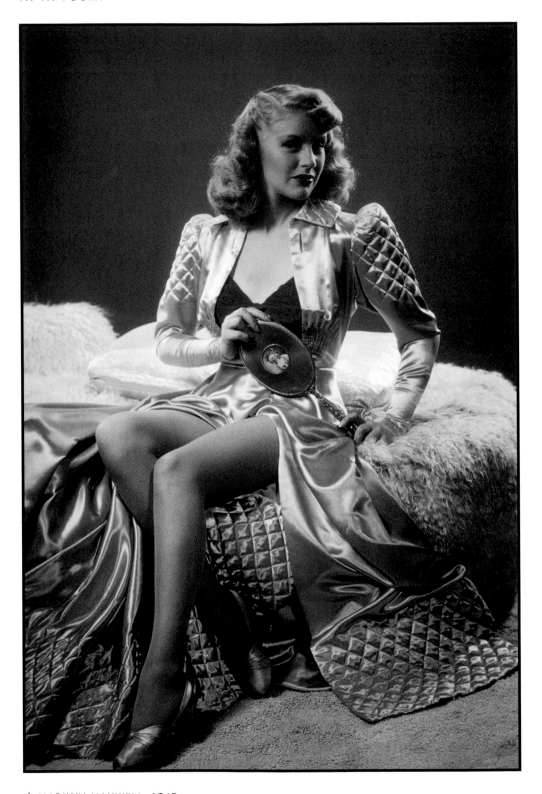

★ MARILYN MAXWELL, 1945

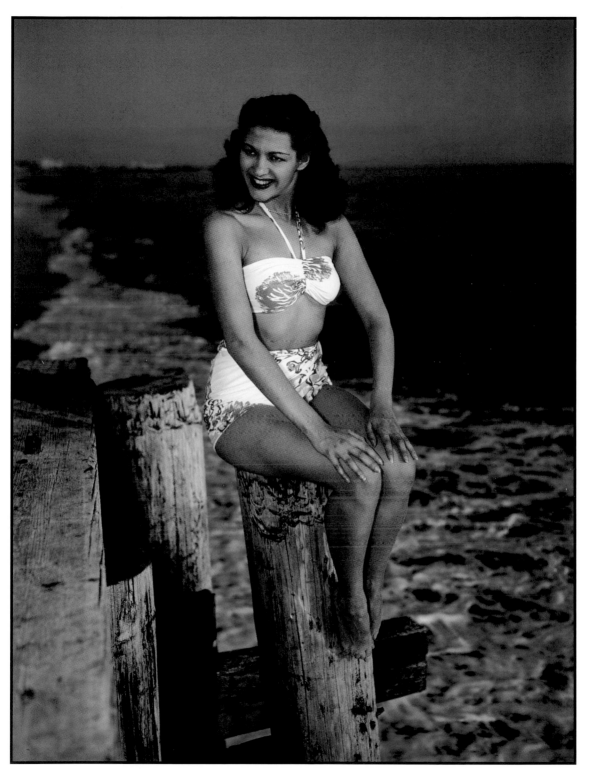

★ YVONNE DE CARLO, 1948

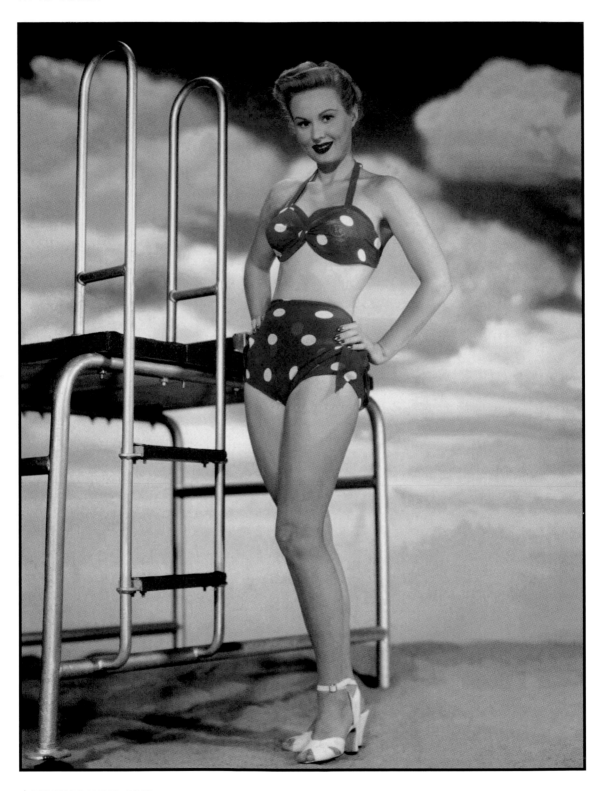

★ VIRGINIA MAYO, 1948

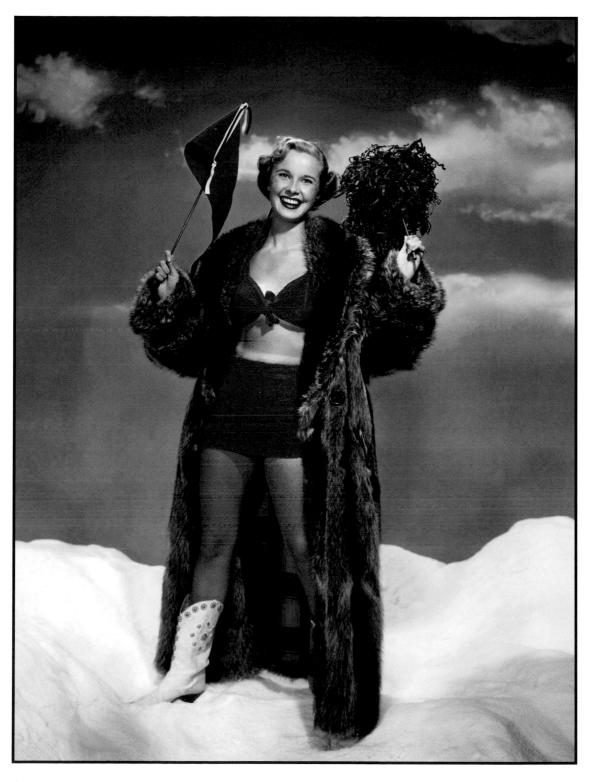

★ MONA FREEMAN, 1948

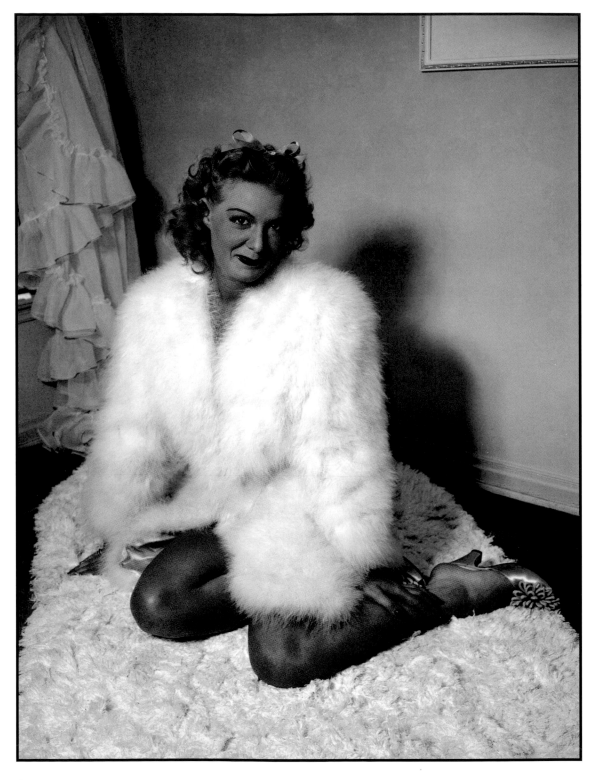

★ BETTY HUTTON, 1943

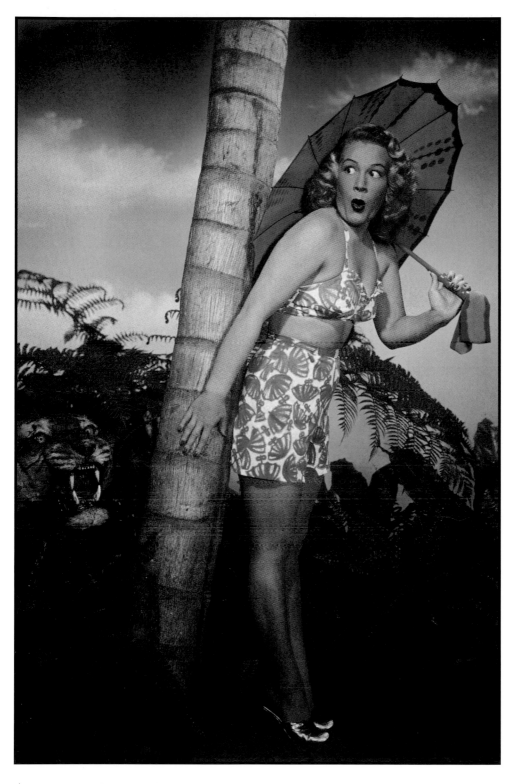

★ BETTY HUTTON, c.1948

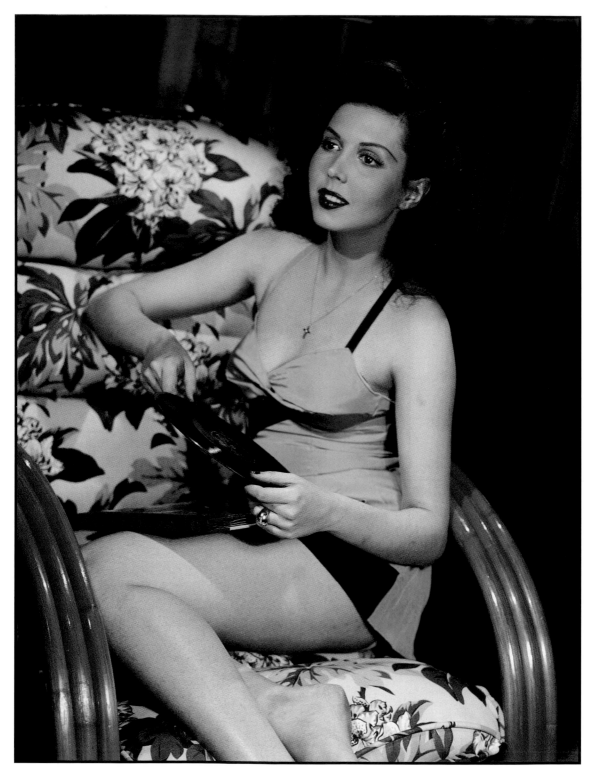

★ ABOVE: ANN MILLER, 1945 ★ OPPOSITE: ANN BLYTH, c.1944

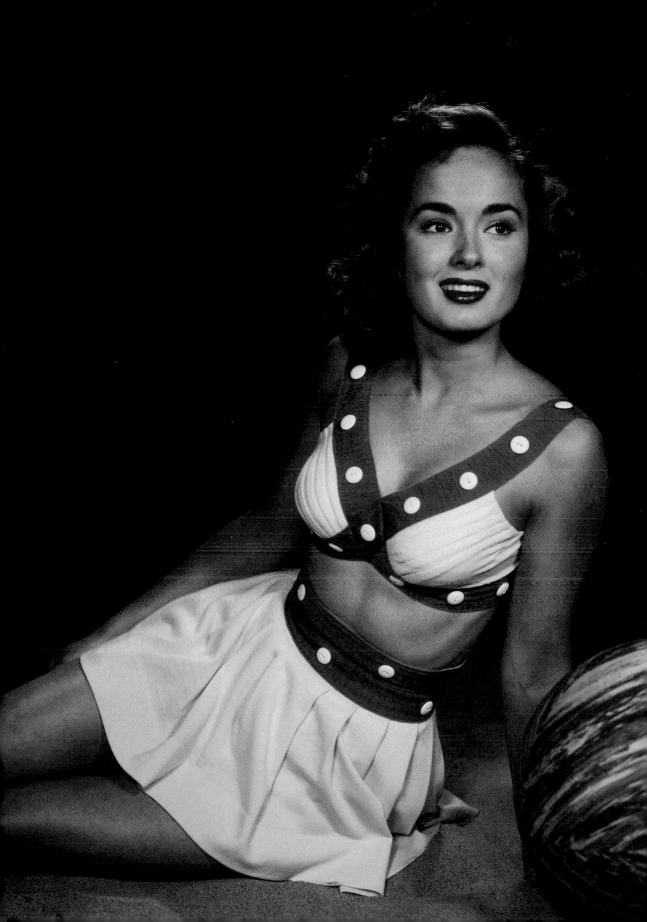

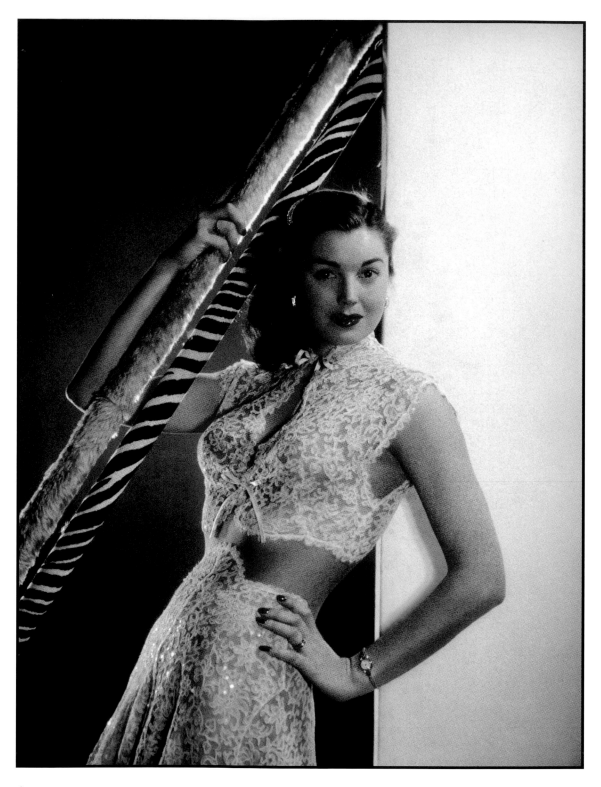

★ ESTHER WILLIAMS, 1943

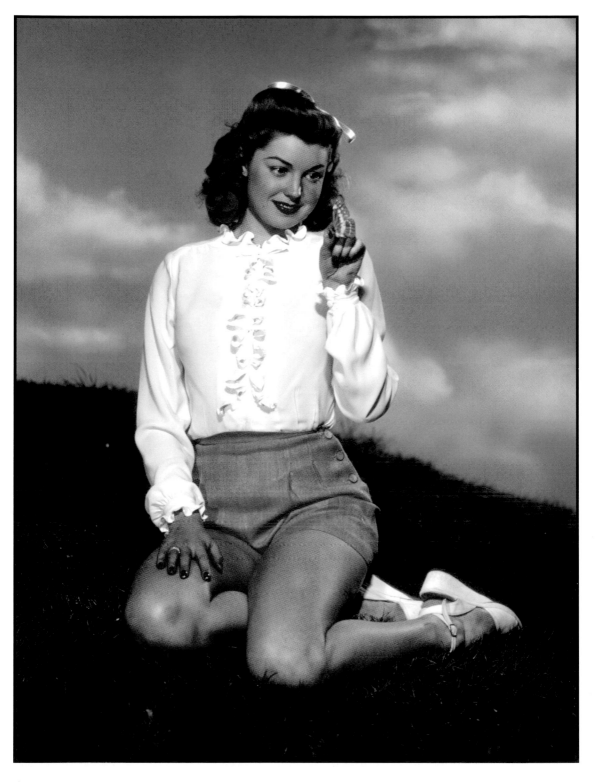

★ ESTHER WILLIAMS, 1944

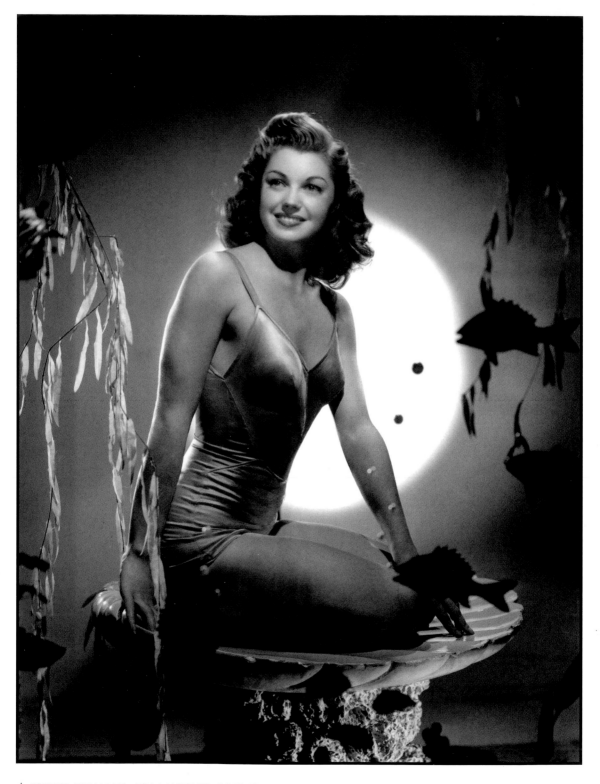

★ ESTHER WILLIAMS, 1944 (ABOVE), 1945 (OPPOSITE)

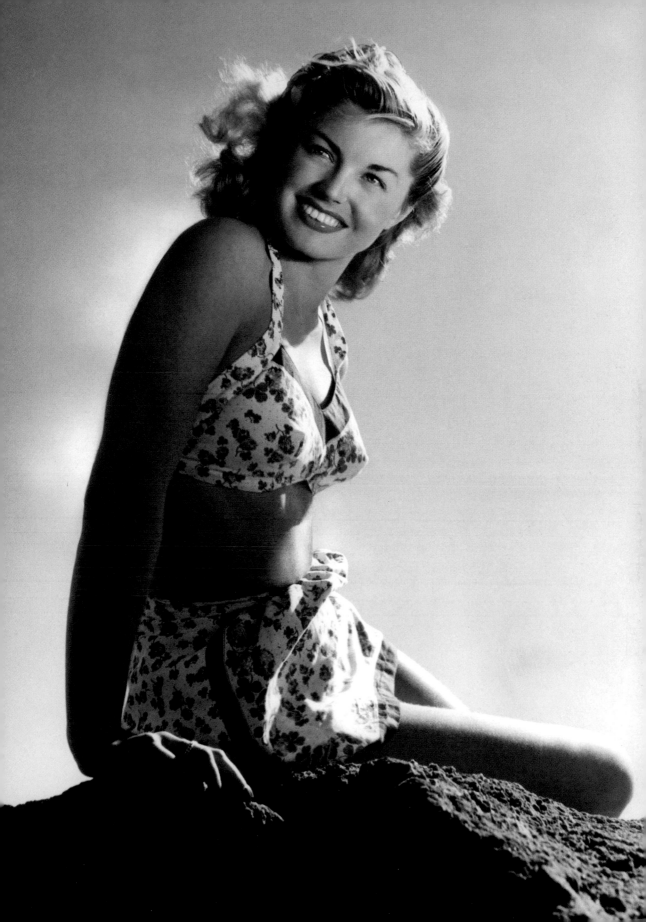

A Roll in the Hayloft

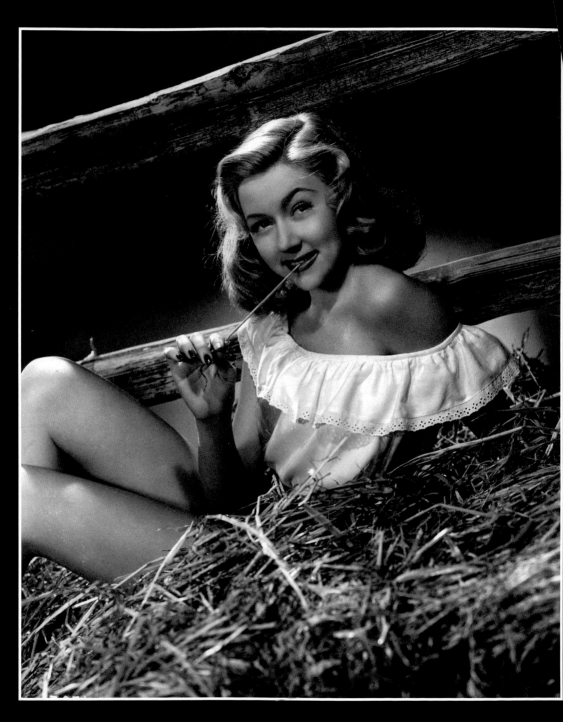

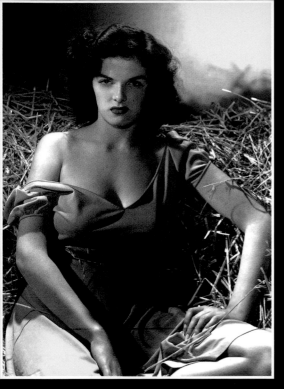

While the hayloft setting has been a longtime favorite for farmer's daughter–themed pin-up shoots, Howard Hughes set the standard with his 1943 dud, *The Outlaw*, a film responsible for unleashing the charms of Jane Russell upon the general public's bug-eyed-consciousness (turn the page). "Make hay," as the saying goes, "while the sun still shines."

OPPOSITE:
GLORIA GRAHAME, 1947

CLOCKWISE FROM TOP LEFT:
JANE RUSSELL, 1943
BETTY GRABLE, 1953
SOPHIA LOREN, 1958

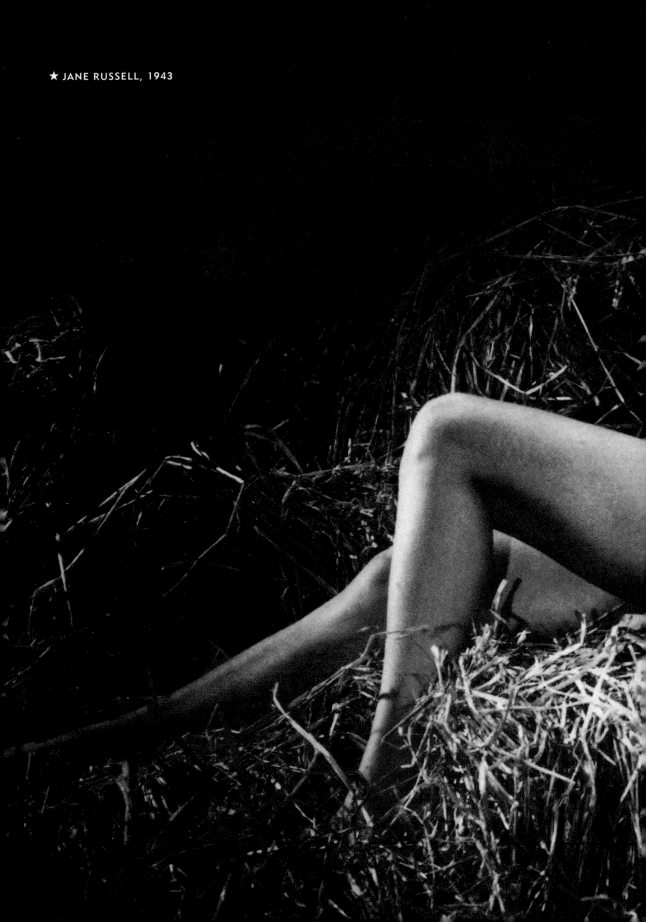

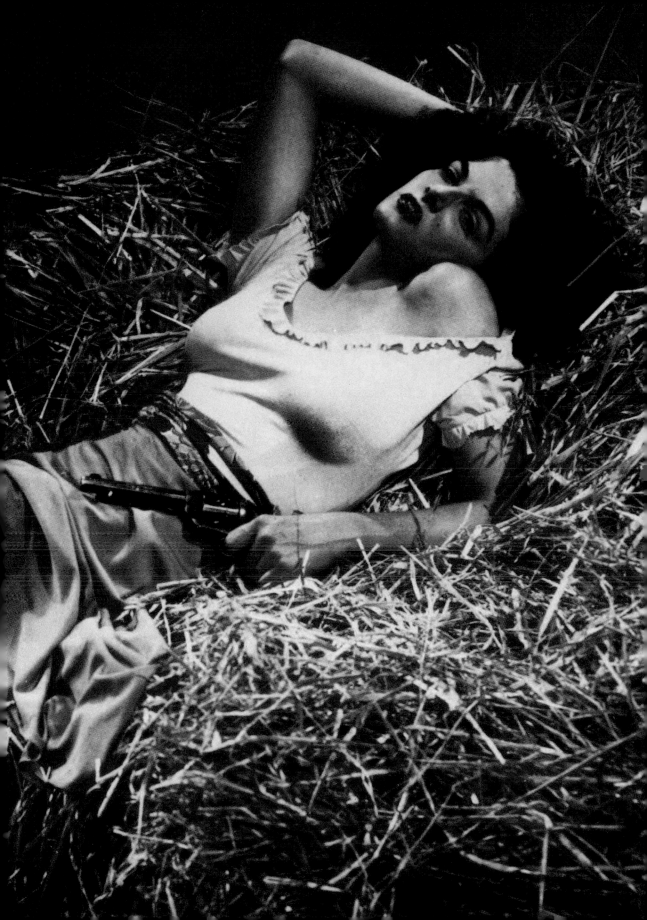

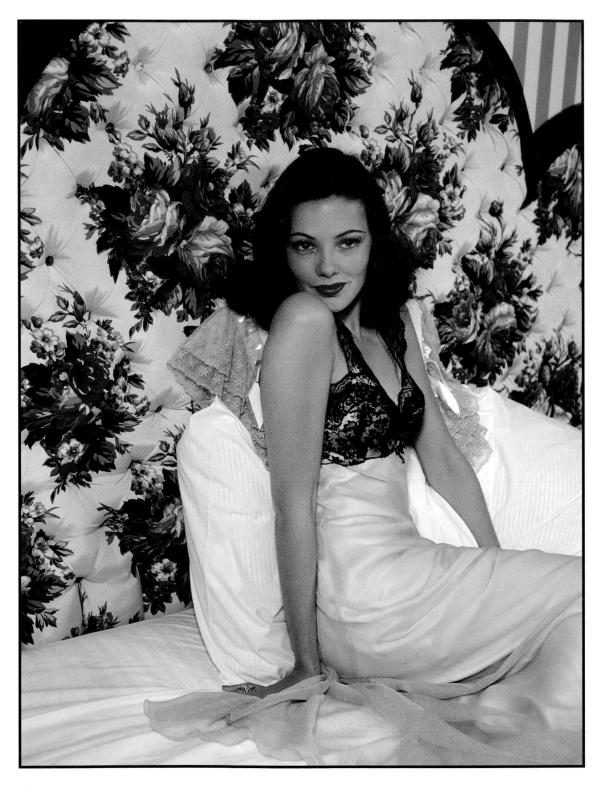

★ GENE TIERNEY, 1945

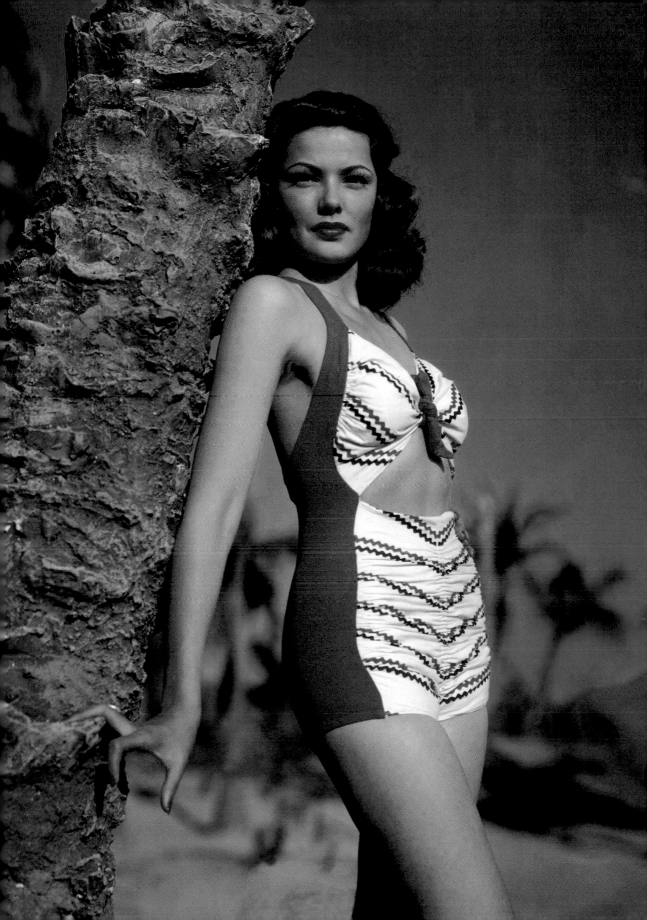

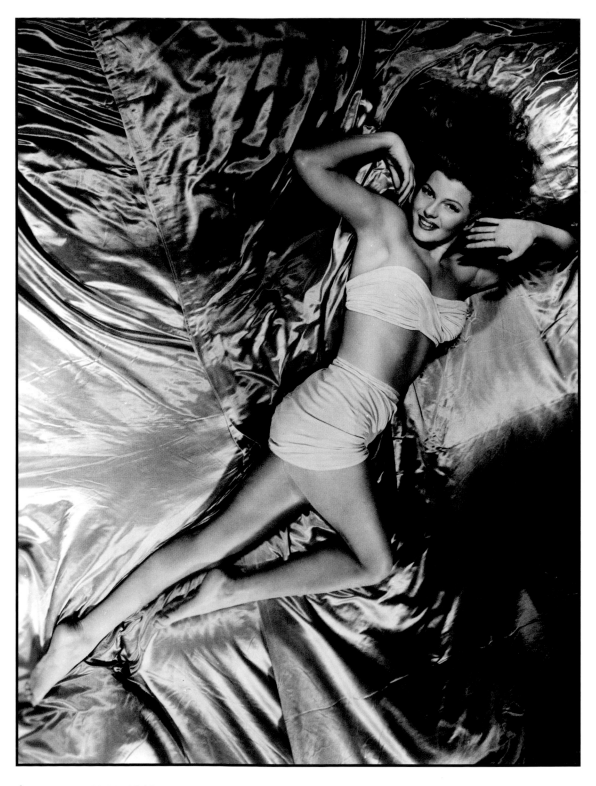

★ RITA HAYWORTH, 1944

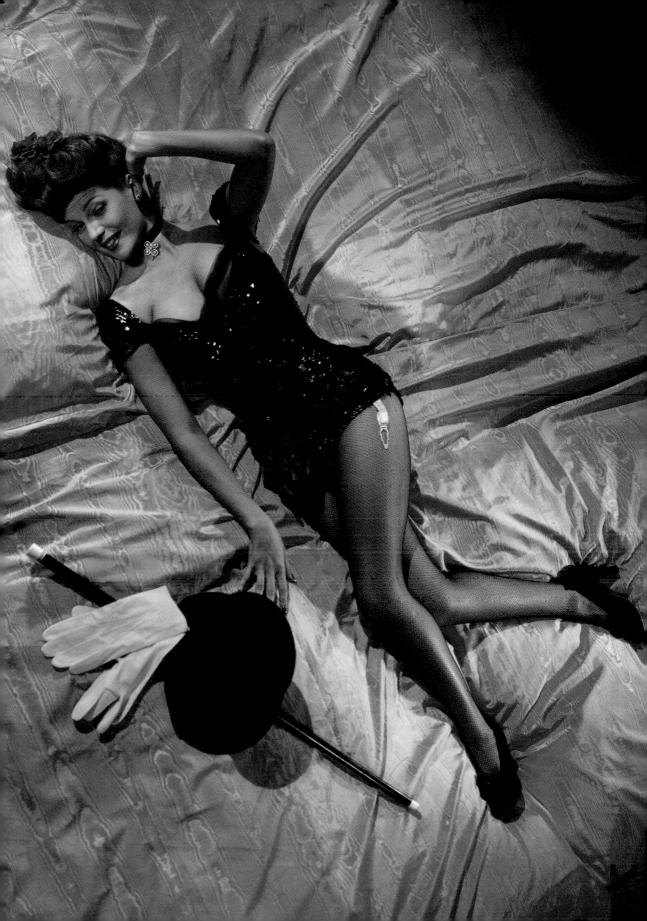

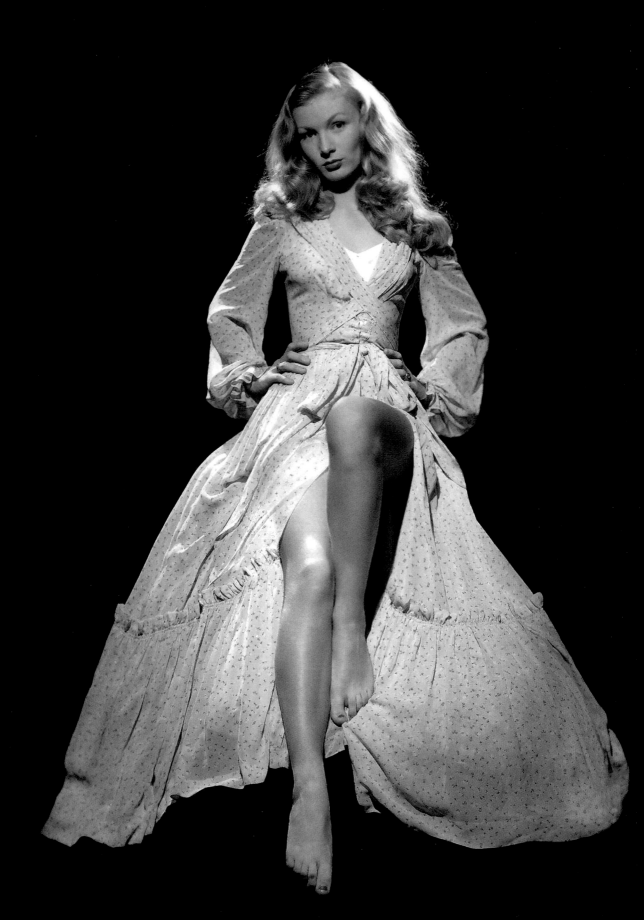

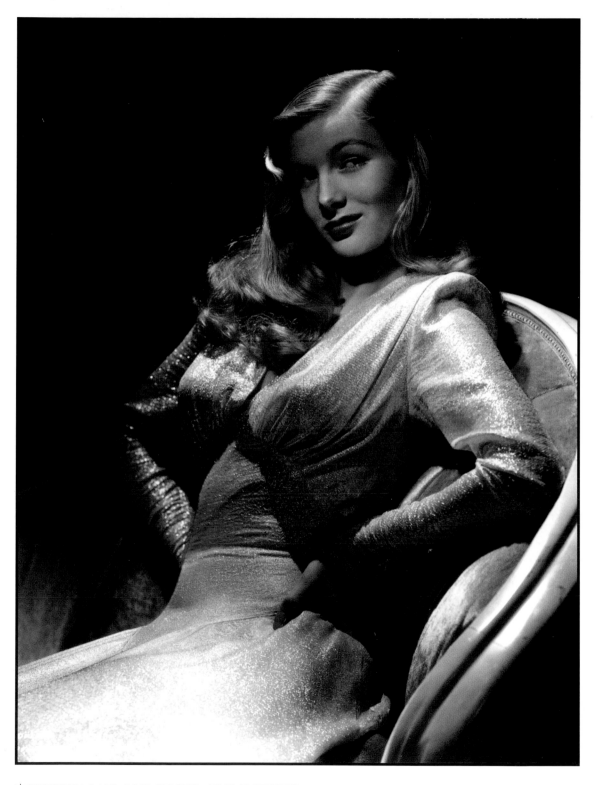

★ VERONICA LAKE, 1942 (ABOVE), 1947 (OPPOSITE)

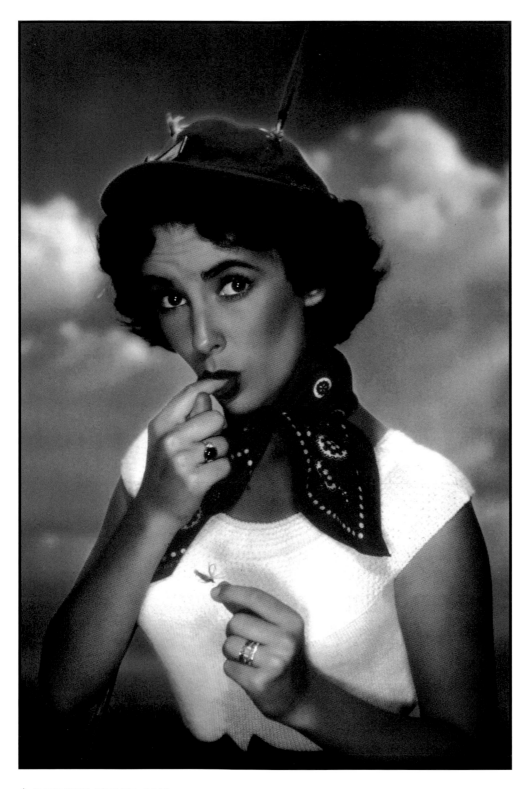

★ ELIZABETH TAYLOR, 1948

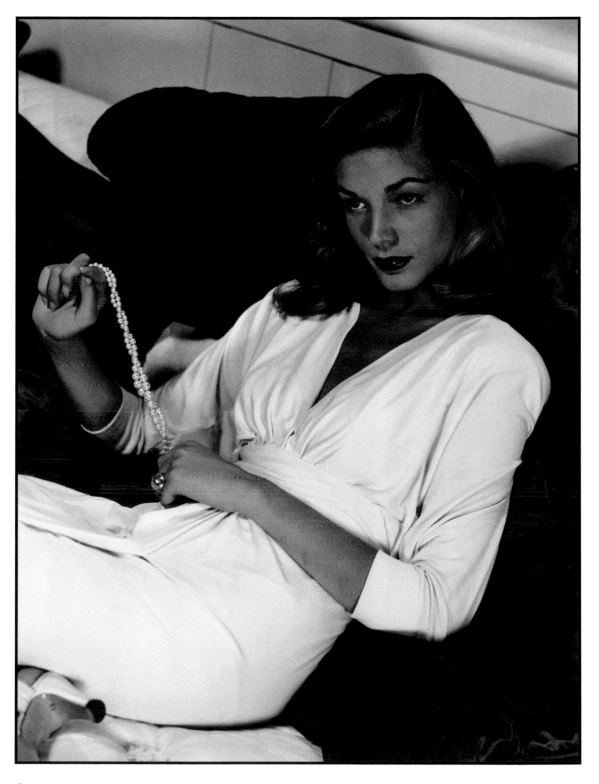

★ LAUREN BACALL, 1945

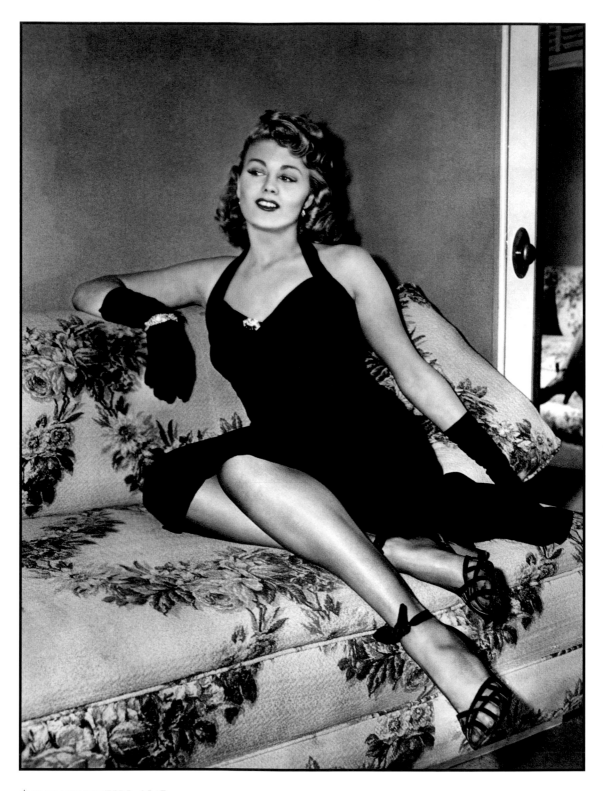

★ SHELLEY WINTERS, 1947

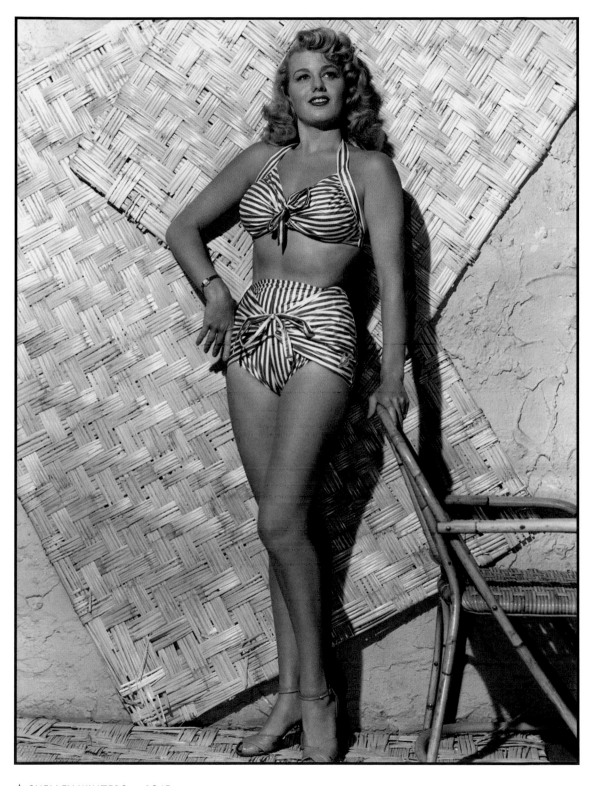

★ SHELLEY WINTERS, c.1945

Will You Be Mine?

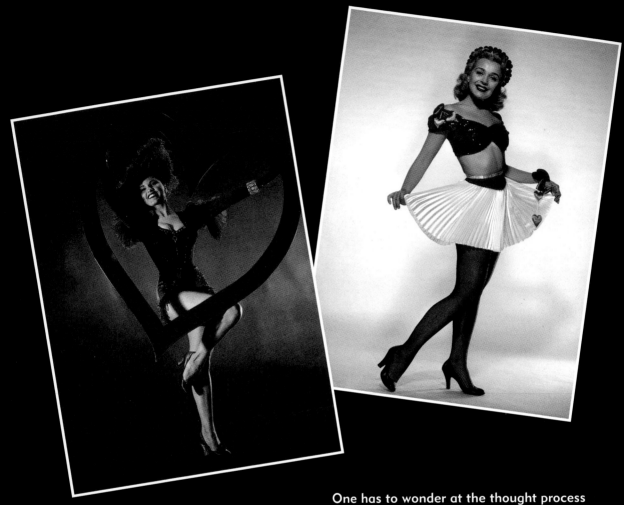

One has to wonder at the thought process behind these Valentine's Day pin-ups. Were they for men to send to their beloved as a way of saying, "This is what I wish you looked like?" When beholding Yvonne De Carlo (turn the page), however, such considerations are likely beside the point.

LEFT TO RIGHT:
DEBRA PAGET, 1955
DOLORES DORN, c.1955
CYD CHARISSE, 1948

To My Valentine

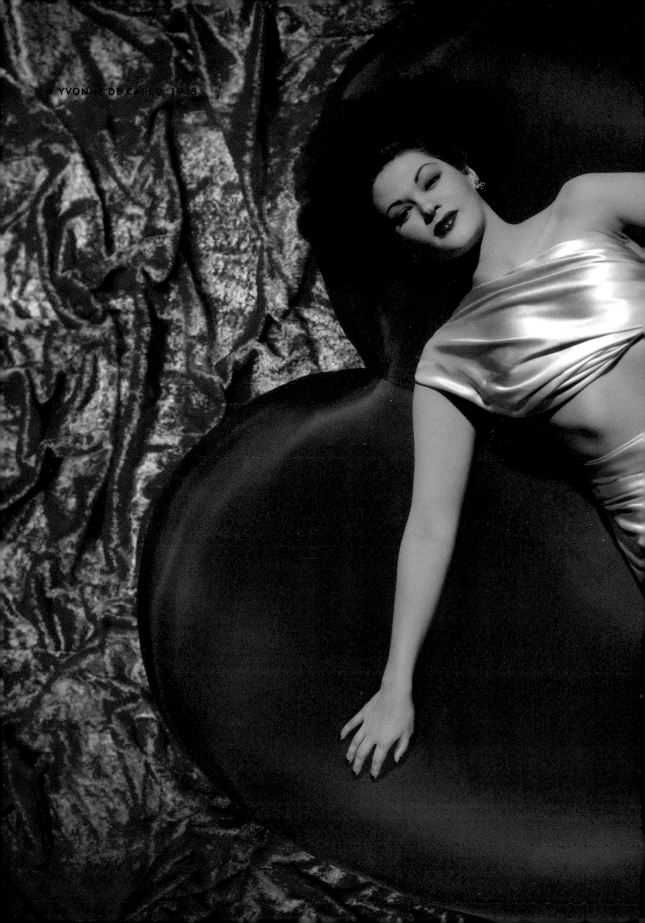

YVONNE DE CARLO · 1945

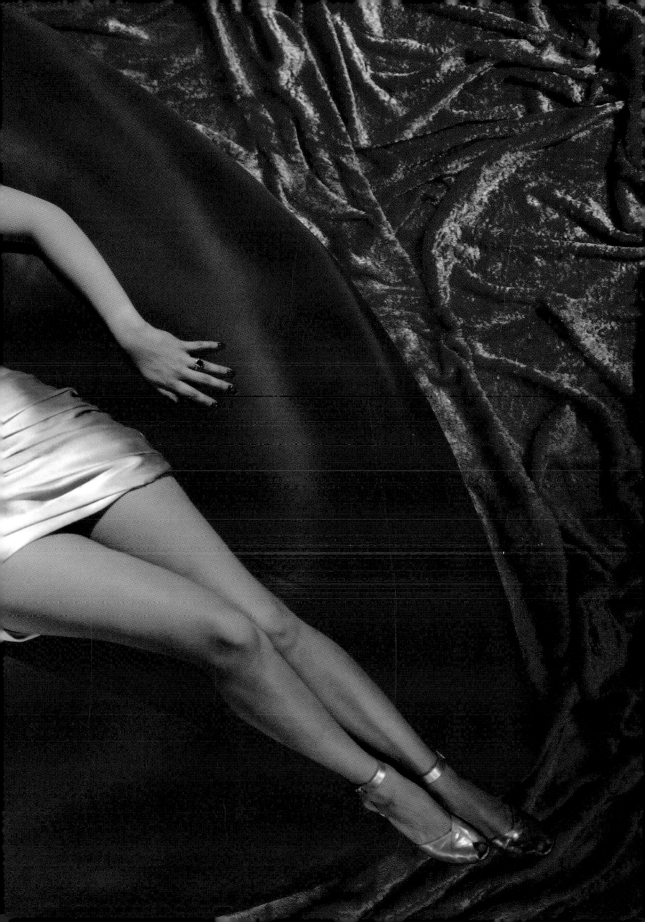

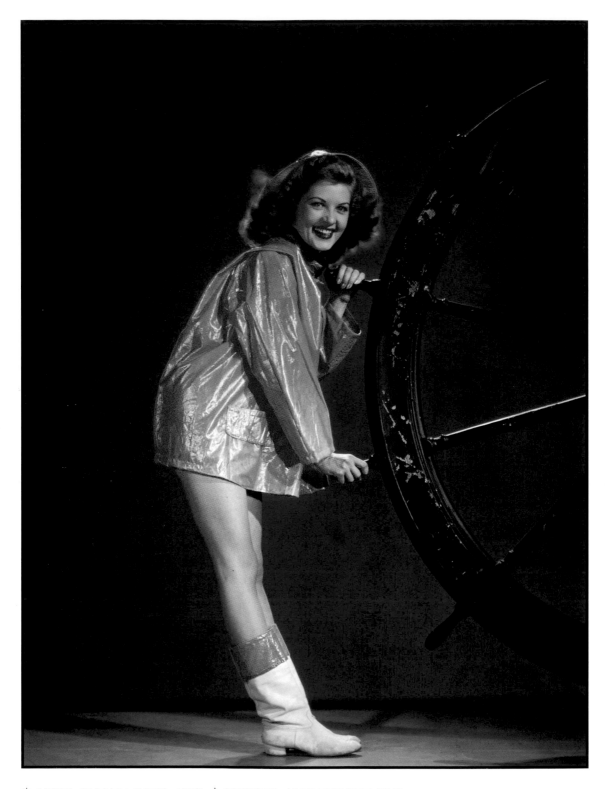

★ ABOVE: BARBARA BATES, 1945 ★ OPPOSITE: JOAN BENNETT, 1948

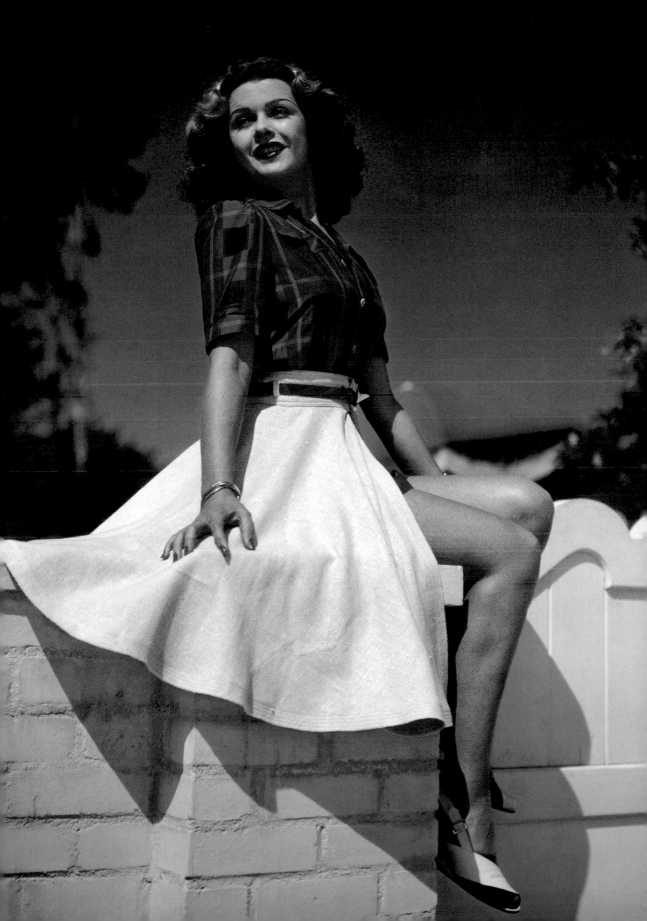

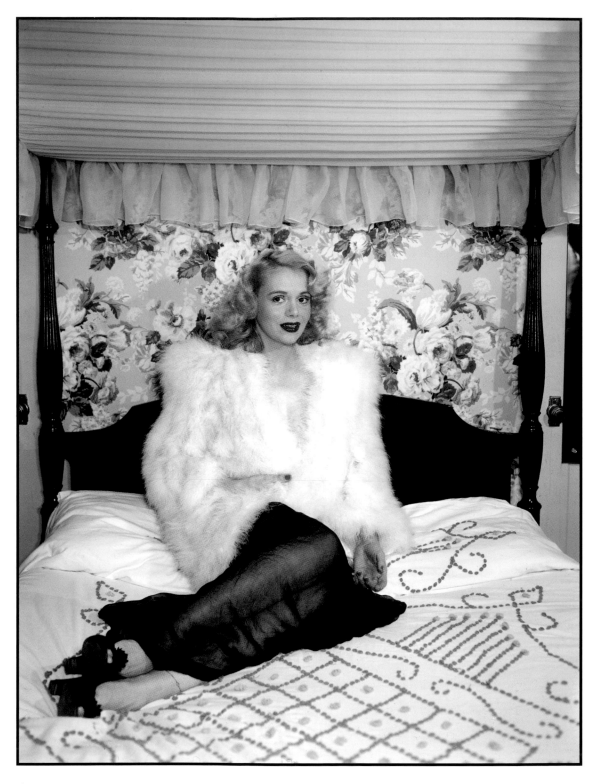

★ MARIE WILSON, 1949

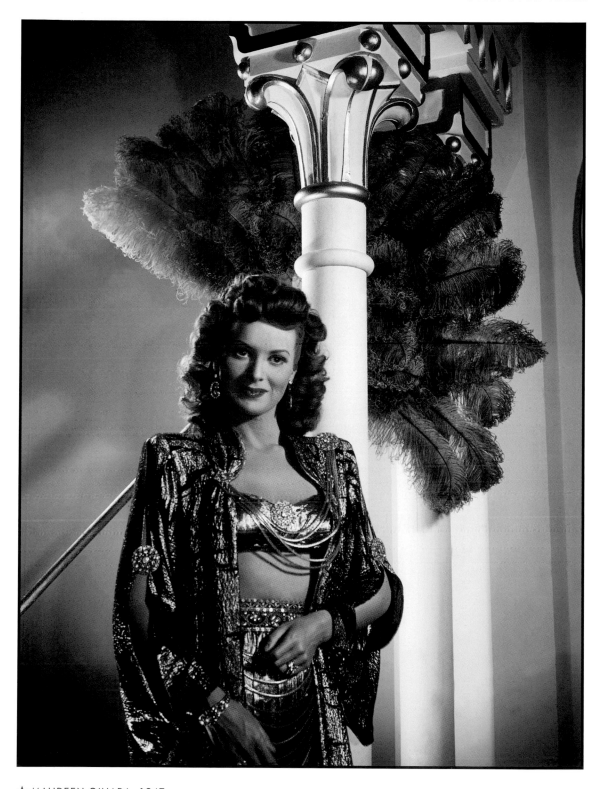

★ MAUREEN O'HARA, 1947

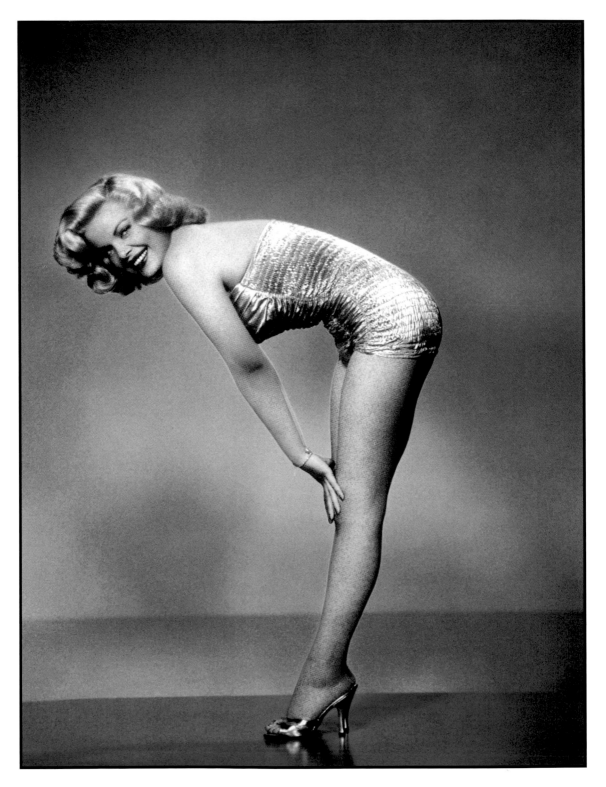

★ CLEO MOORE, 1951

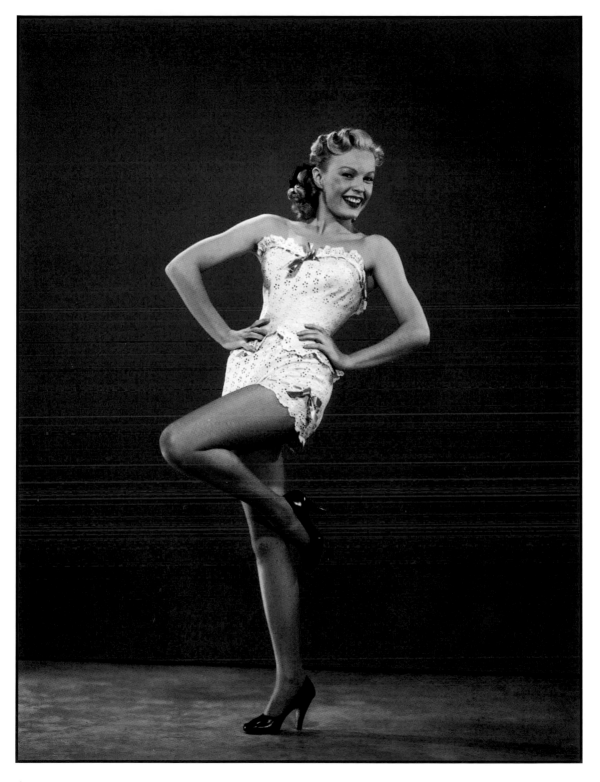

★ JUNE HAVER, 1949

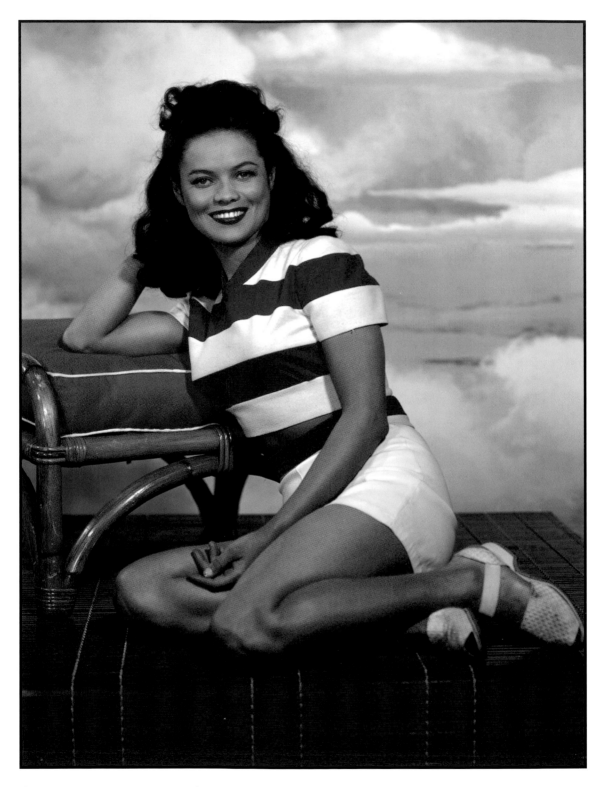

★ ABOVE: DONA DRAKE, 1942 ★ OPPOSITE: CAROLE LANDIS, 1943

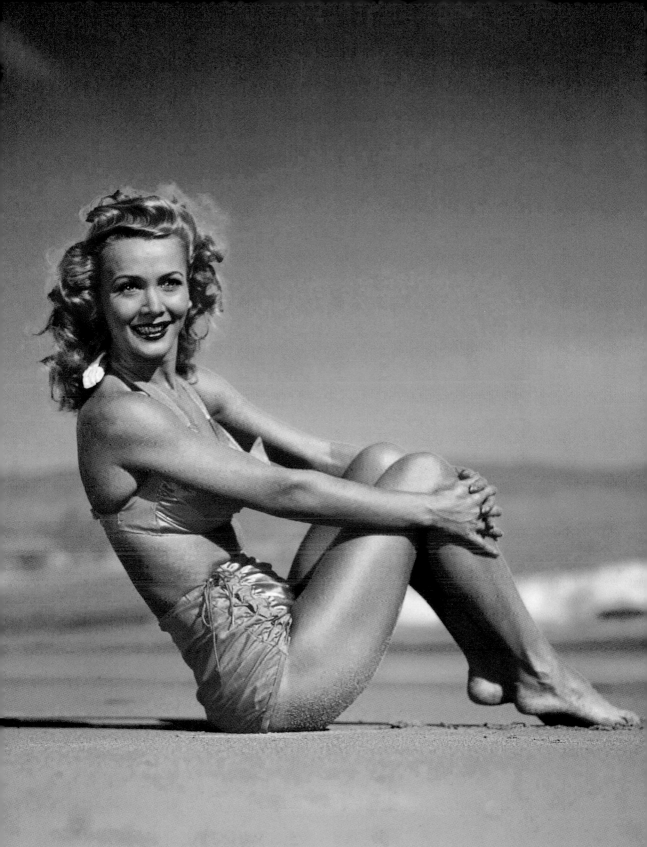

The 1950s: Postwar Bombshells

There's a curious path from the First to the Second World War that leads to the most iconic pin-up of all time. A British Royal Air Force pilot named Reginald Denny came to Hollywood following WWI to reinvent himself as an actor. He did pretty well. In mostly supporting roles in more than 200 films, he excelled at playing somewhat stereotypical upper-class Brit types. In 1940, when he was 49, the polymathic Denny began working for the U.S. Army manufacturing radio-controlled drone airplanes. When Norma Jeanne Mortenson's husband left home to join the merchant marines, she acted like a proper Rosie-the-Riveter girl, moved in with her mother-in-law, and started working for Denny's Radioplane Company inspecting parachutes—among other duties. It was there, as legend has it, that she was discovered by a photographer working for *Yank* magazine.

At its high point, this wartime weekly was read by more than 2.5 million military personnel, a great many of whom had an obvious fondness for the weekly pin-up strategically positioned in each issue. From Lauren Bacall to Lucille Ball, the list of female stars that graced the publication's pages—in the obligatory provocative attire—is extensive. Mortenson's appearance in *Yank* led to a modeling gig, which in turn led to numerous magazine covers, and finally a screen test and contract with 20th Century Fox. After a few missteps on the stairway to stardom (not to mention some surgical enhancements, hair lightening, and a name change), Marilyn Monroe was fully realized. Whether she was ready for what followed is another matter. Judging by the 1950 pose with the large block of ice (page 181), she looks pretty much ready for anything—and ready to help usher in a completely new era for the pin-up.

Aside from a few unfortunate chapters—McCarthyism, the Korean War—the postwar period, and the 1950s in general, was an era of American prosperity, luxuriance, and a general softening of the collective brain. Even Madison Avenue lost its marbles: "The Bomb's brilliant glow reminds me of the brilliant gleam Beacon Wax gives

★ Marilyn Monroe, 1953: In Monroe's mix of whimsy and sensuality, she captured the hot-to-trot girl-next-door pin-up appeal that led directly to an appearance in *Playboy*'s first issue, in 1953.

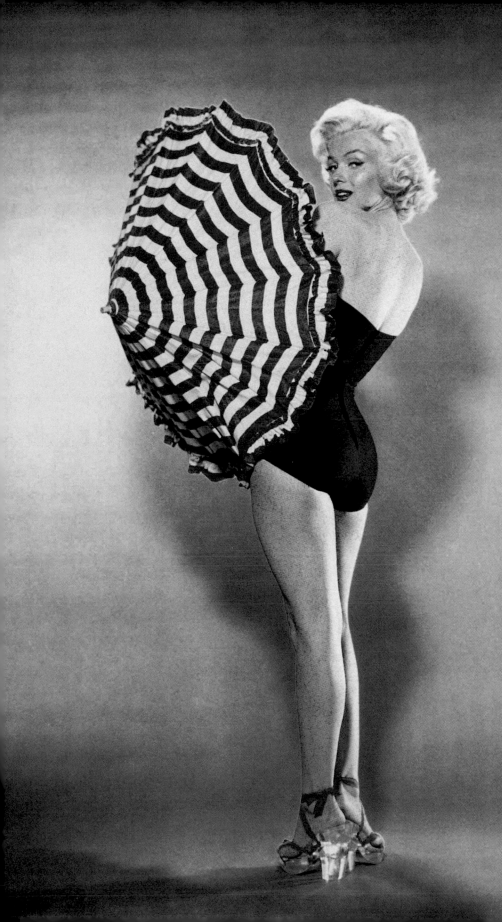

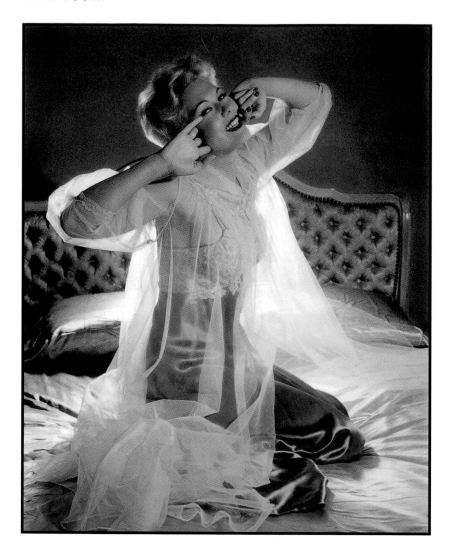

★ Kim Novak, 1955: Originally poised to be another Monroe, in 1955 Novak was about to make her own mark playing opposite William Holden.

to floors. It's a science marvel." Key cultural developments included the arrival of television, the birth of the teenager, and a significant shift in where people chose to live their lives—for the first time ever, suburban populations outnumbered their urban counterparts. Pin-up culture shifted accordingly—at least in terms of tone. Consider the ultra-suburban Kim Novak (page 209). Color photography had been commercially available since the introduction of Kodachrome in the 1930s, but something about the utopian tenor of the 1950s added an entirely new dimension to the pin-up aesthetic: everything became loopier, hyper-idealized, and, on occasion, downright garish. This, of course, makes for deliriously fun imagery. For example, what exactly is Shelley Winters *doing* on page 179?

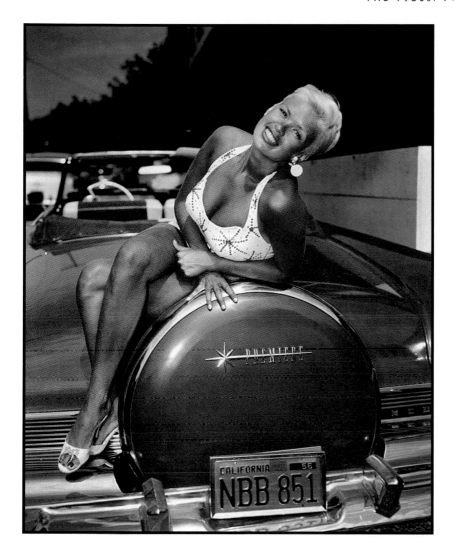

★ Jayne Mansfield, 1956: A former pageant queen, the beautiful Mansfield was also groomed as a Monroe-style bombshell, but with a more comedic edge.

In keeping with the decade's loud new emphasis on color and fantasy, iconic types like the Dumb Blonde and the Blonde Bombshell, and a few curious hybrids such as Doris Day, further entrenched themselves into the cinematic landscape (witness Mamie Van Doren's blondeness on page 184). They were probably following the lead of the forever-doomed flaxen progenitor, Jean Harlow, dead in 1937 at age 26. (To see an astonishing hair day, take a look at what appears to be a cross between bleached fiberglass and cotton candy on page 67.) Clearly, the process of coiffure stereotyping was in full effect. "Arthur Miller wouldn't have married me if I was just a dumb blonde," Monroe declaimed in a famous (and perhaps apocryphal) retort. To call Monroe, and other similarly pigeonholed people such as Jayne Mansfield, dumb

is patently off the mark. (As for occasionally *numb*, that's a different story.) Magnum photographer Eve Arnold claimed that Monroe would "manipulate every situation until it became totally her own" and do so "better than anyone I know." (The actress trusted the photographer so completely that impromptu photo shoots in bathrooms were not out of the question.) Many of the screen's so-called "dizzy dames" were players exploiting their own potential for being cast as such. (But let's face it, the ultimate Dumb Blonde would eventually appear on television—courtesy of the all-pin-up all-the-time entity known as *Baywatch*.)

While John Huston's 1962 film *The Misfits* technically belongs in the next decade (and chapter), it symbolically functions as an endpoint for the dizzy spirit of the 1950s. Unfortunately, it is a literal dead-end

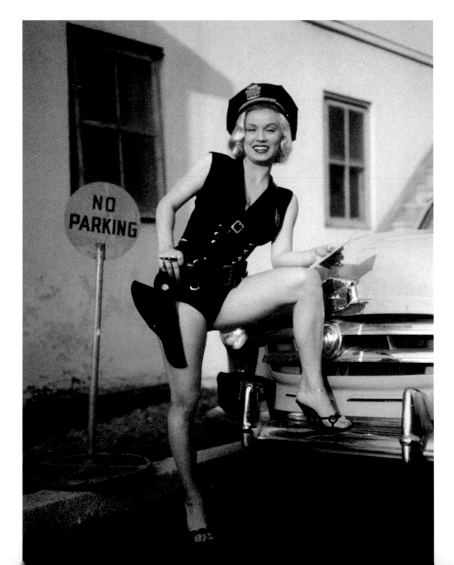

★ Mamie Van Doren, 1959: When she wasn't stopping traffic, Van Doren was playing the bombshell in B-movie classics like *High School Confidential* and *Guns, Girls, and Gangsters*.

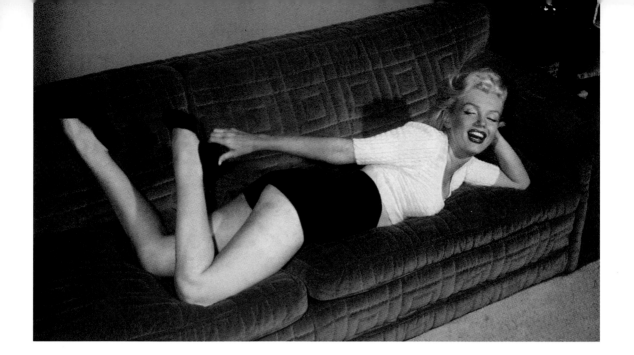

point. Written by Arthur Miller, who would divorce Monroe before the film's release, the film portrays the demise of the cowboy ethos. (The narrative's most morbidly over-determined metaphor is the conversion of wild horses into dog food.) The irony cuts deep: It would be Monroe's, as well as Clark Gable's, final film—and Montgomery Clift, even though he would live for five more years, can be seen here as a distinctly waning star. If this was the end of an era, the paparazzi (and other "legitimate" photogs) certainly smelled blood. The set of *The Misfits* was the most photographed production at that point in film history.

Monroe would have been a bit on the young side for a role in George Cukor's *The Women*, but she certainly would have fit in to that film's scheme of things. Just prior to *The Misfits*, she starred in Cukor's *Let's Make Love*, with Yves Montand. After *The Misfits* wrapped, Monroe had started work on another Cukor film, a project that now has the dubious designation as "the most notorious unfinished film in Hollywood history." Monroe's health deteriorated during a prolonged, contentious, and over-budget film-production nightmare—even though she continued to look great in the dailies and stills that survive. The film was officially scrapped when Monroe died of a possibly self-administered overdose of sleeping pills on August 5, 1962. The title of the uncompleted movie pretty much says it all, for both Monroe and the 1950s: *Something's Got to Give*.

★ Marilyn Monroe, 1954: One has to wonder if Monroe is laughing at yet another casting-couch joke made at her expense.

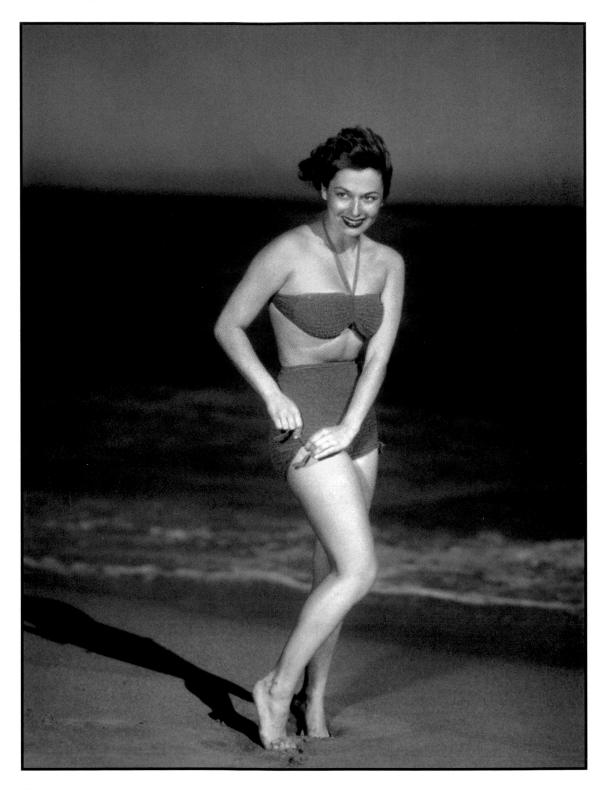

★ RUTH ROMAN, 1952

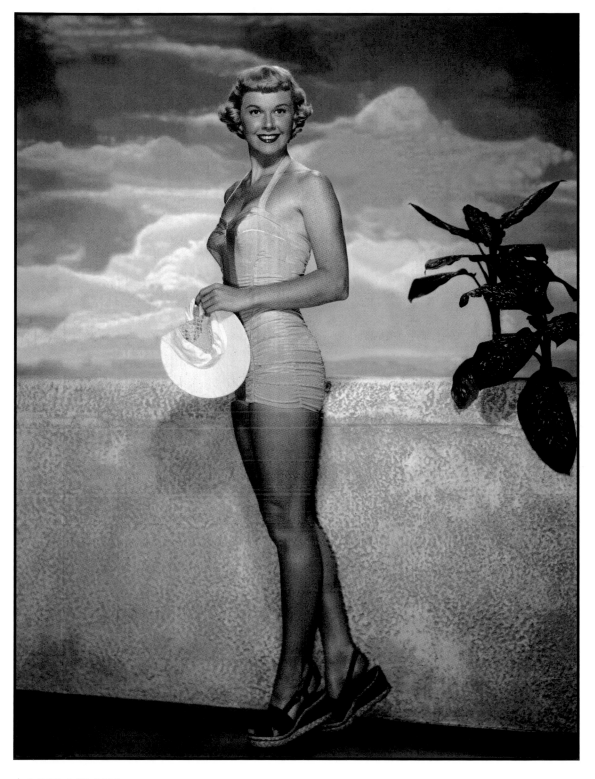

★ DORIS DAY, 1950

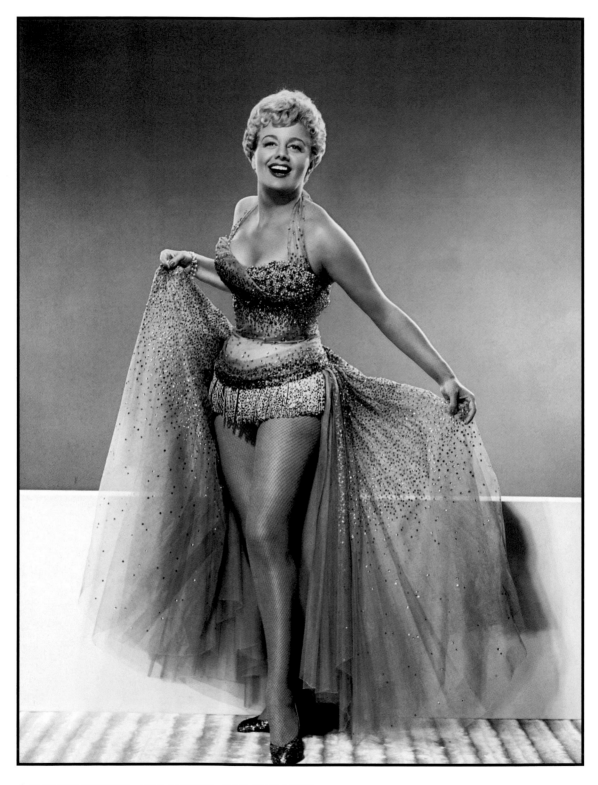

★ SHELLEY WINTERS, 1951 (ABOVE), 1952 (OPPOSITE)

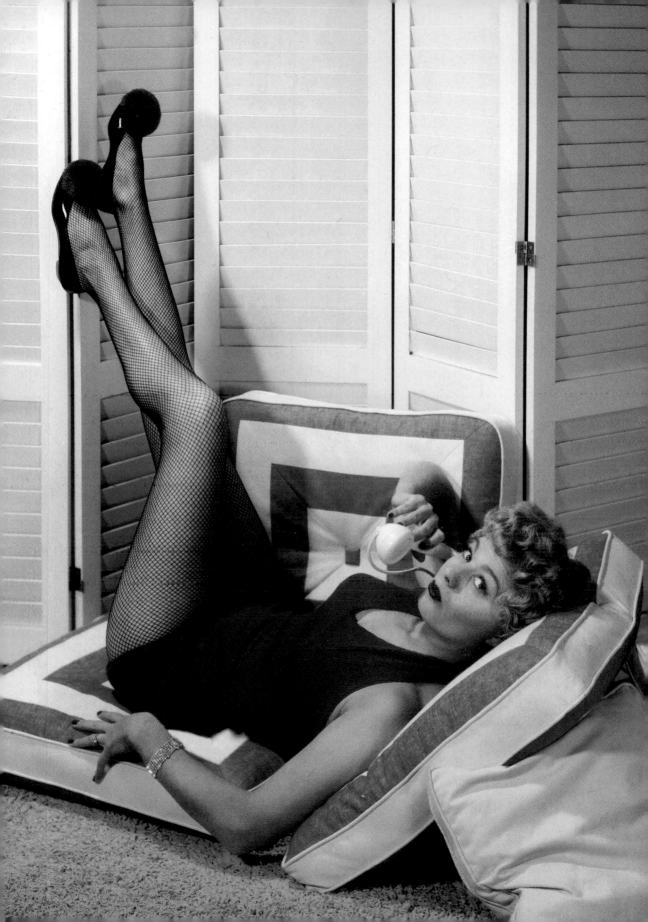

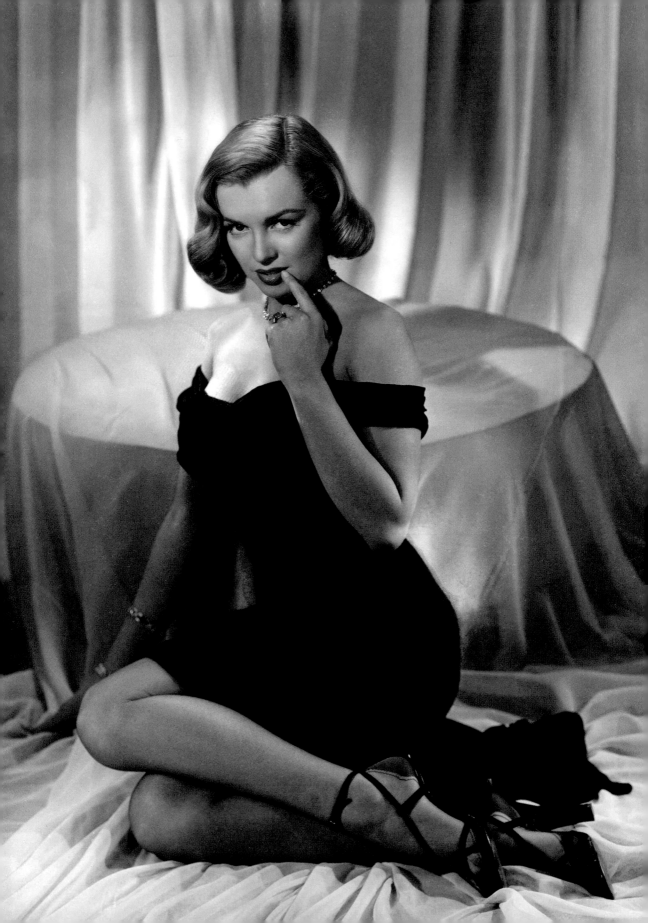

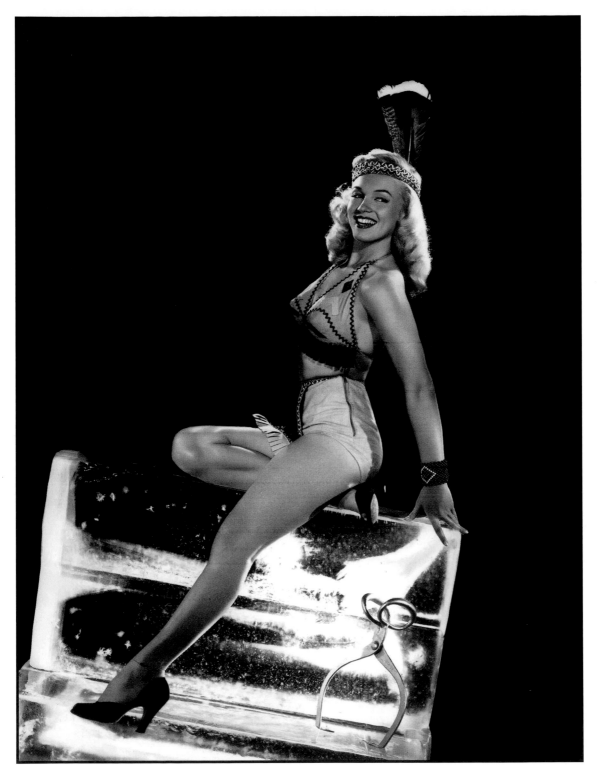

★ MARILYN MONROE, 1950

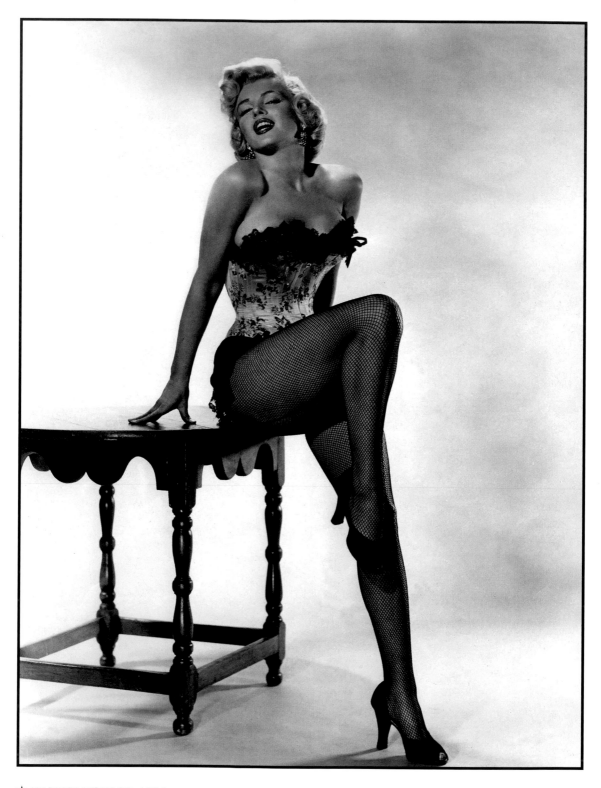

★ MARILYN MONROE, 1954

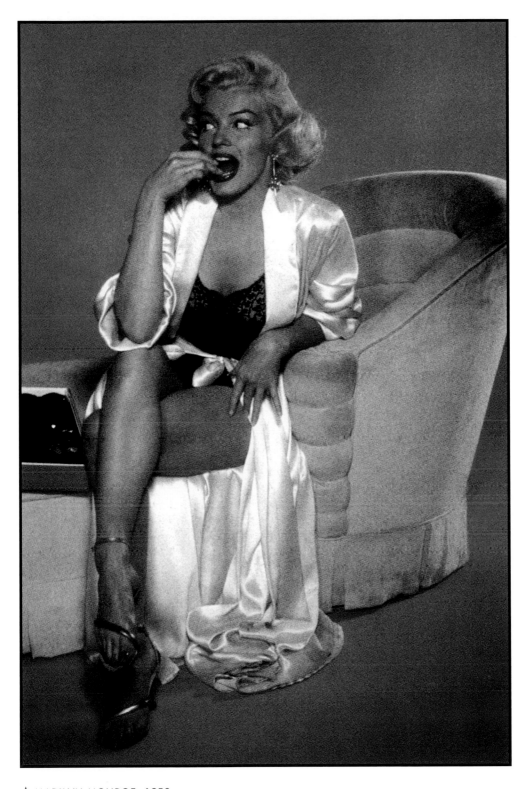

★ MARILYN MONROE, 1953

Blonde Ambition

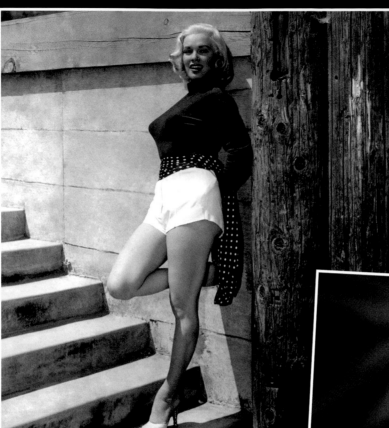

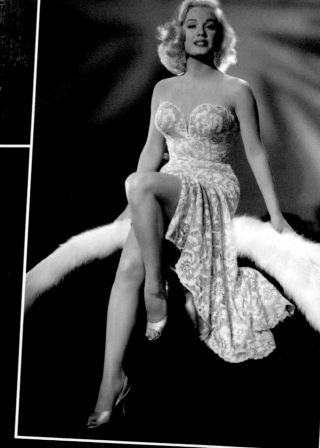

Way before *Forbes* dubbed workaholic Madonna the "Cash Queen" of music, flaxen go-getters sacrificed plenty, not to mention withstood plentiful sarcasm directed their way, to get to some position of prominence in the entertainment business. For some, fame and fortune came naturally, while for others surviving success became the real issue.

MAMIE VAN DOREN, 1954

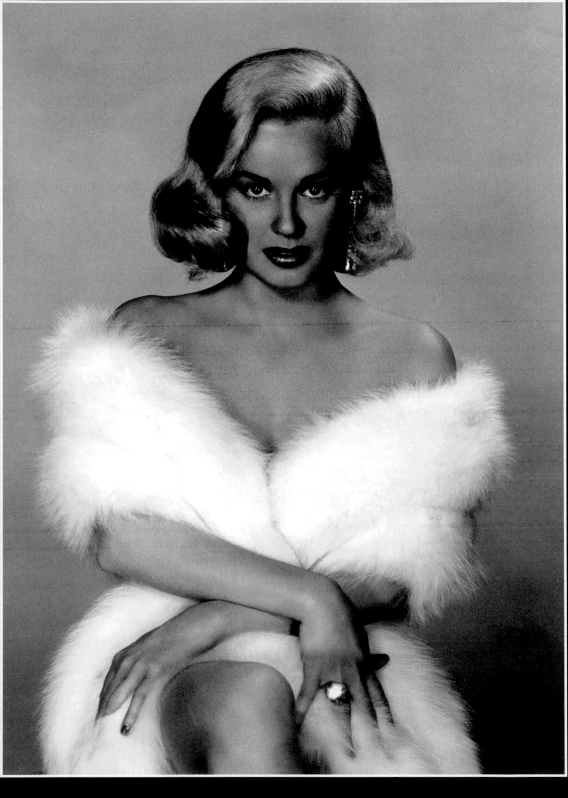

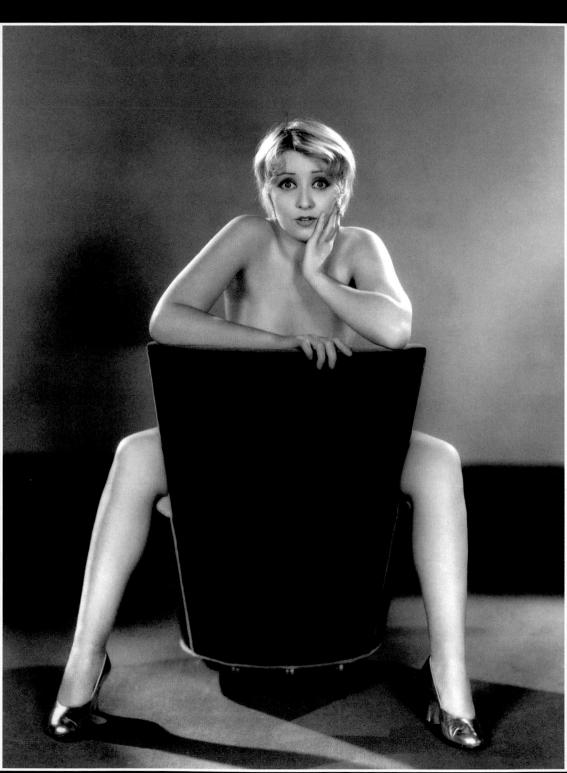

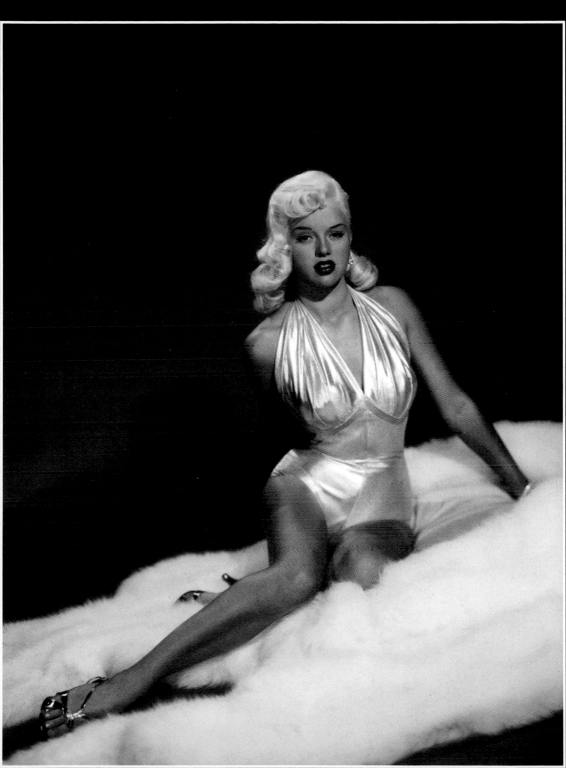

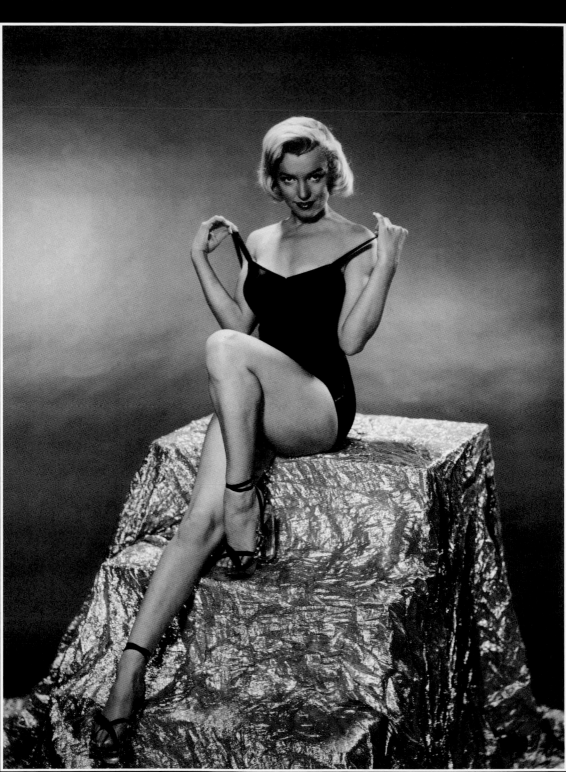

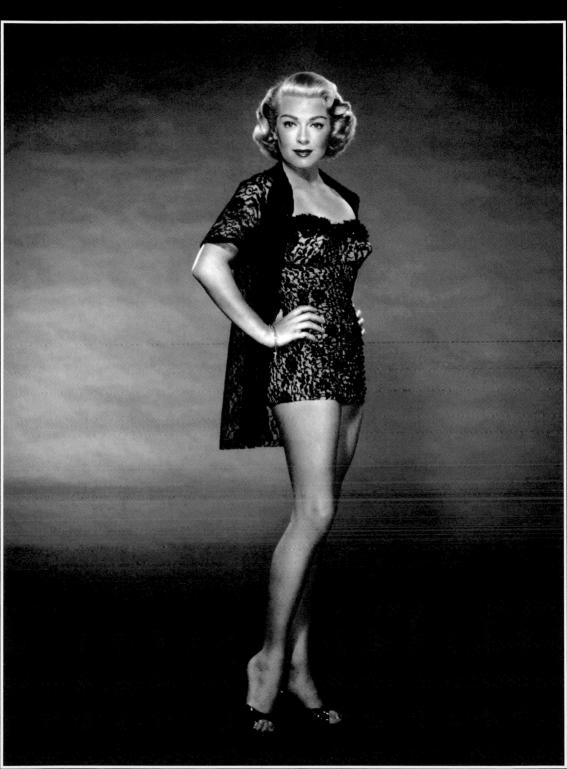

★ ABOVE: RITA MORENO, 1954 ★ OPPOSITE: ESTHER WILLIAMS, 1953

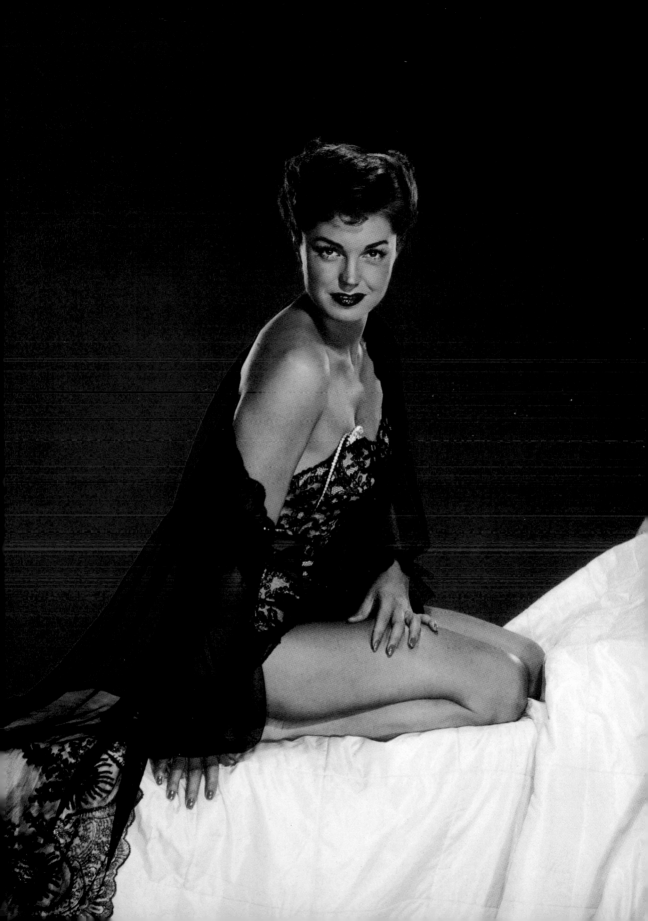

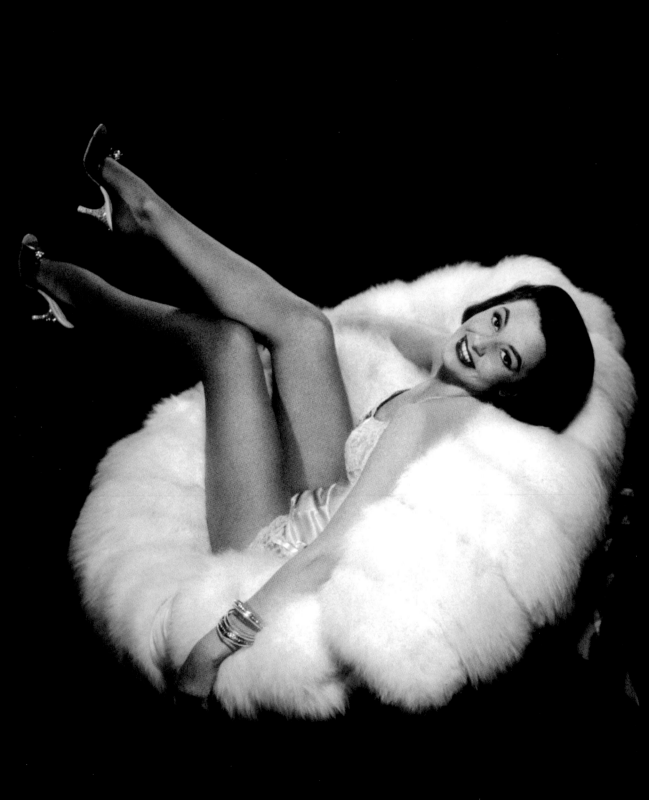

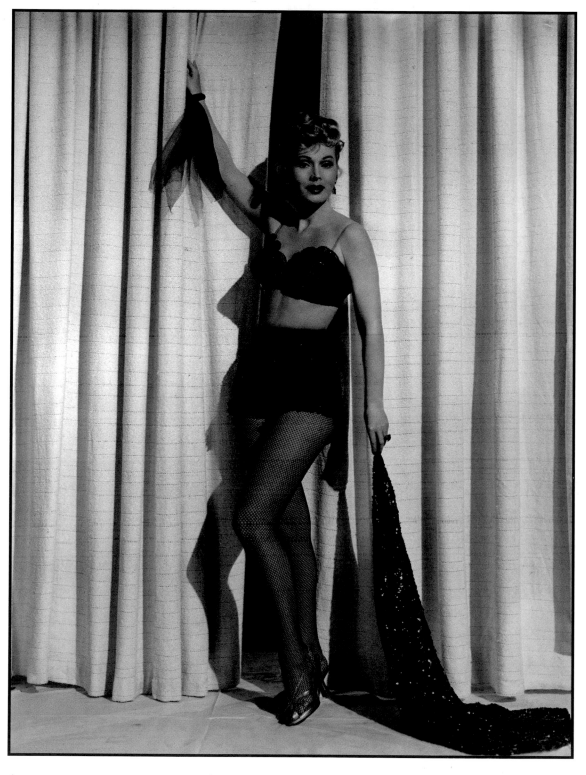

★ OPPOSITE: CYD CHARISSE, 1953 ★ ABOVE: ZSA ZSA GABOR, 1953

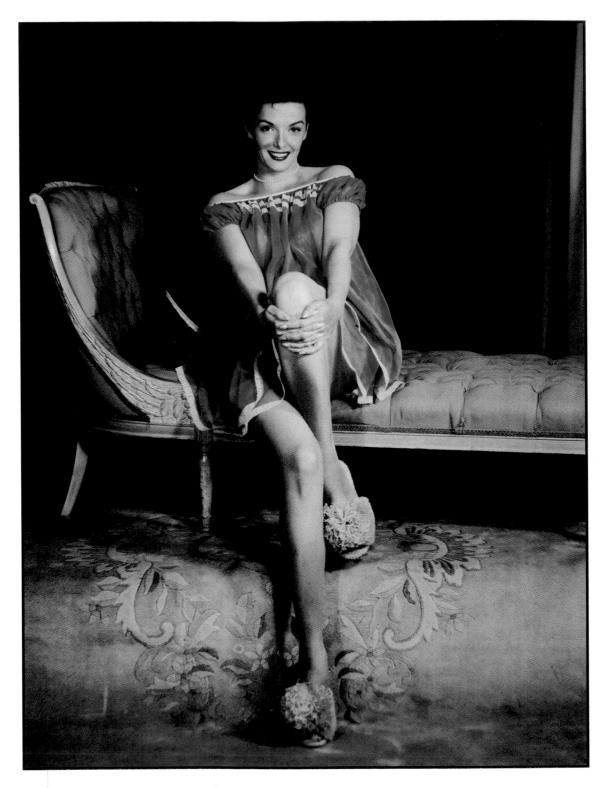

★ ABOVE: JANE RUSSELL, c.1955 ★ OPPOSITE: GLORIA GRAHAME, 1953

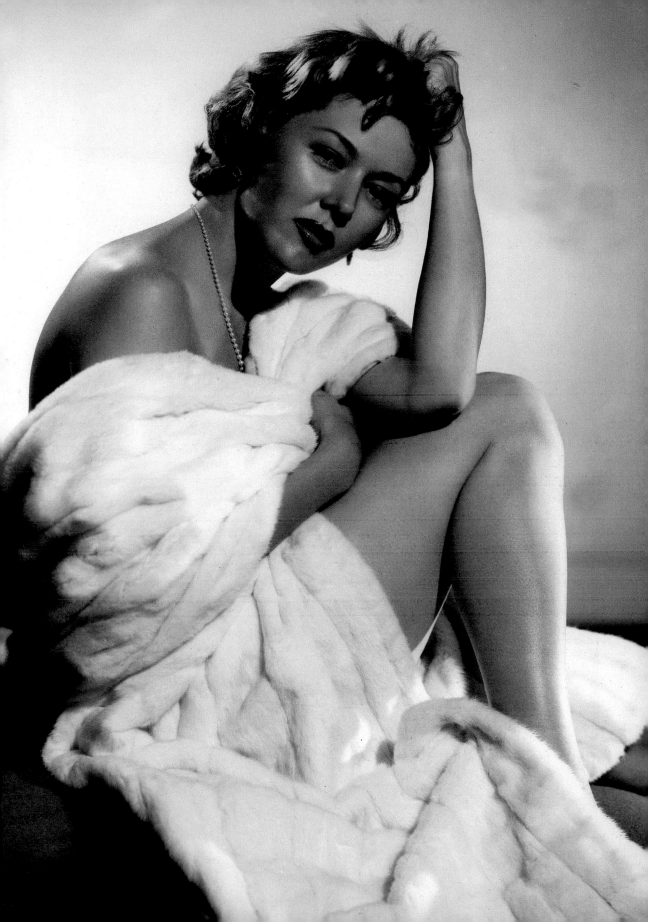

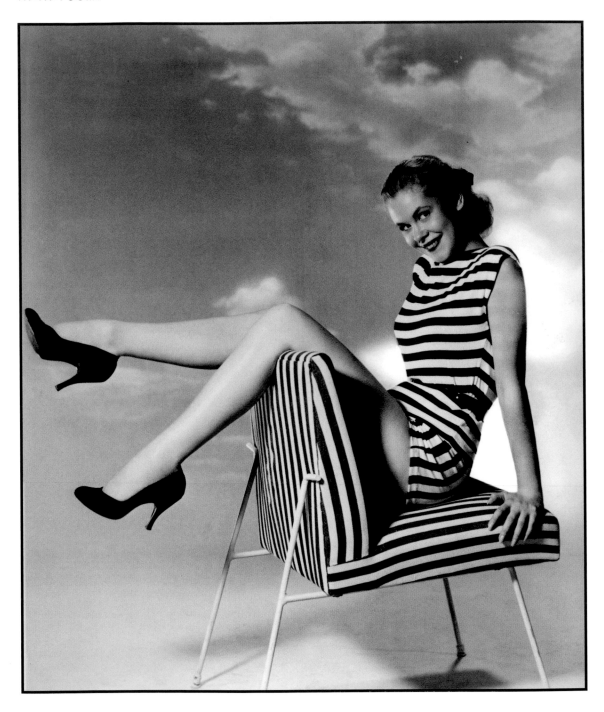

★ ELIZABETH MONTGOMERY, 1955

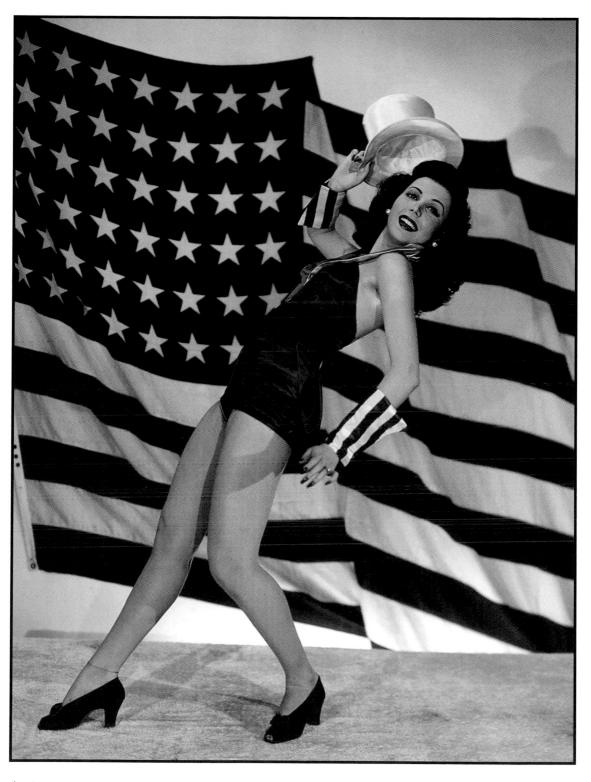

★ ANN MILLER, 1953

Patriot Act

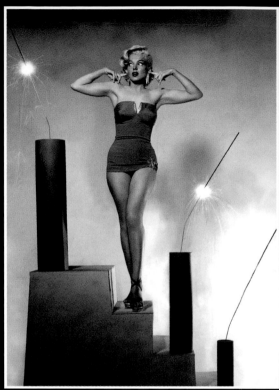

Although the Fourth of July for many Americans means barbecues, the photographers for these pin-up shots decided to go for patriotic gusto, covering their ladies in stars and stripes and whipping out the firecrackers for a big finale. The overall effect is not unlike when Bob Hope, on one of his many USO tours, would bring out the bombshell *du jour* in order to show the boys "what you're fighting for."

LEFT TO RIGHT:
-- DOROTHY SEBASTIAN, ANITA PAGE, c.1930
-- MARILYN MONROE, 1953
-- JAYNE MANSFIELD, 1955

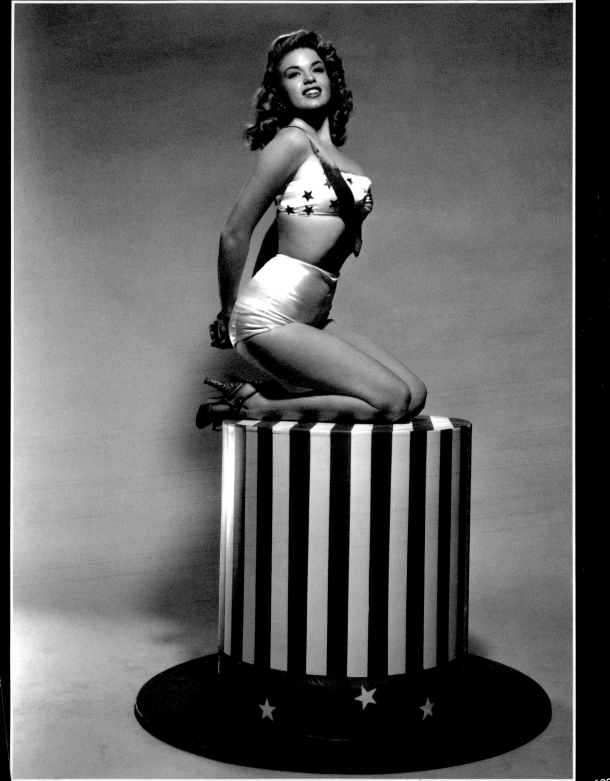

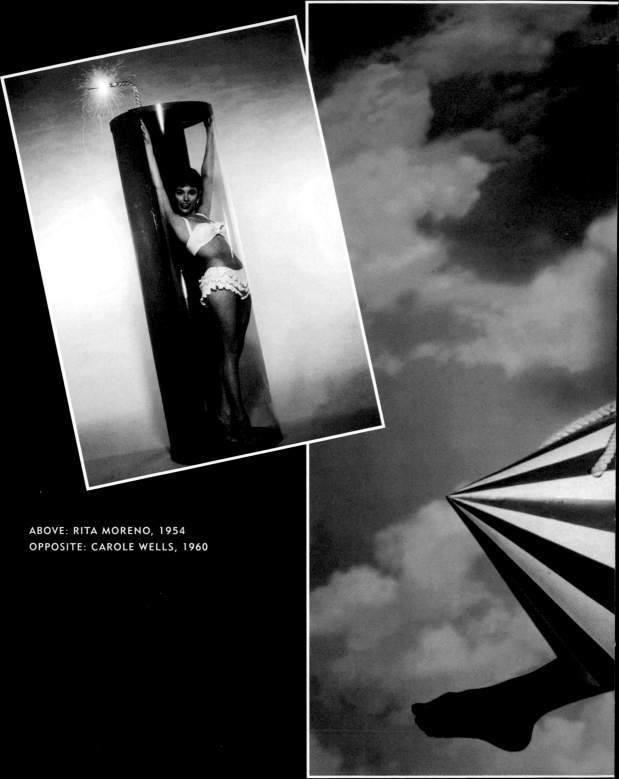

ABOVE: RITA MORENO, 1954
OPPOSITE: CAROLE WELLS, 1960

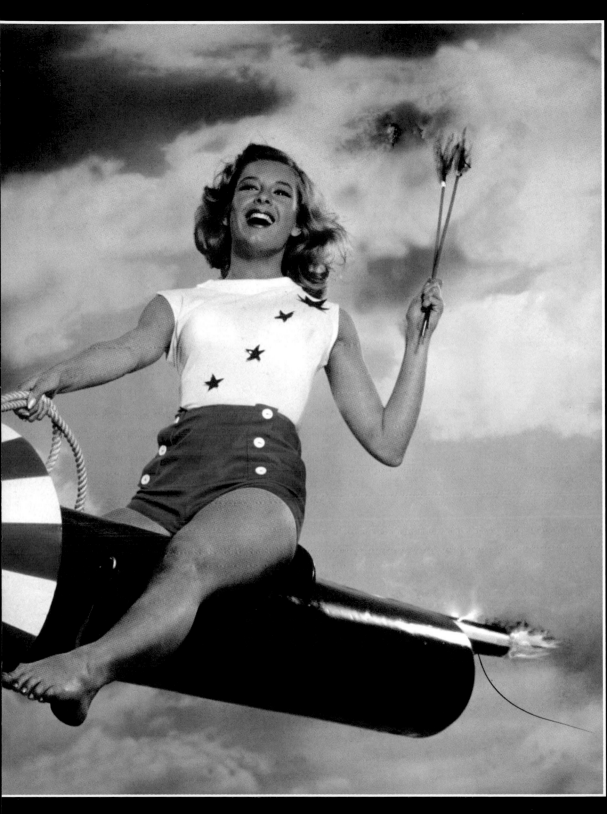

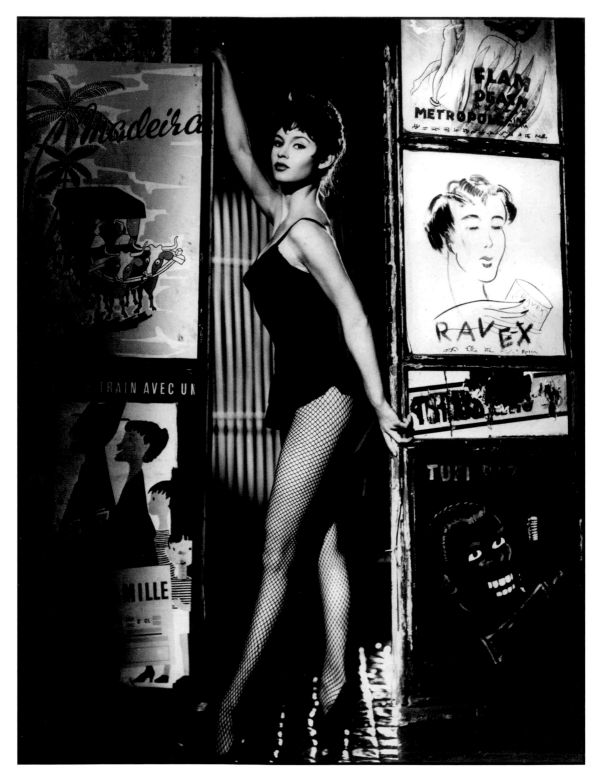

★ BRIGITTE BARDOT, 1955

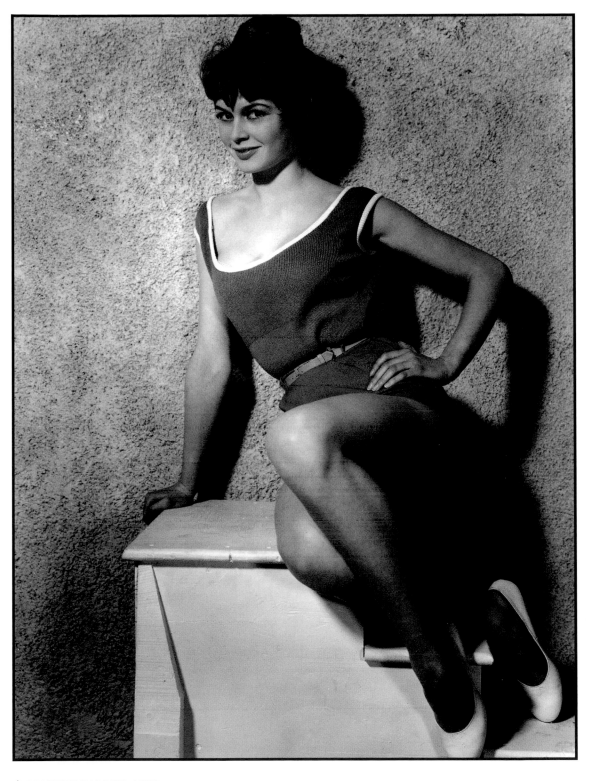

★ BRIGITTE BARDOT, 1955

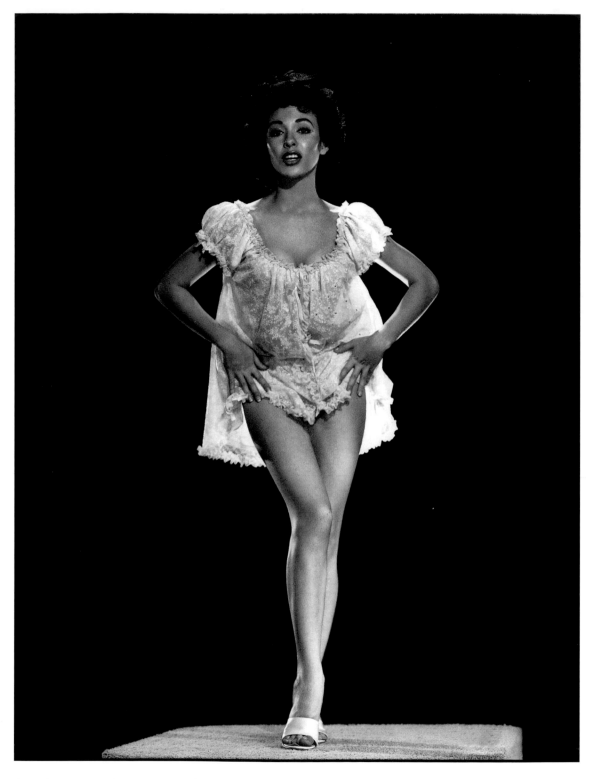

★ ABOVE: RITA MORENO, 1956 ★ OPPOSITE: LILI SAINT CYR, 1951

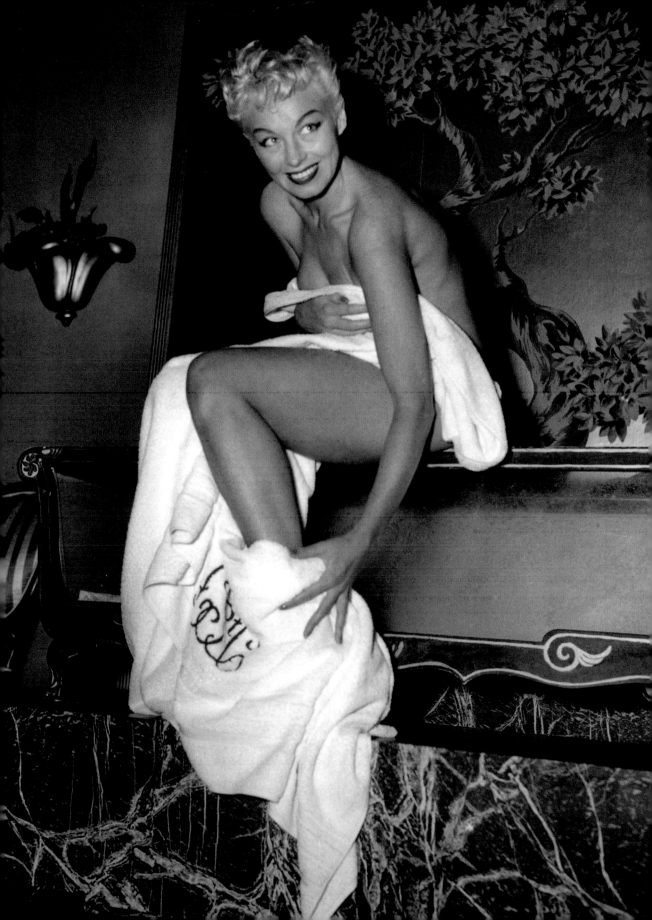

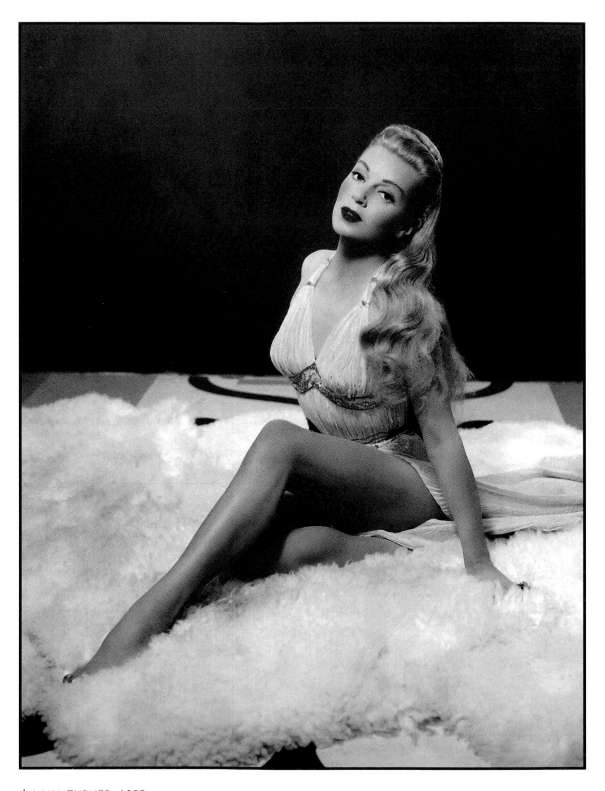

★ LANA TURNER, 1955

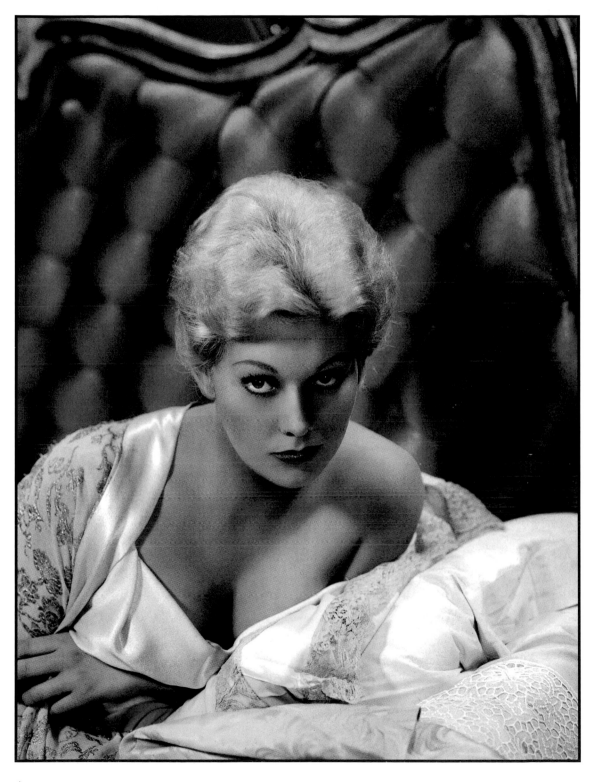

★ KIM NOVAK, 1955

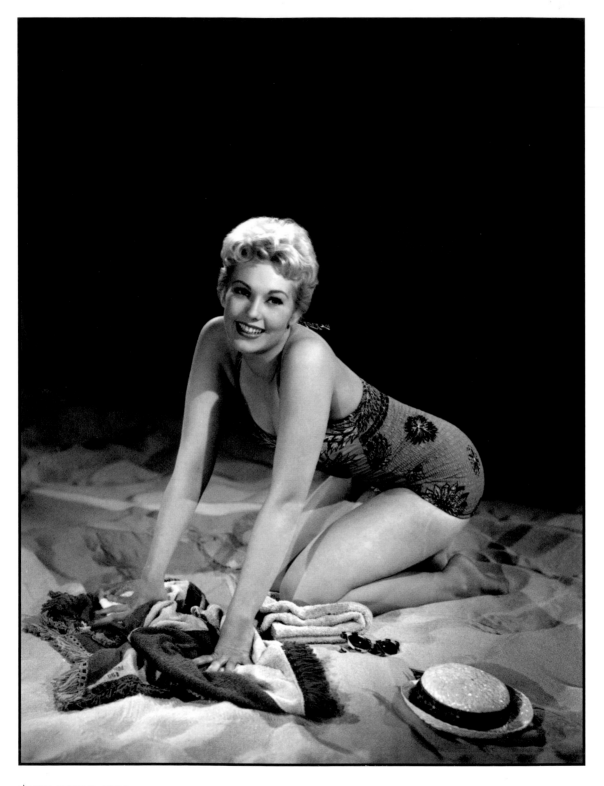

★ KIM NOVAK, 1956

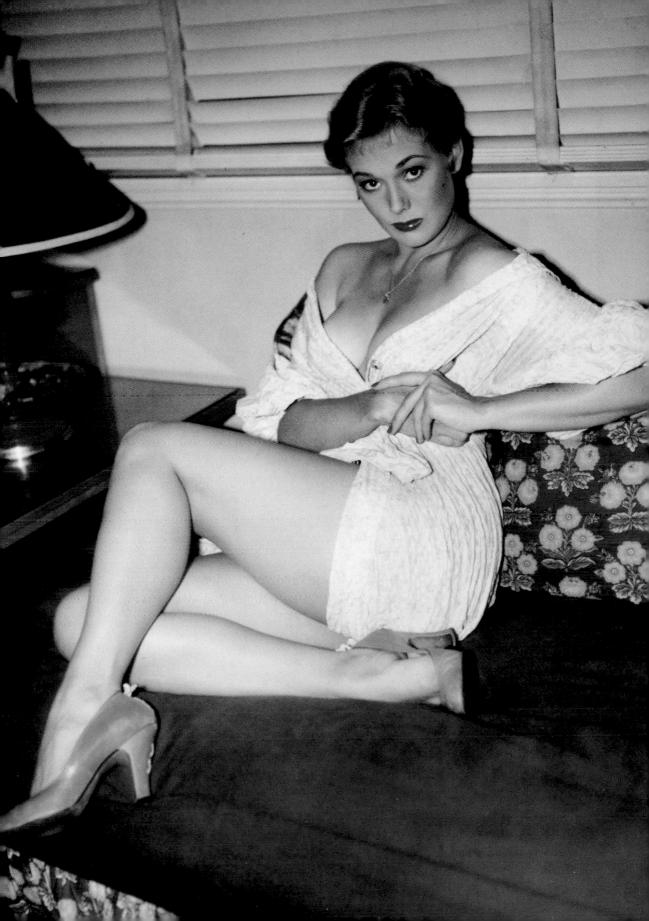

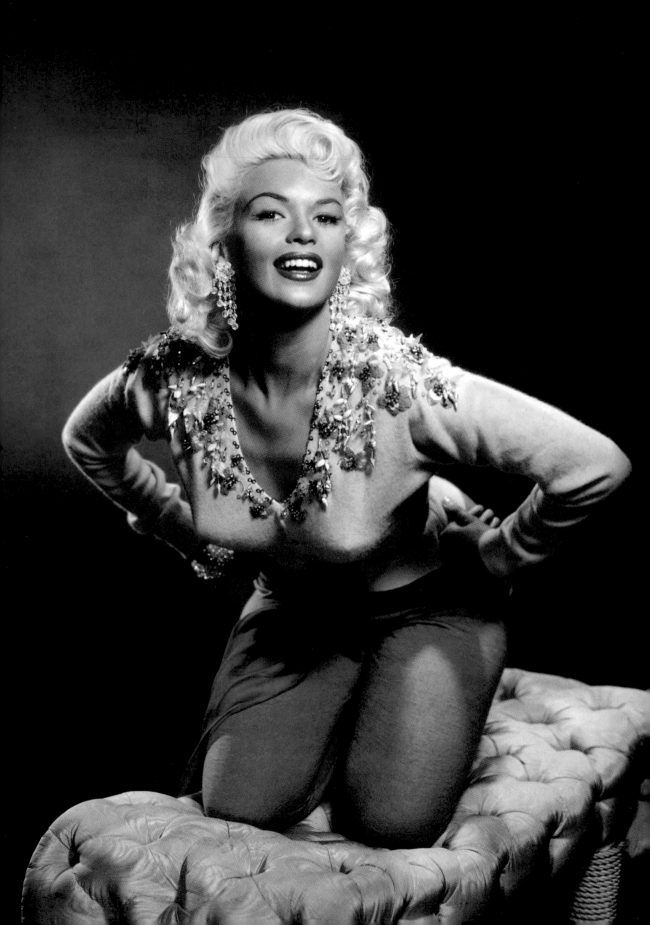

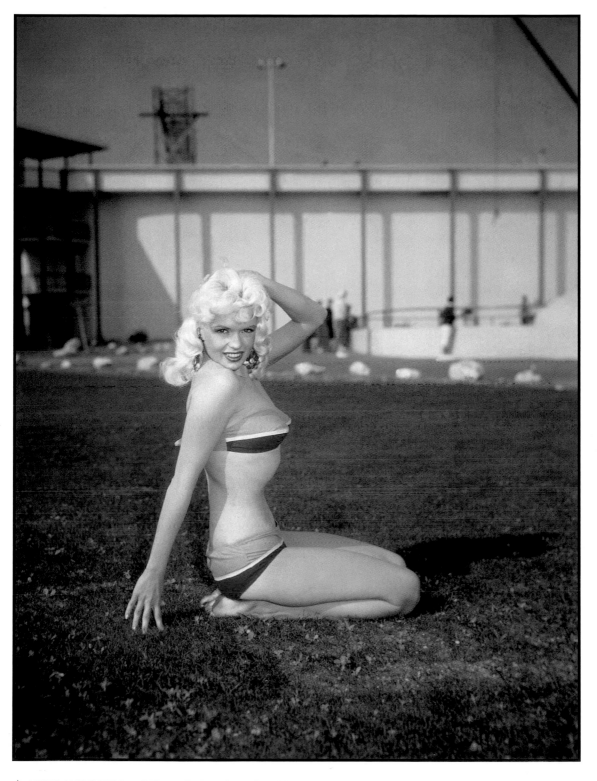

★ JAYNE MANSFIELD, 1957 (ABOVE), 1956 (OPPOSITE)

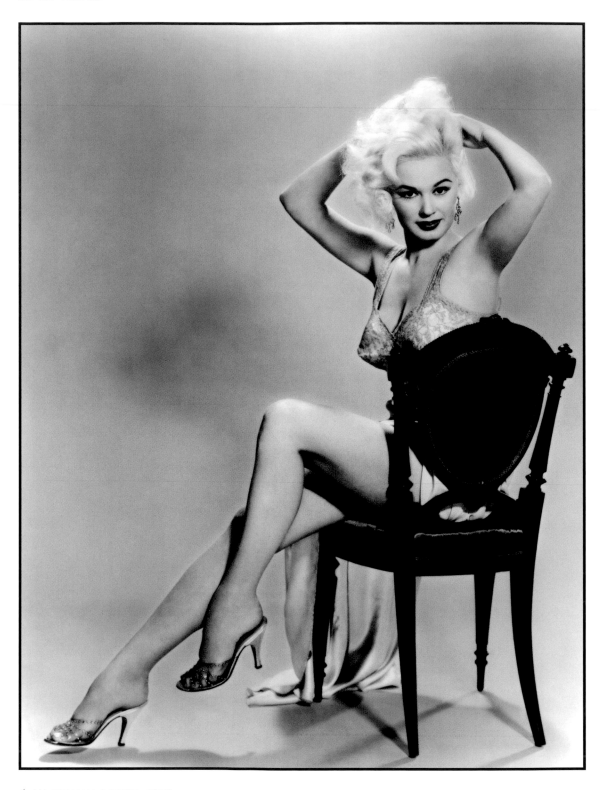

★ MAMIE VAN DOREN, 1958

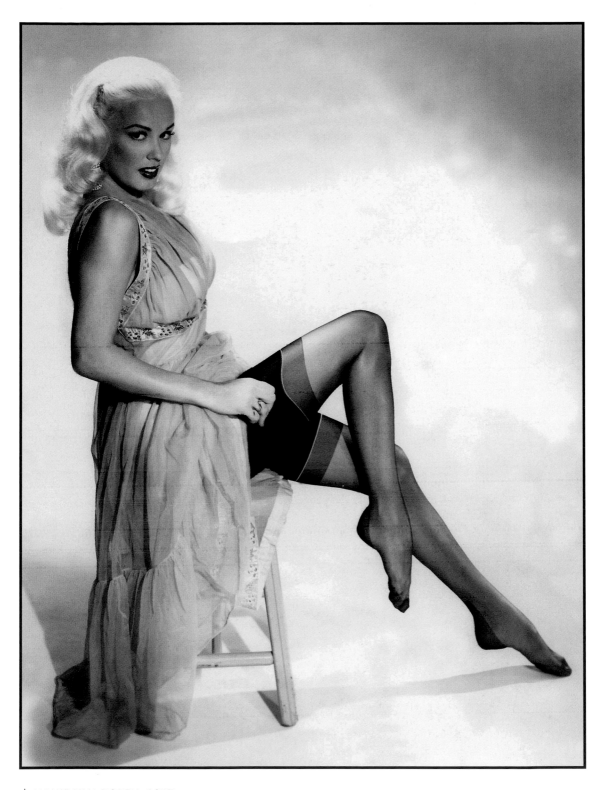

★ MAMIE VAN DOREN, 1957

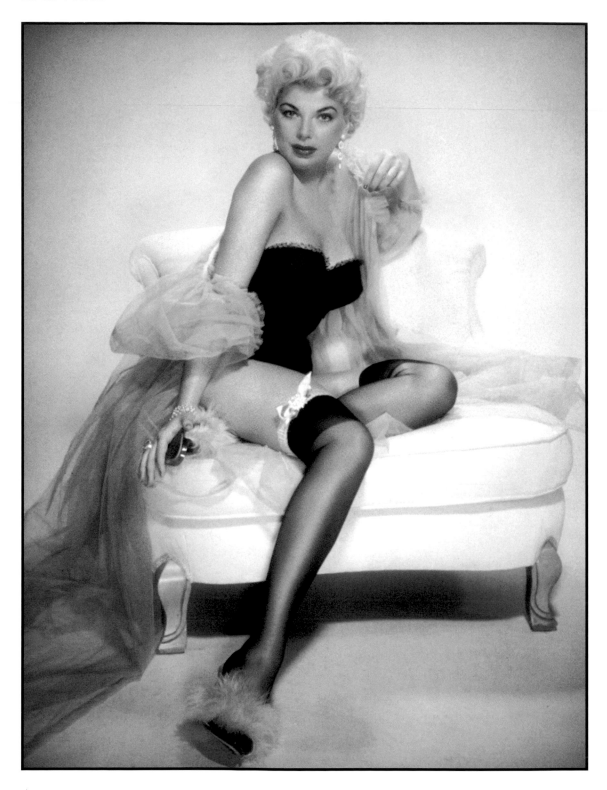

★ BARBARA NICHOLS, 1957

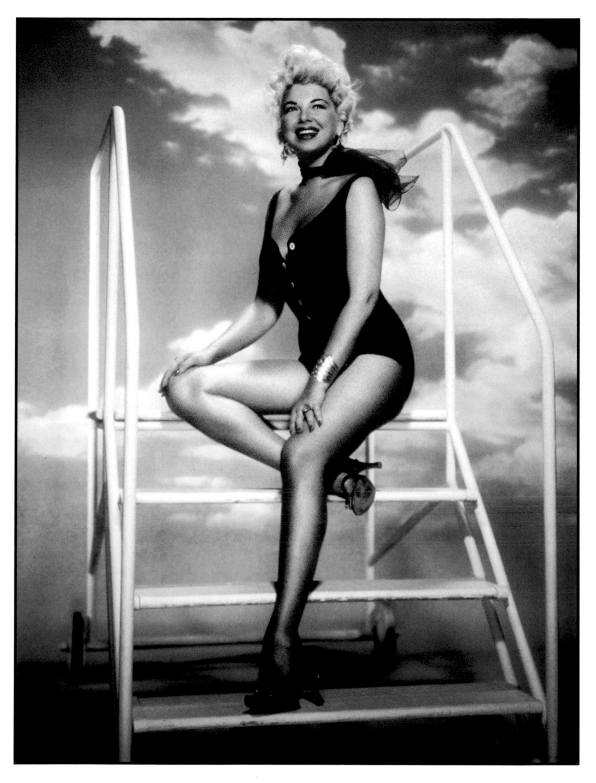

★ BARBARA NICHOLS, 1957

★ TERRY MOORE, 1957

★ TERRY MOORE, 1957

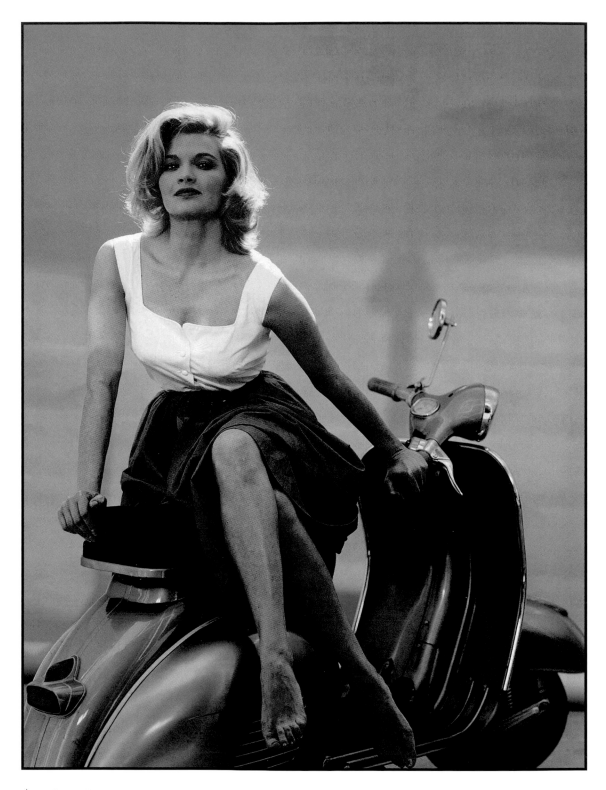

★ ANGIE DICKINSON, c.1958

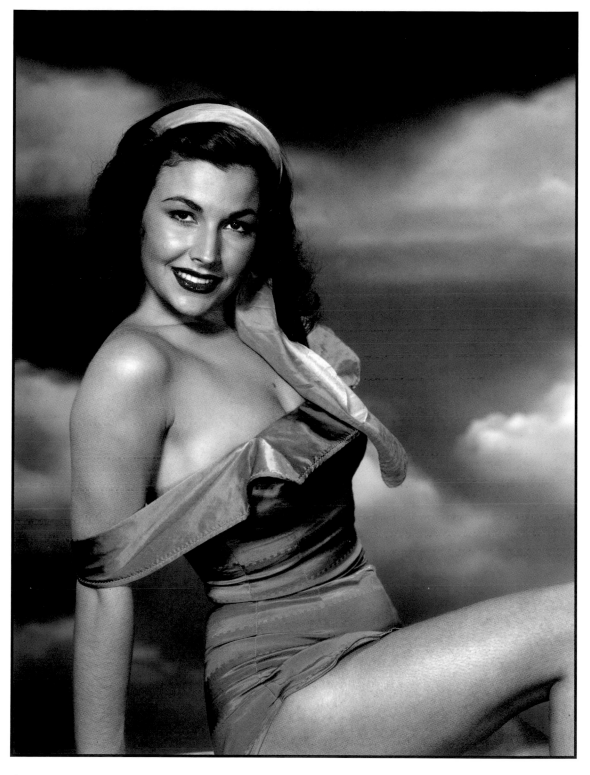

★ MARA CORDAY, 1955

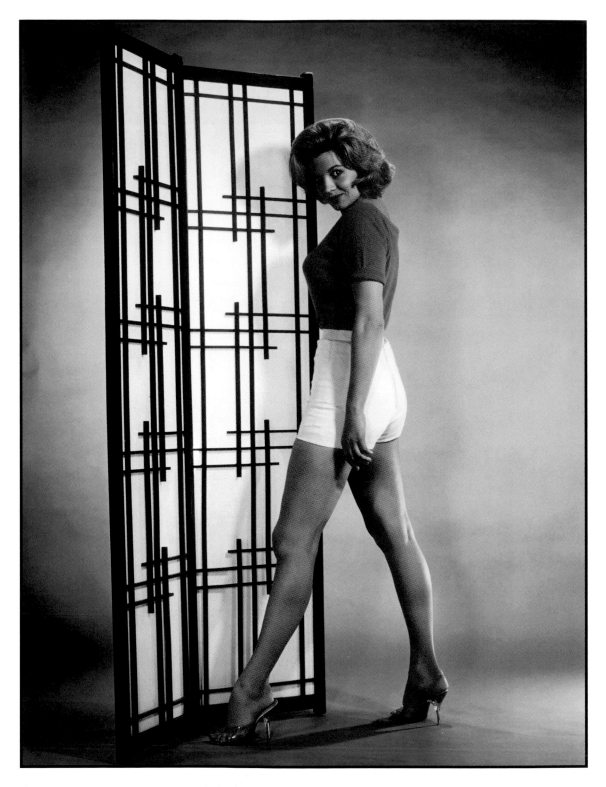

★ ABOVE: ANGIE DICKINSON, c.1958 ★ OPPOSITE: SOPHIA LOREN, 1958

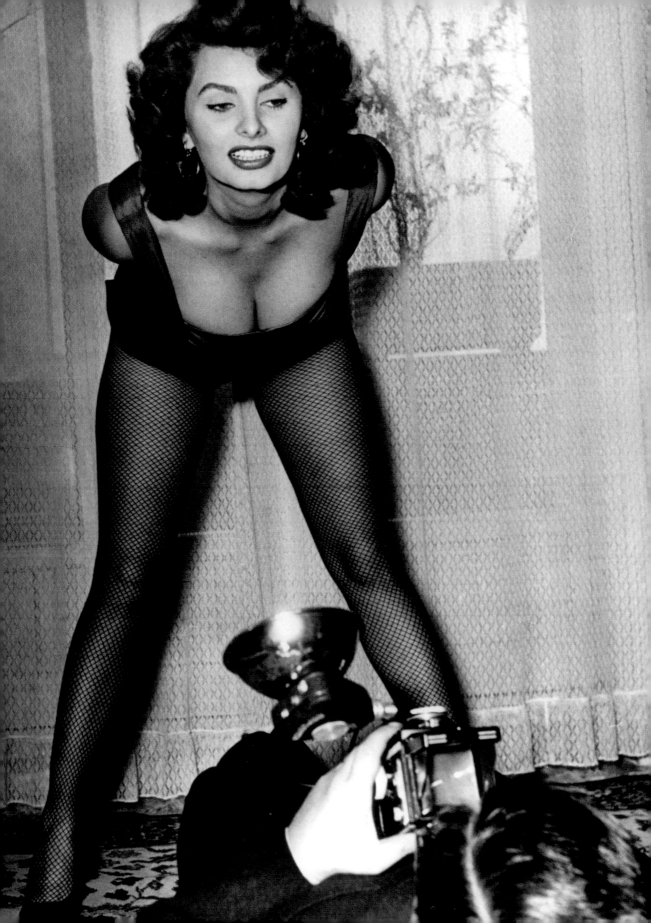

The 1960s: End of an Era

For one particular pin-up, the 1960s got off to a pretty good start: Elizabeth Taylor, after three consecutive nominations, finally won a best actress Oscar in 1961 for her portrayal of the aptly named call-girl Gloria Wandrous in the awkwardly titled *BUtterfield 8*. In 1960, Taylor was a contender for her role in *Suddenly Last Summer*, but lost out to Simone Signoret in *Room at the Top*. Even though *BUtterfield* and *Room* won the awards, *Suddenly* produced the best pin-up, and it's easily one of the most provocative in the Liz Taylor collection (see opposite).

Clad in an alluring one-piece swimsuit, with a wind-swept raven-haired halo, Taylor perches at ocean's edge like a Roxy Music siren. "Come hither," she might be saying, "and drown with me." This might be the appropriate point to bring Sigmund Freud into the pin-up discussion, particularly two of his psychoanalytic *bêtes noires*: the experience of religious fervor (which Freud sometimes referred to as the "oceanic feeling") and "woman" as psychological threat. The way Taylor is posed in this picture, with the emphasis of her alone in the sea, ultimately alters the sense of scale: she could be a giant—or at least an Amazon. In fact, the image contains a visual echo of a classic (and blatantly Freudian) poster for a B-movie released one year earlier: *Attack of the 50 Foot Woman*. In an alternate universe one can imagine both pin-up and poster hanging in Freud's office—as he trembles in fear beneath the couch.

The one-piece bodysuit, à la Liz, has a venerable history going back to the days when even men wore them. The bikini, on the other hand, is a postwar phenomenon that has always been (almost) strictly for women. As all swimwear historians know, the name derives from the Bikini Atoll in the Pacific Ocean, and the weapons tests that took place there during the 1940s and 1950s. Presumably, the thrills triggered by exploding nuclear weapons were somehow akin to the excitement generated by the debut of midriff-baring fashion. (Surely an obscene conflation of event and artifact.) By the 1960s, the bikini was a standard element of pin-up couture. And, as always, theme and

★ Elizabeth Taylor, 1960: As Norma Desmond might say, Liz Taylor was always big, it was the pictures that got small.

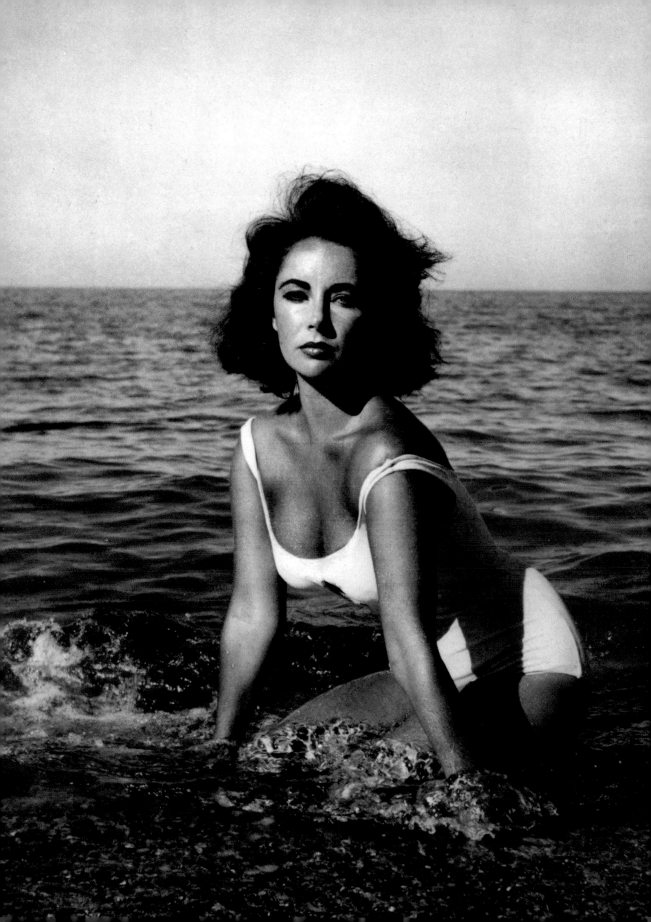

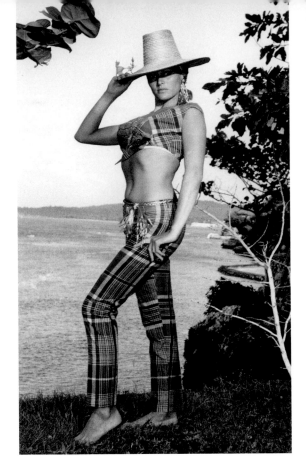

variation were the order of the day: Consider Ursula Andress's madras-plaid almost-bikini top with matching slacks, or Sandra Dee's girl-next-door polka dots (see above). Or our "prehistoric" friends, Imogen Hassal, Victoria Vetri, and Magda Konopka, posing in a confrontational publicity shot from 1970's *When Dinosaurs Ruled the Earth* and clad in a material of unidentifiable composition (see opposite).

No trip to the bikini stone age would be complete without dropping in on the 1966 romp, *One Million Years BC*. If people remember the film for anything, it's the fur (or lack thereof) covering Raquel Welch's body (page 246); that, or Ray Harryhausen's dinosaurs. Welch was indeed a poster girl for 1960s swimwear, perhaps never more outrageously than in the patriotic concoction seen on page 226. (One can imagine a cowboy hat at the beach or beside the pool, but red patent-leather opera gloves?) *Myra Breckinridge*, the 1970 film in which she wore this particular outfit, has been described as: "tasteless," "a travesty," "a major disaster," "dirty," "disgusting," "vulgar," and "the low point of the American cinema." In a mild defense, Terrence Rafferty wrote: "But as a Raquel Welch movie, it's better than most."

★ ABOVE LEFT:
Ursula Andress, 1963

★ ABOVE RIGHT:
Sandra Dee, 1961

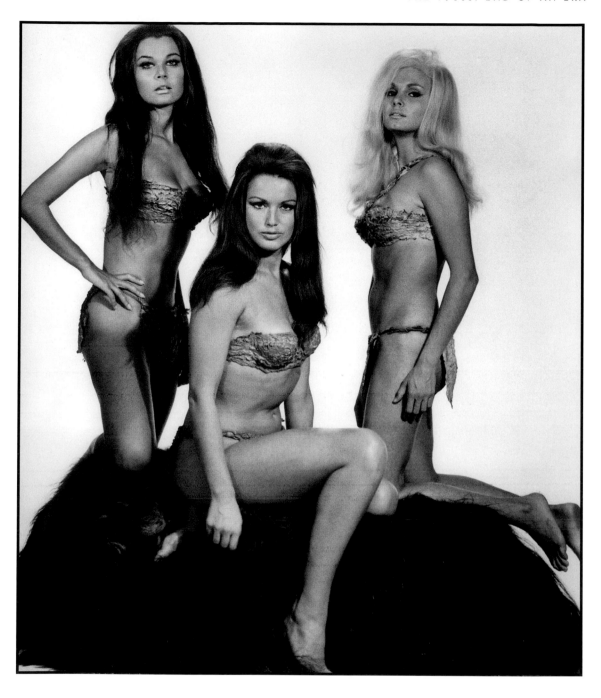

★ Imogen Hassall, Victoria Vetri, Magda Konopka, 1970

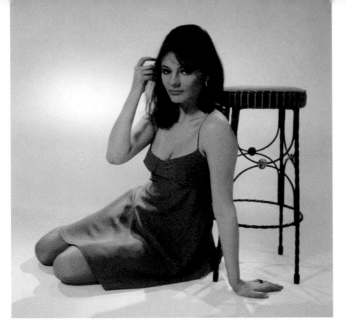

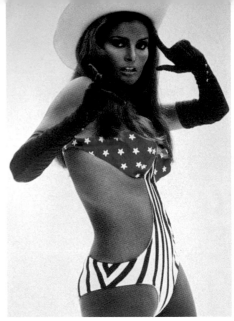

★ ABOVE LEFT:
Jacqueline Bisset, 1957

★ ABOVE RIGHT:
Raquel Welch, 1970

Dramatic range is not what first comes to mind when one thinks of 1960s pin-ups in general, or Welch in particular. But there are many talented actors in this chapter who've made indelible filmic contributions with great performances or, barring that, savvy appearances in intriguing guilty pleasures. Herewith, a few standouts: Jacqueline Bisset in François Truffaut's *Day for Night*; Angie Dickinson opposite Lee Marvin, in John Boorman's *Point Blank* and Don Siegel's *The Killers* (not to mention her leading-lady role in Howard Hawks's 1959 *Rio Bravo*); Carroll Baker in Elia Kazan's *Baby Doll* (admittedly from 1956, but she continued to do excellent work in the 1960s in lesser-known films); Janet Leigh in Hitchcock's *Psycho*; Jane Fonda in *They Shoot Horses, Don't They?*; and Jean Seberg in Godard's *Breathless*.

Supplementary pin-up respect is also due—especially in the context of the bikini—to the original Bond girl, Ursula Andress (opposite and page 241). She was in high demand in 1965, making six features, including *What's New, Pussycat?*, a key 1960s-zeitgeist flick. Andress also helped capture the spirit of the mod/pop era when she appeared in Elio Petri's madcap *The 10th Victim*. Set in the not-too-distant future, the film involves an ultraviolent and government-sanctioned televised phenomenon called "The Big Hunt" in which contestants compete to be the first to kill ten human targets. Before Andress is pitted against Marcello Mastroianni, and the real mayhem begins, we are introduced to her character dancing on a table in a high-tech club. The midsection of her seemingly one-piece swimsuit is removed by a patron. Now, bikini-clad, she slaps him hard with the

detached bit of clothing. He likes it. She proceeds to roam the room with an air of predatory sexuality, locates her prey, and—with orgasmic glee—kills him with bullets fired from her bikini top.

The 10th Victim is a smorgasbord of 1960s culture and anticipates a lot of what lies ahead (everything from reality TV to Austin Powers). It's decadence, camp, and kitsch in extremis, openly deriding the abuse of state power and the perversions of media and advertising. But the film is ultimately about the battle of the sexes—in this case a conflict fought by an indispensable pin-up personality, wearing outrageous outfits, near the end of the golden age of the pin-up.

★ Ursula Andress, 1963: Andress was the James Bond pin-up *par excellence*, as *Dr. No's* Honey Ryder (the iconic bikini scene) and as Vesper Lynd in the spoof *Casino Royale*.

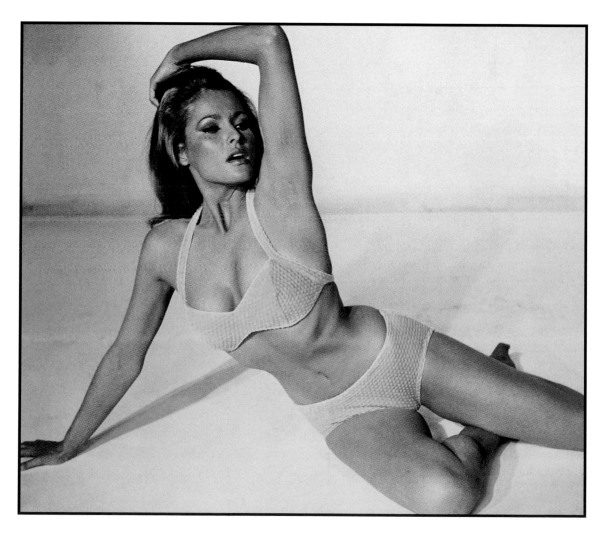

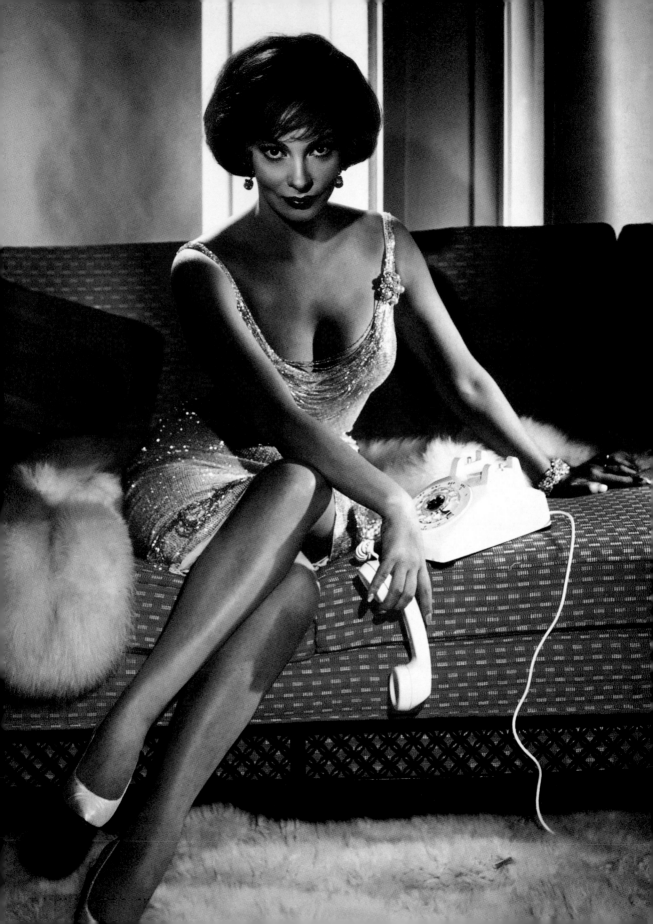

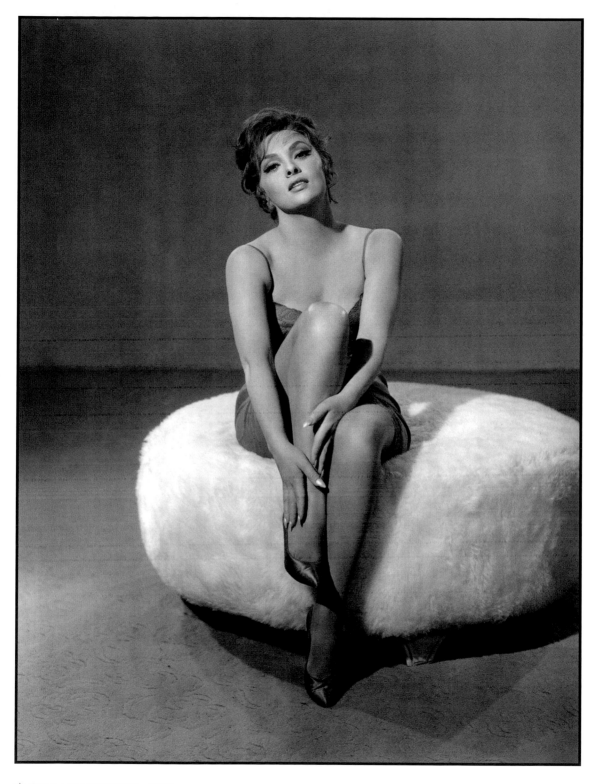

★ GINA LOLLOBRIGIDA, 1959

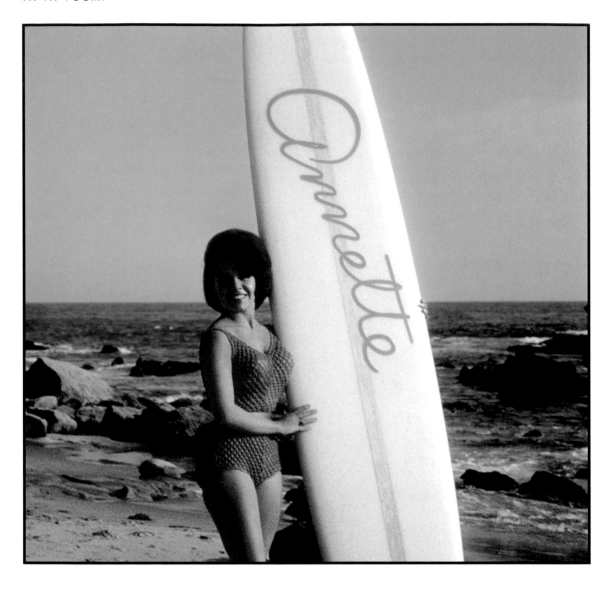

★ ANNETTE FUNICELLO, 1964

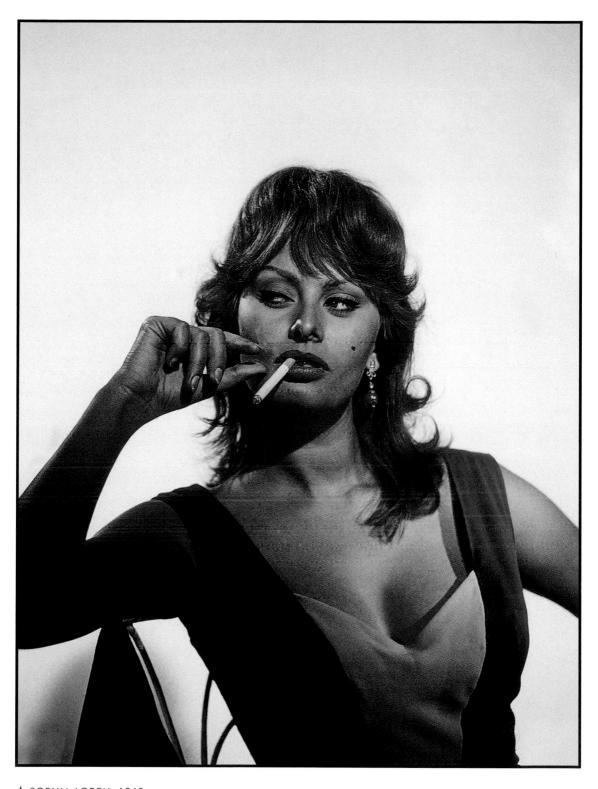

★ SOPHIA LOREN, 1960

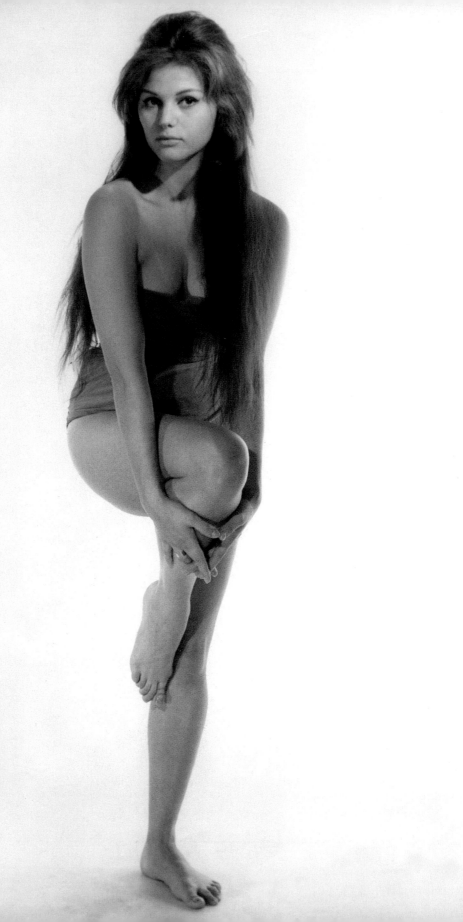

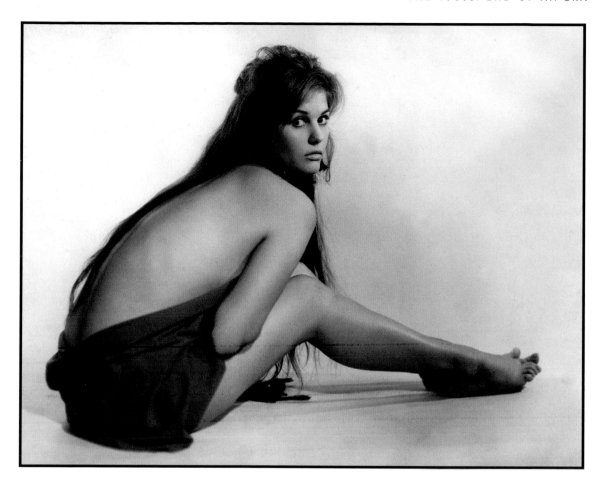

★ CLAUDIA CARDINALE, 1960

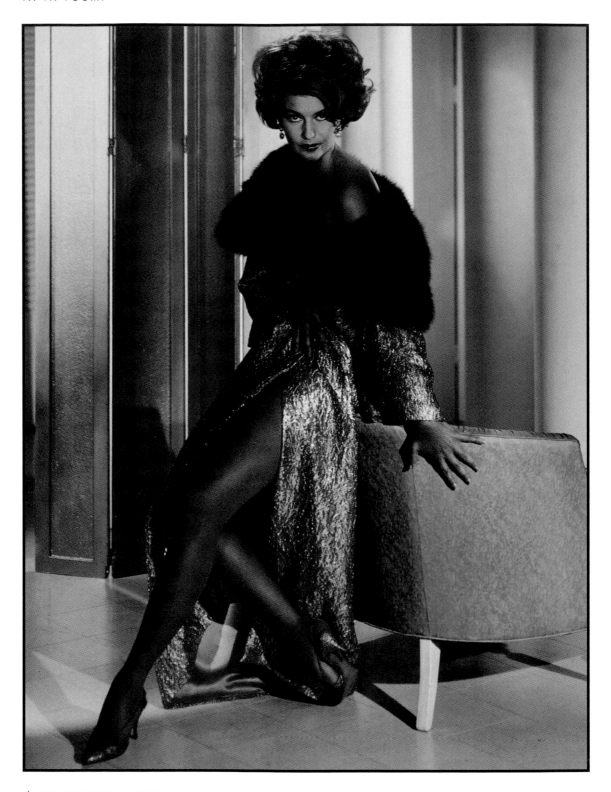

★ CYD CHARISSE, c.1962

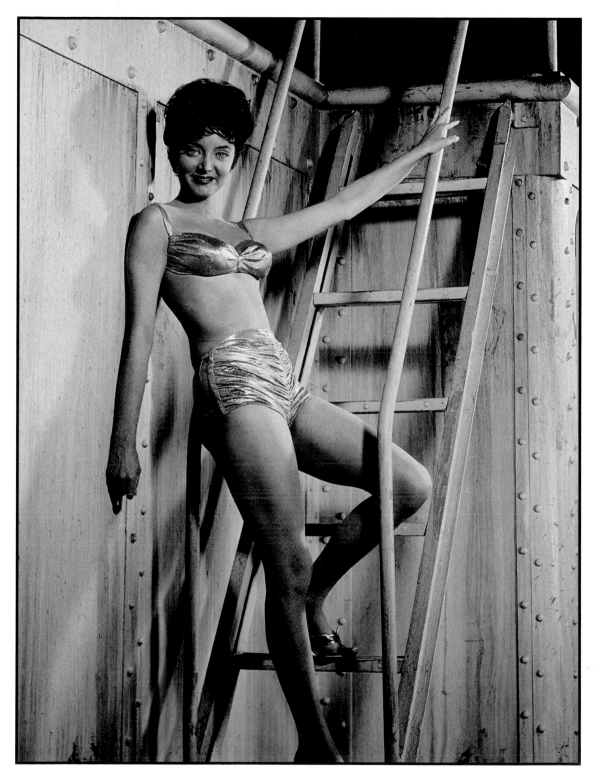

★ CAROLYN JONES, 1961

It's a Jungle Out There

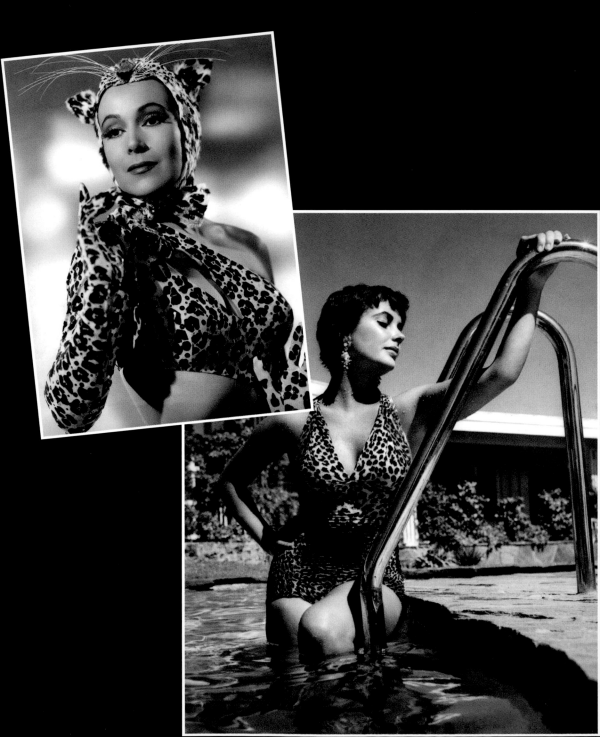

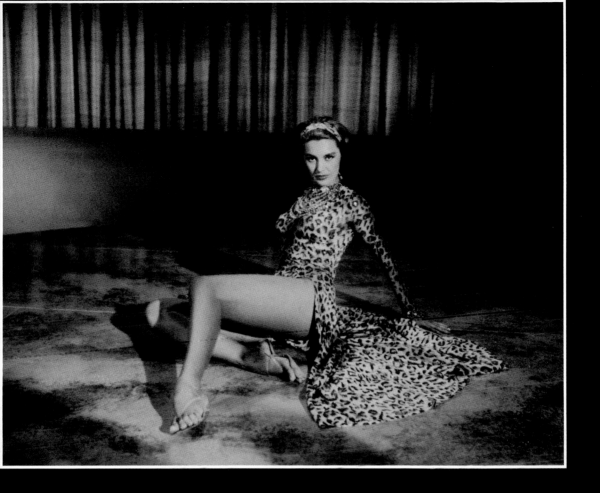

Leopards may not be able to change their spots, but movie stars can, and often do, change their names. Some of the transmogrifications are dizzying: Tula Ellice Finklea became Cyd Charisse. Dolores Martínez Asúnsolo y López Negrete distilled herself down to Dolores Del Rio. And, as an example of someone cutting against the name-change grain, there'll always be Elizabeth Rosemond Taylor.

LEFT TO RIGHT:
DOLORES DEL RIO, 1942
ELIZABETH TAYLOR, 1954
CYD CHARISSE, 1958

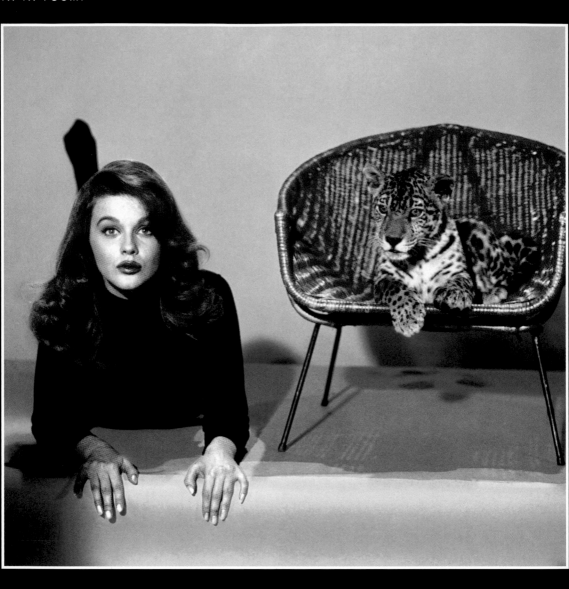

ABOVE: ANN-MARGRET, 1963 OPPOSITE: JAYNE MANSFIELD, 1957

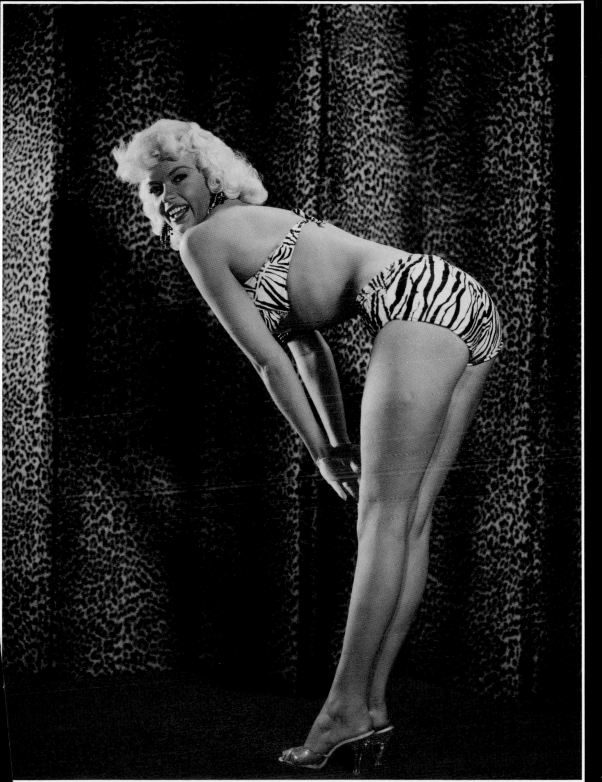

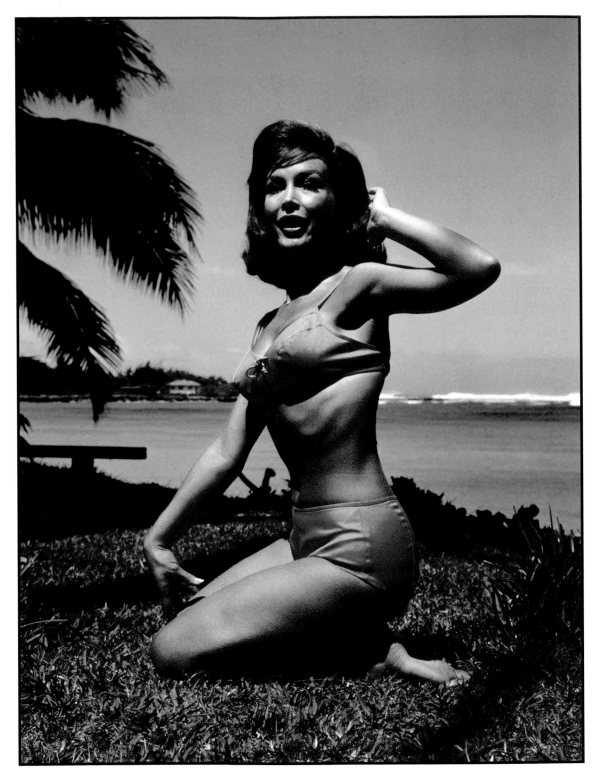

★ BARBARA EDEN, 1964

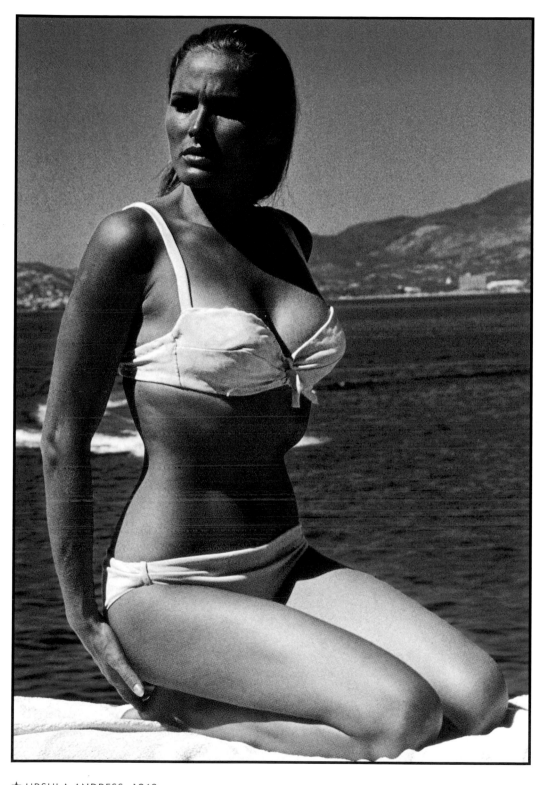

★ URSULA ANDRESS, 1962

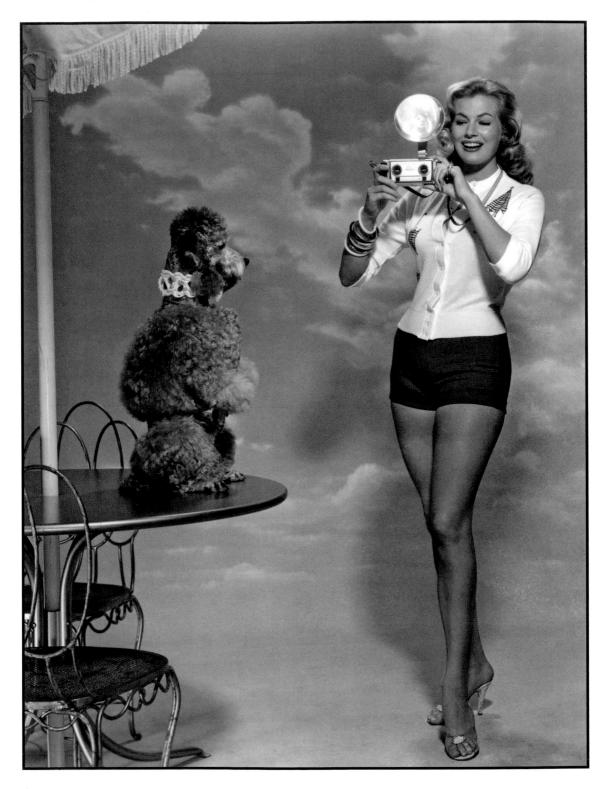

★ ANITA EKBERG, 1963

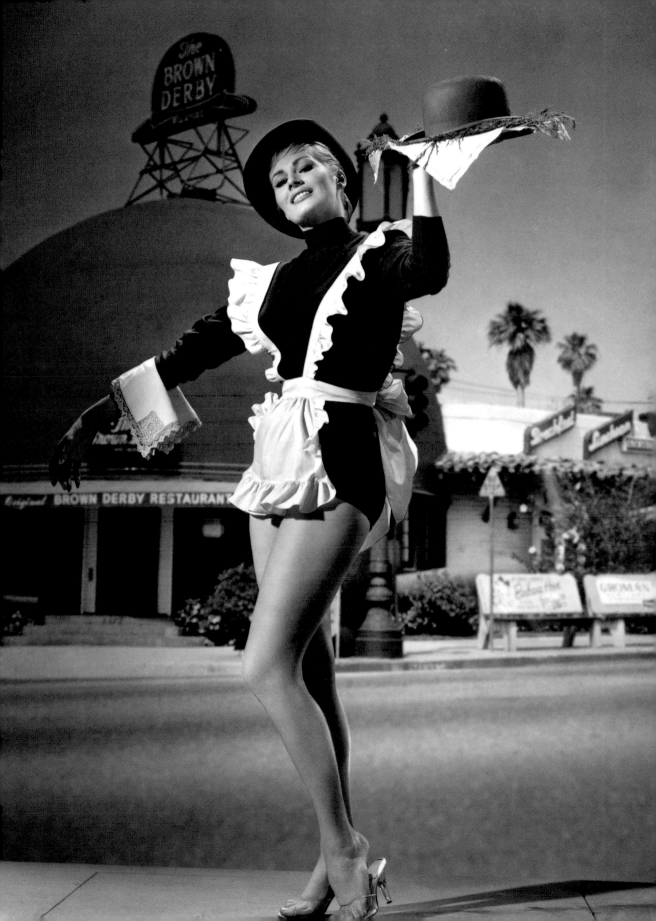

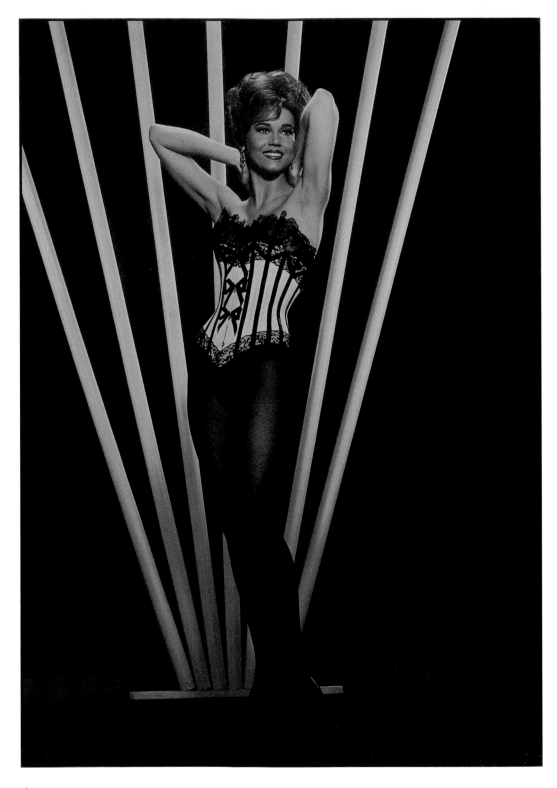

★ JANE FONDA, 1965

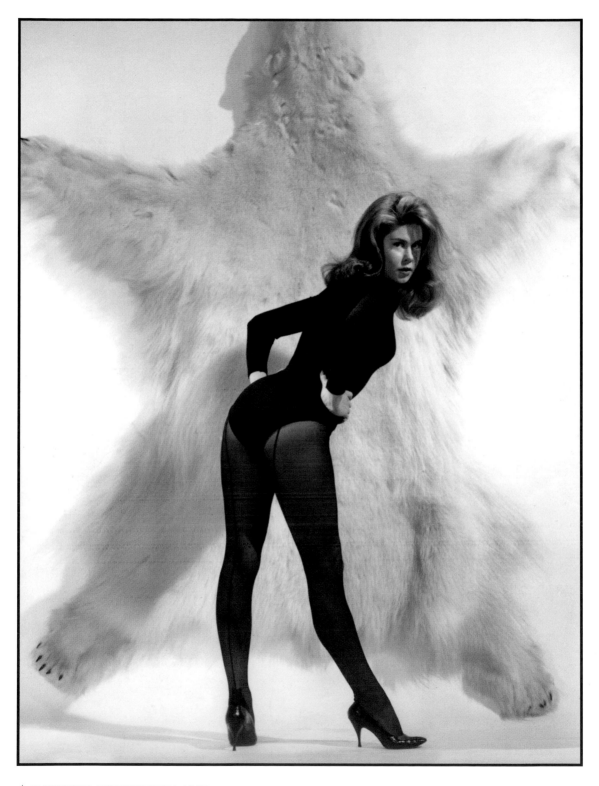

★ ELIZABETH MONTGOMERY, 1963

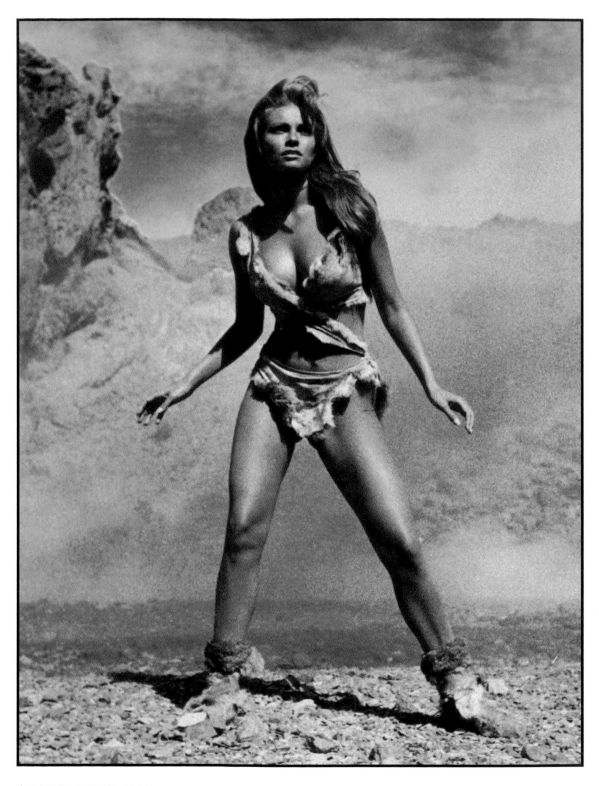

★ RAQUEL WELCH, 1966

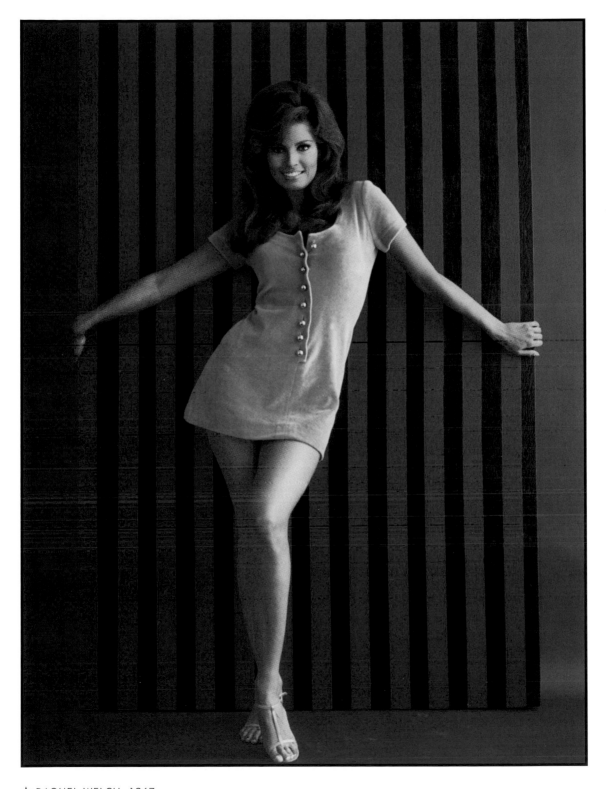

★ RAQUEL WELCH, 1967

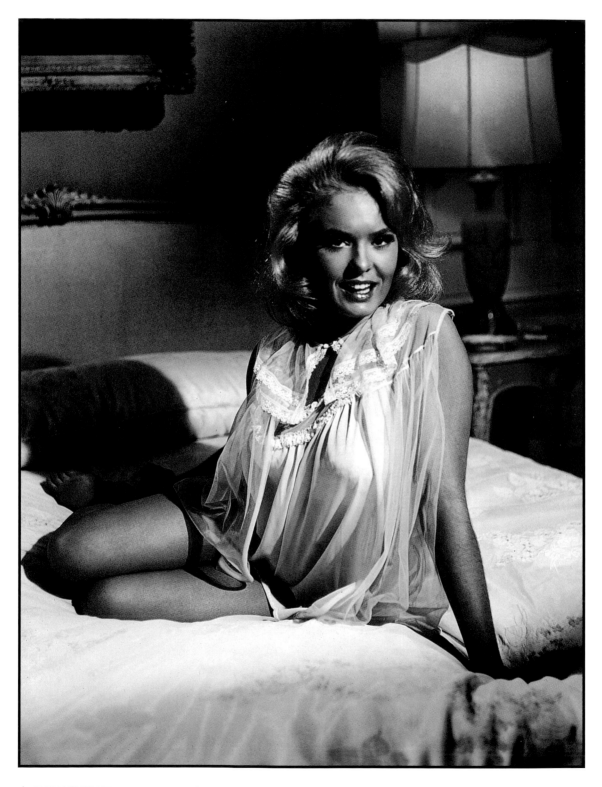

★ JOEY HEATHERTON, 1965 (ABOVE), 1963 (OPPOSITE)

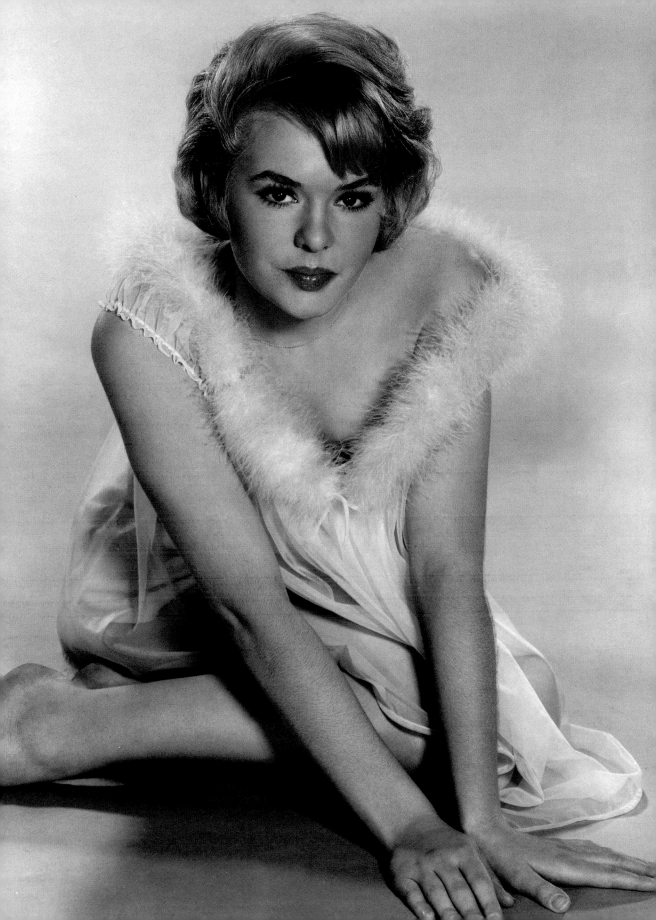

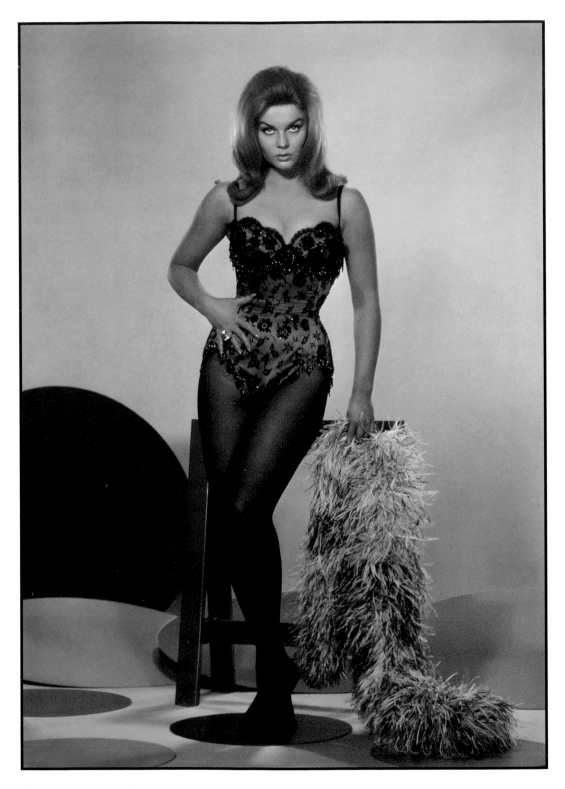

★ ANN-MARGRET, 1966

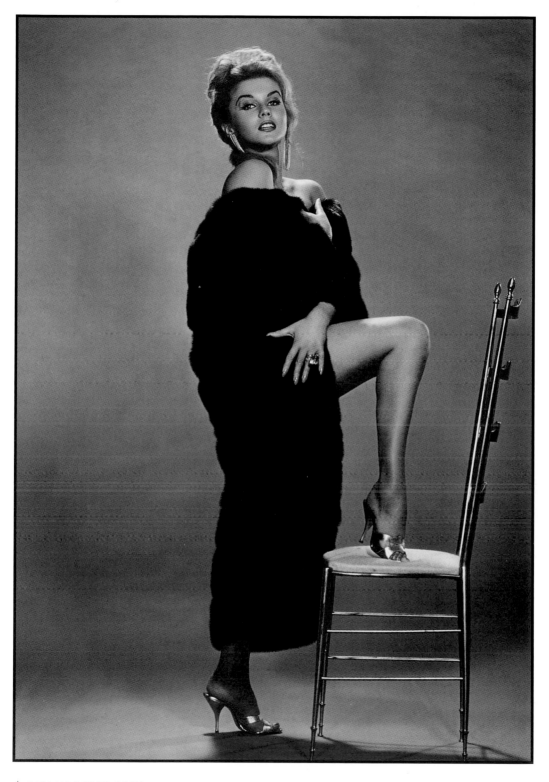

★ ANN-MARGRET, 1965

★ ANN-MARGRET, 1966

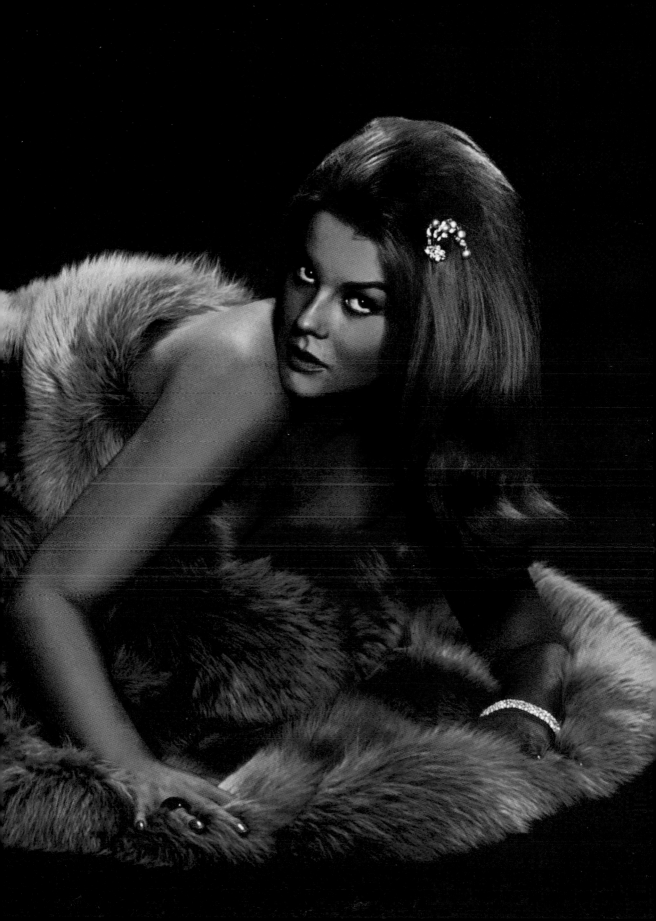

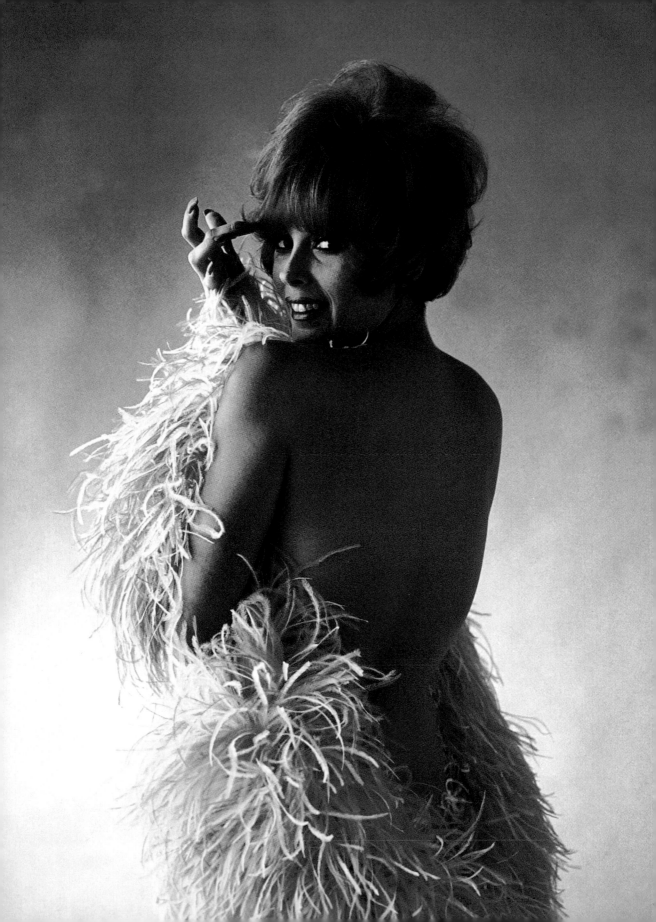

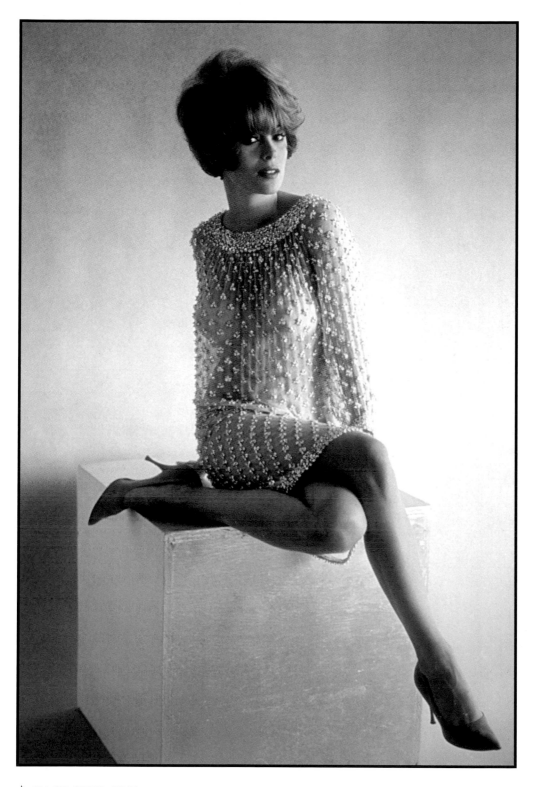

★ JILL ST. JOHN, 1967

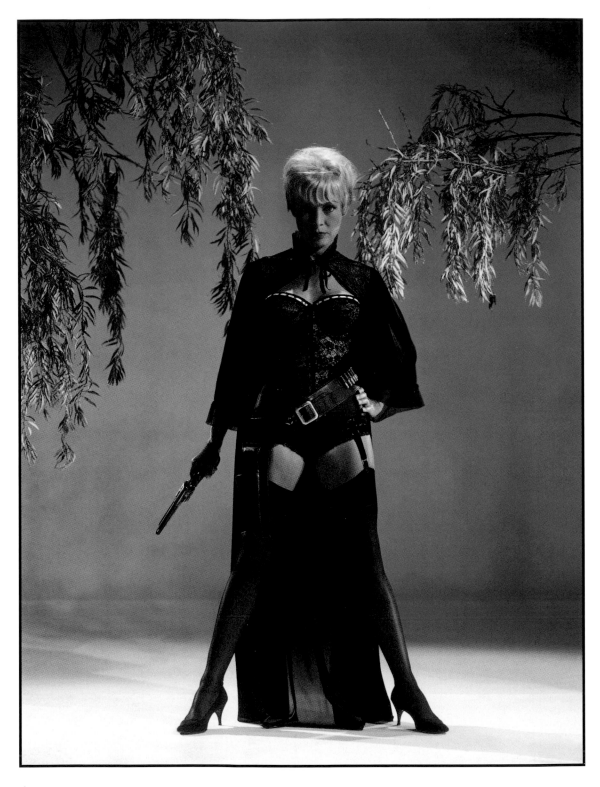

★ JANET LEIGH, 1965

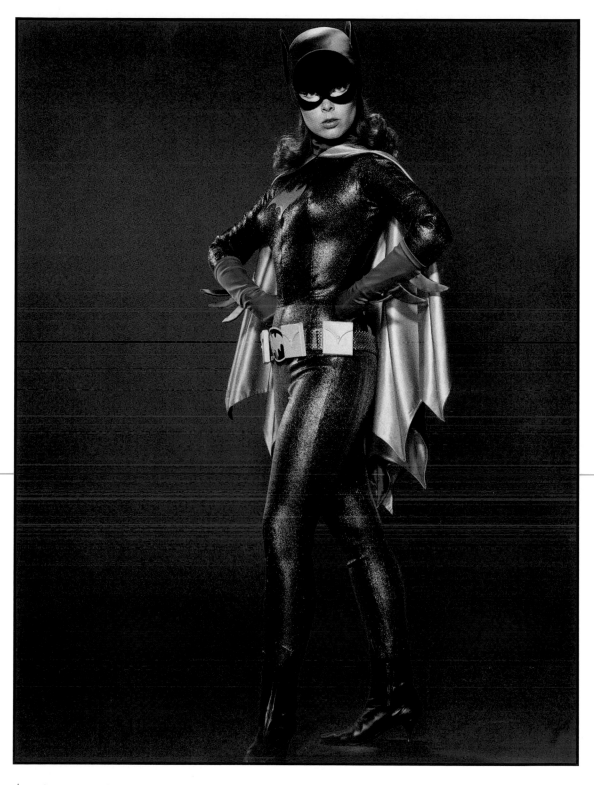

★ YVONNE CRAIG, c.1966

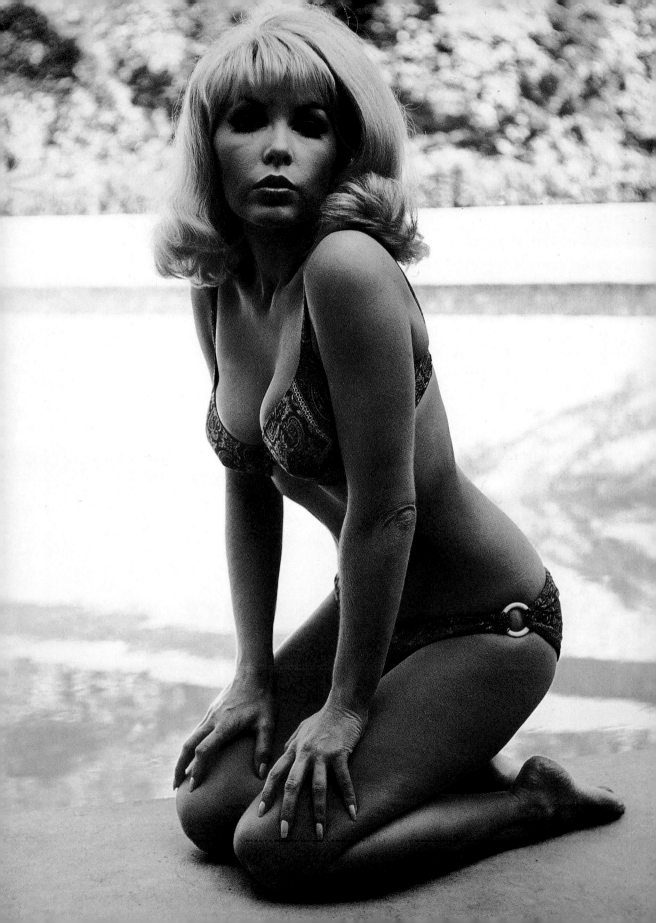

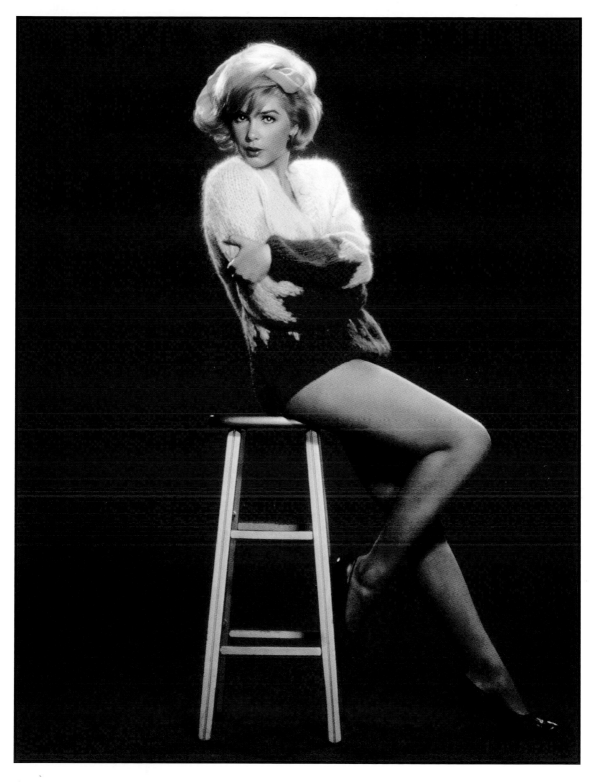

★ STELLA STEVENS, 1963 (ABOVE), 1966 (OPPOSITE)

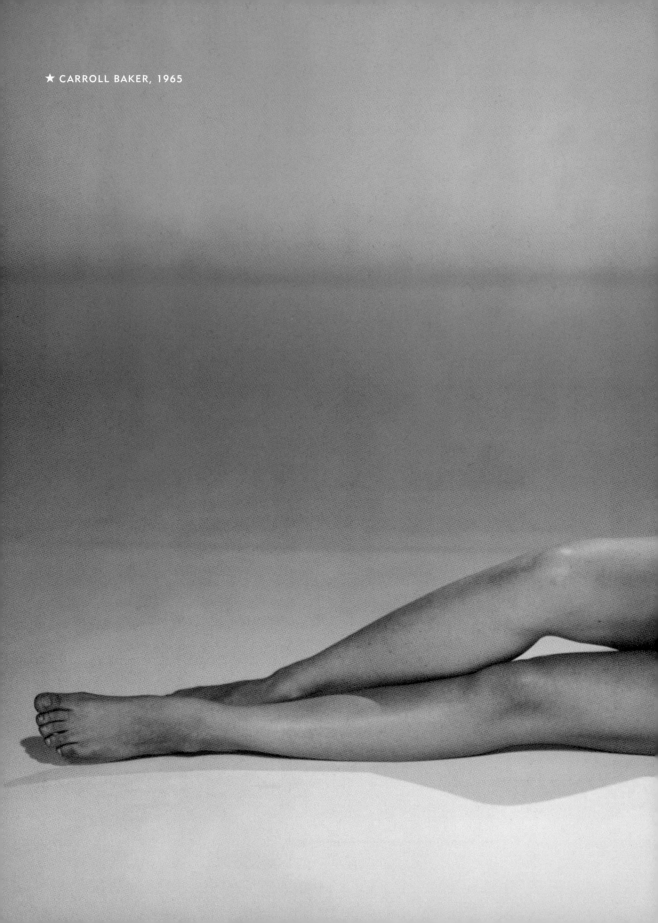

★ CARROLL BAKER, 1965

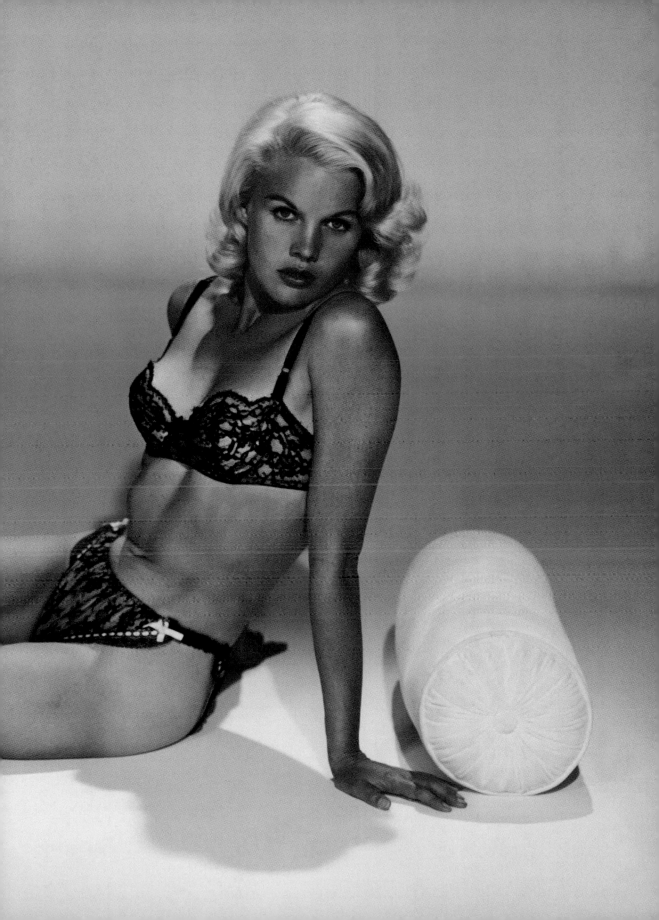

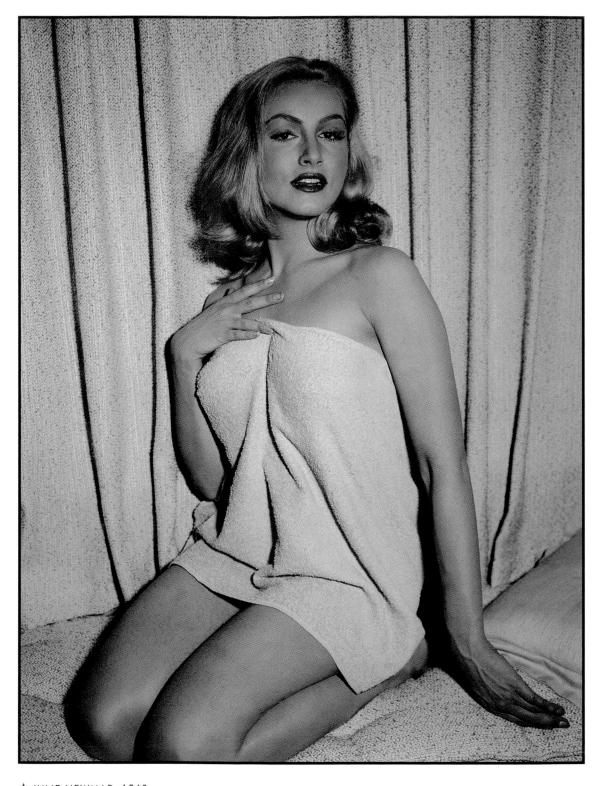

★ JULIE NEWMAR, 1960

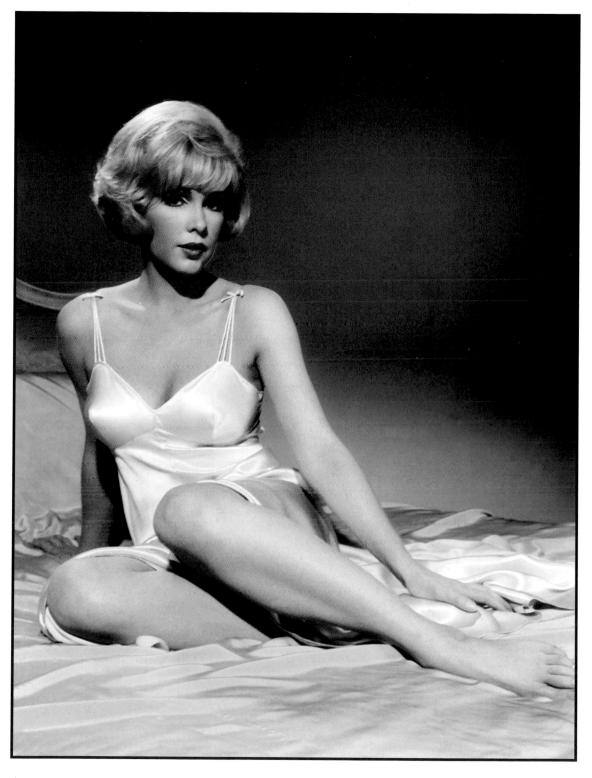

★ STELLA STEVENS, 1964

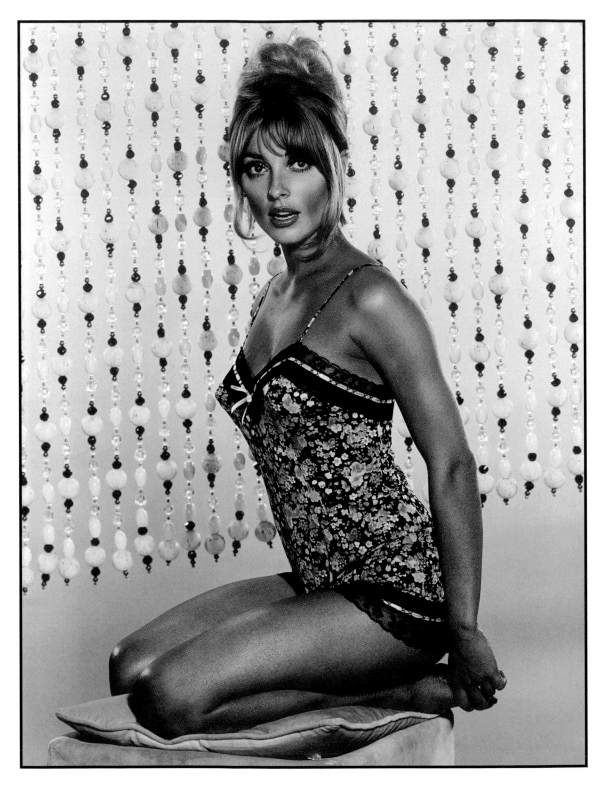

★ SHARON TATE, 1967

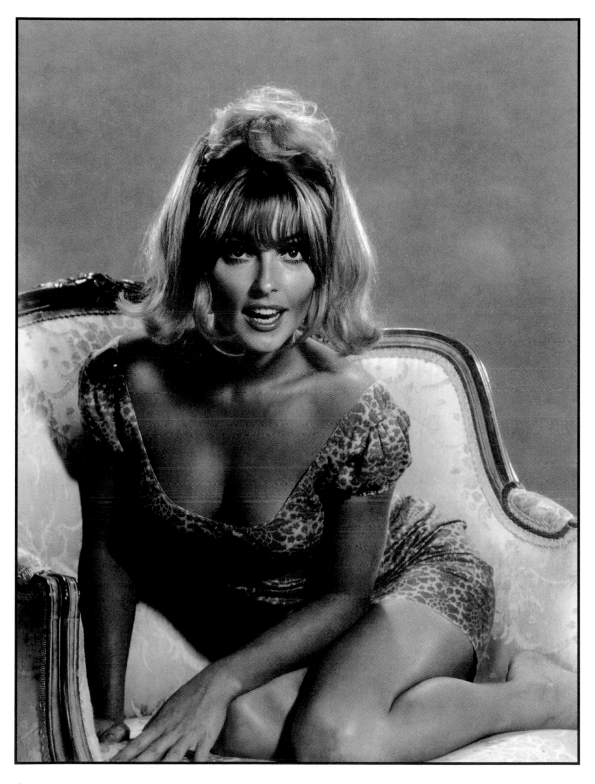

★ SHARON TATE, c.1966

The 1970s: Fade Out

The "Classic Hollywood Pin-up"—a concept whose power went into terminal decline after the death of Marilyn Monroe—would breathe its last gasp in the 1970s. The rise of a new art form spelled the death of an old one. Near the end of the '60s, Hollywood was in the throes of a full-on identity crisis. The star system had gone out. The studios were pouring money into ever more bland product, and the movie-going public wasn't buying it. Things would eventually hit bottom with *Hello, Dolly!*, a film that would be a top grosser for 1969 and a winner of four Academy Awards, but a failure due to its enormous expense.

During the "anything goes" era that followed, a small army of ultra-creative filmmakers was given a chance to resuscitate the system—and they did so by subverting it. You only have to compare the aesthetic sensibility of *Hello, Dolly!* with something like *Chinatown* or *The Godfather* to realize what this meant. Most everyone knows the directors of the two 1970s classics. But can anyone name the man responsible for *Hello, Dolly!?*

Neither Farrah Fawcett, Bo Derek, Cheryl Ladd, nor any of the other actresses in this chapter graced the films of any key 1970s directors (Roman Polanski, Francis Ford Coppola, Robert Altman, Martin Scorsese, etc.). There seems to be a loose connection between the decline of the classic pin-up and the studio system that engendered it. The pin-ups seen in the previous decades could often be linked directly to the cinematic achievements of their eras. Of course it wasn't always so, but there are plenty of past instances of great pin-ups allied with great filmmaking (see page 226). There are certainly candidates from the 1970s who clearly have pin-up-worthy allure (Faye Dunaway and Julie Christie spring to mind), but for the most part, the actors involved in the new wave of American cinema were either unwilling to play the pin-up card, or (in the case of Shelley Duvall, Sissy Spacek, and Diane Keaton, to name three examples) were just not pin-up "material" in the traditional sense of things.

The pin-up has always been about fantasy; the 1970s, at least in terms of the period's great films, had everything to do with reality.

★ Farah Fawcett, 1979: By the end of the 1970s, the decade's golden girl had started to adopt a harder and less fantasy-derived tone, a sign of what was to come.

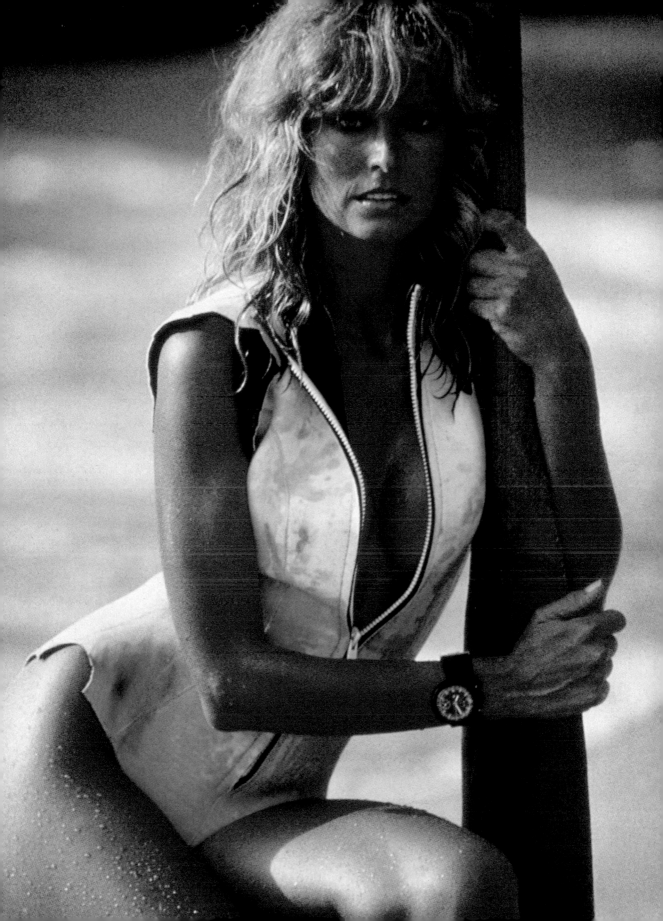

So the women who continued to pursue the pin-up practice—or who were pursued by it—generally remained on the fantasy side of the equation. (Think of Bo Derek in *10*, Barbara Bach in *Caveman*, or Lynda Carter as Wonder Woman—not exactly the stuff of classic film studies.) To see what is probably the most iconic "reality"-based pin-up from this time period you would have to open a different book. It involves the male of the species, one John Travolta, and a little project called *Saturday Night Fever*.

But while the decade's pin-ups weren't involved with the cutting-edge creativity of the 1970s, that's not to say they were actors without any talents. Special mention must go to Farrah Fawcett, whose bathing suit image (page 11) appeared in more dorm rooms than even Pink Floyd's *Dark Side of the Moon* poster. Fawcett, in addition to contributing to such guilty pleasures as *Logan's Run* and the original *Charlie's Angels*, would later portray the ultimate "objectified" (i.e., physically abused) woman in the classic 1984 made-for-TV movie, *The Burning Bed*—and then return to the revenge-against-abuse theme in 1986 with *Extremities*. Clearly, she is an actor perfectly aware of the power of the image (in this case her own)—and the dangers that are inherent when it backfires.

The decade was also good to Jane Fonda, who had started out as a hot-to-trot starlet in the 1960s (see page 244) but by the 1970s had matured into a respected actress, while simultaneously carrying over the previous decade's political activism. Fonda was Oscar-nominated three times in the 1970s and won once for Alan Pakula's *Klute* (1971). However, by the early 1980s she would become the anti-pin-up (or possibly *post*-pin-up) through her *Jane Fonda Workout* tapes, still the most famous celebrity self-help videos of all time. One line of reasoning has it that workout videos like Fonda's are tools of female empowerment: strong women helping the not-so-strong. In terms of physical strength, maybe so. But in reality? Some feminists have warned of the dangers of seeking power through the images of others, preferring to see women make themselves healthier without adopting the unobtainable image of some superstar.

(The one thing that can be said about the pin-up: It is rarely possible to be confused with any semblance of reality.)

★ Bo Derek, 1979: It wasn't until the decade was almost over that Fawcett was finally de-throned as 1970s pin-up queen, courtesy of Bo Derek's *10*.

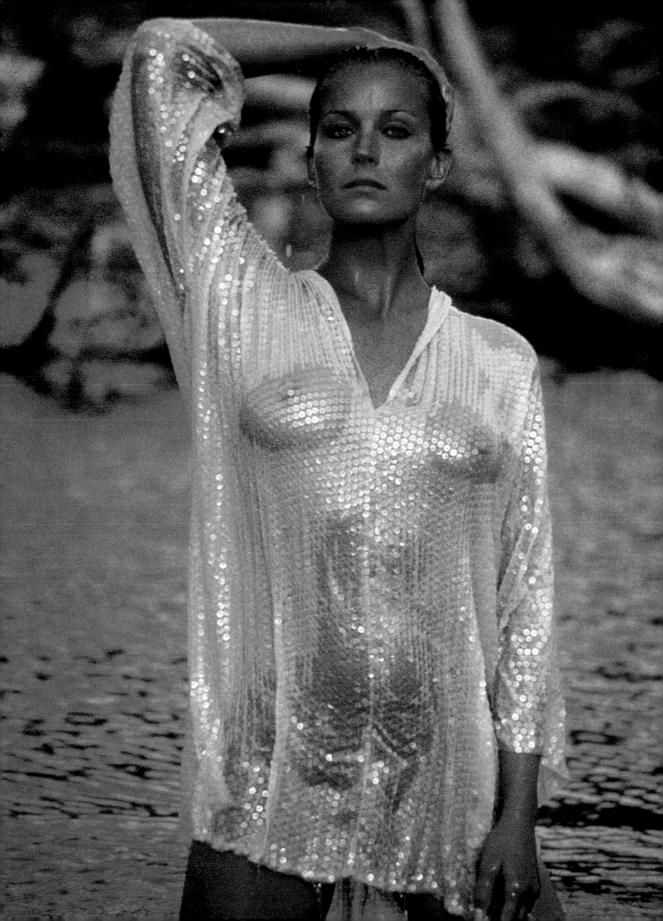

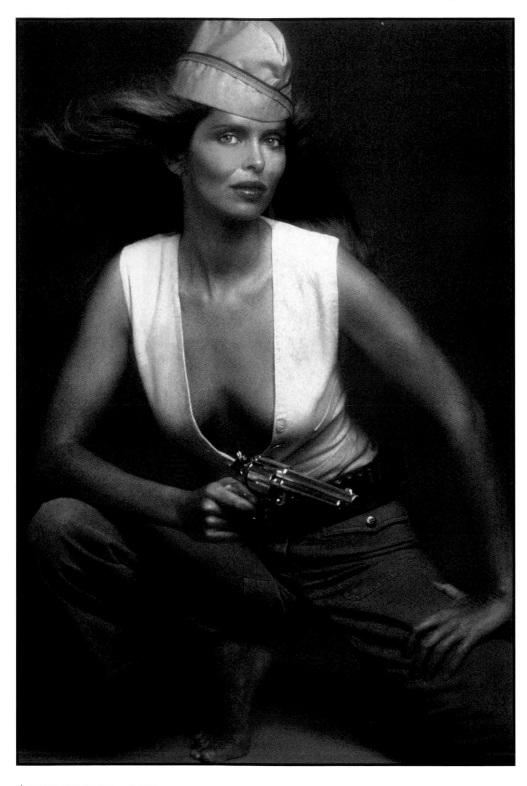

★ BARBARA BACH, c.1979

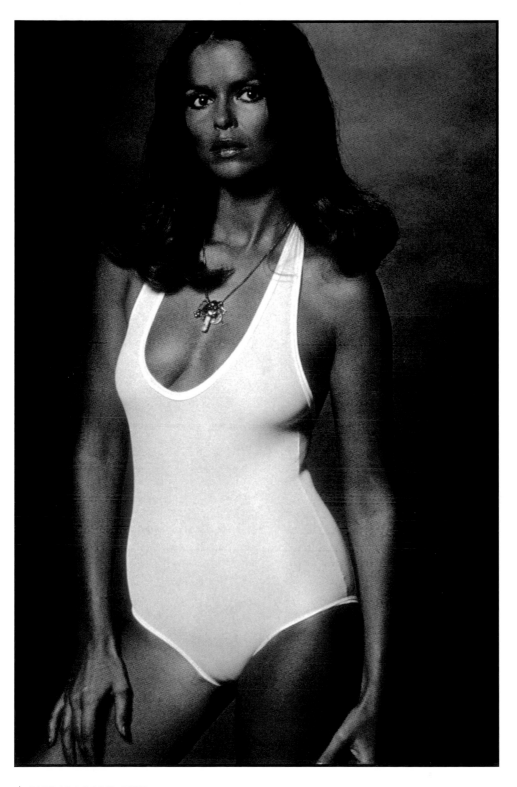

★ BARBARA BACH, 1977

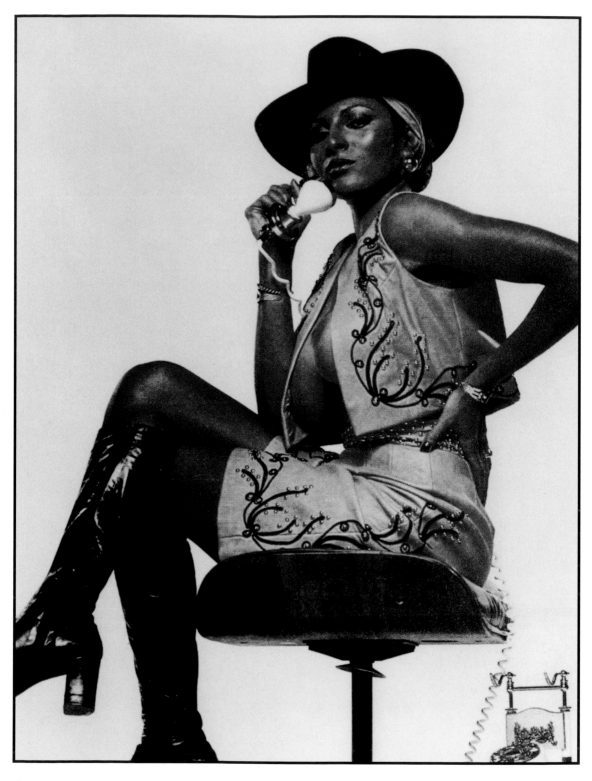

★ PAM GRIER, 1974

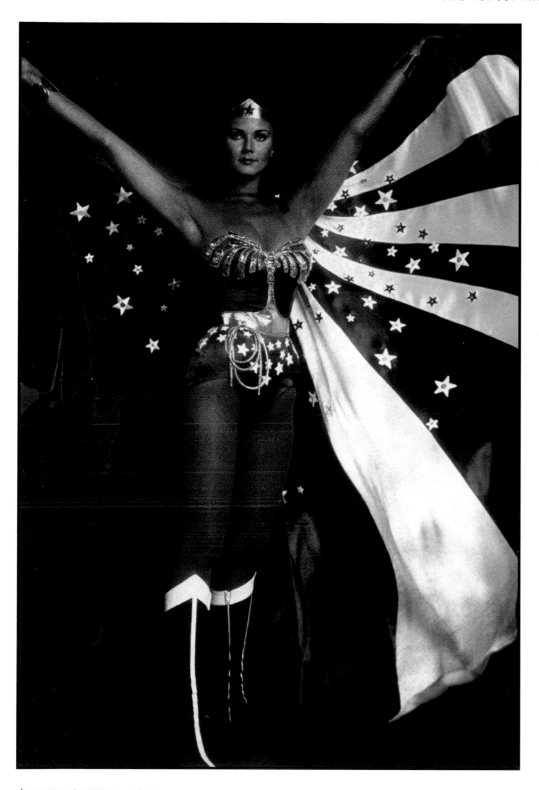

★ LYNDA CARTER, c.1976

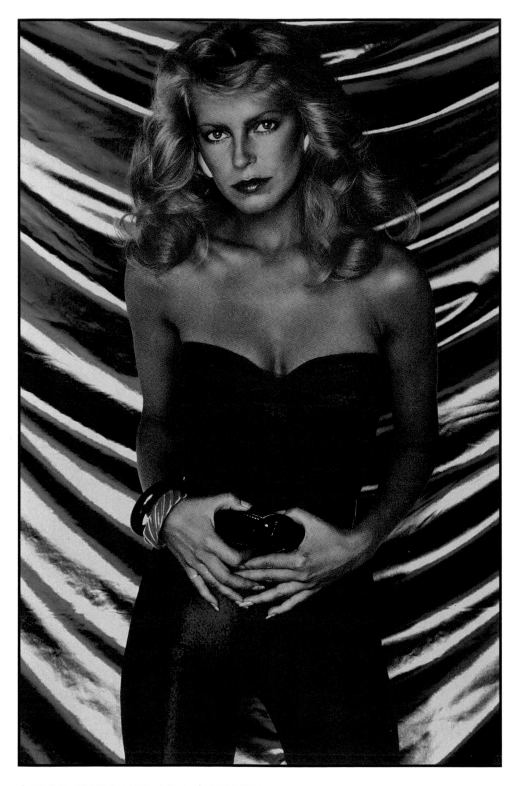

★ ABOVE: CHERYL LADD, 1979 ★ OPPOSITE: SUZANNE SOMERS, 1982

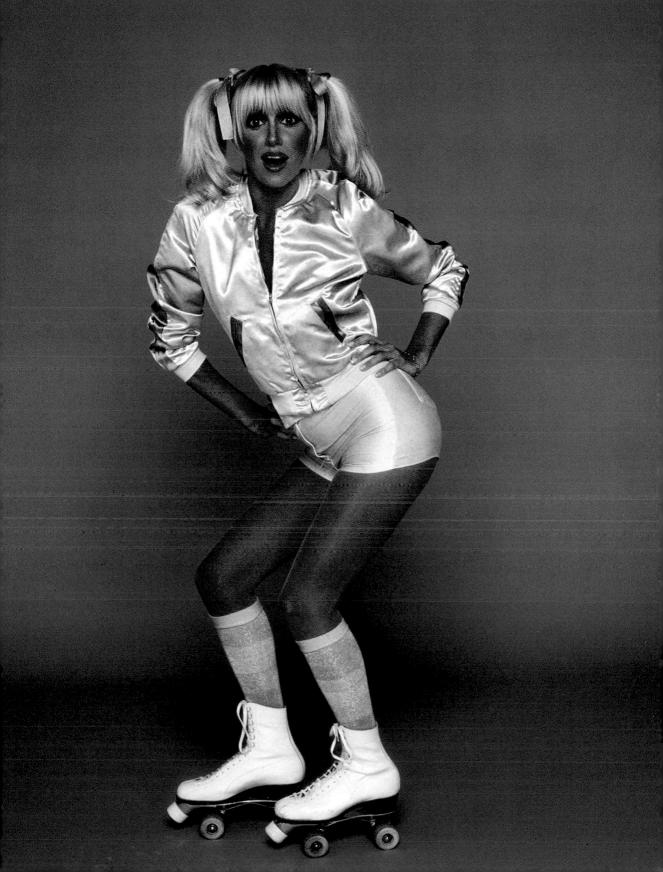

Afterglow

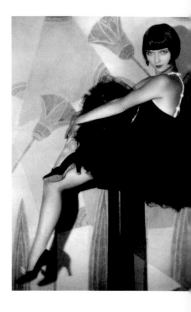

Flipping through the pages of this book, looking at all the blithe, alluring, and often carefree images contained herein, one can't help but feel a those-were-the-days sense of loss. (That's par for the course with almost any collection of ephemera.) When glancing at these particular photographs, one can sense lifestyles, generations, and even an entire age of (almost) innocence flash by. Perhaps at some point in the future people will pine away for our current era and the suspect charms of public personae such as Angelina Jolie, Jessica Alba, or Paris Hilton (the latter being an unpleasant yet necessary barometer of cultural waste); but as keepers of the flame, we must somehow seriously doubt it.

There's no denying that the Golden Age of Hollywood has come and gone. Nonetheless, how exactly you define that time period, and where you put the nail in the chronological coffin, remains a matter of perennial debate. John Kobal, founder of the photo collection that bears his name, considered the 1930s to be "the richest era of the American cinema." He's obviously not alone in the sentiment, even though many of the images under consideration here extend far past the expiration date of artistic potency he had in mind.

Describing the aesthetic changes wrought by World War II, Kobal decried, "Stars who were thought supreme were peremptorily tossed from the illuminating shadows of their glamour to sink or swim in the garish spotlight of the pin-up and the cheesecake." The statement appears in the introduction to his 1977 book, *Movie-Star Portraits of the Forties*. That was the year Suzanne Somers made a name for herself as the lovable but not-so-bright roommate in the TV series *Three's Company*. That she's the icon who ends this pin-up survey (see page 275) is a fact that would surely irk Mr. Kobal. He considered the small-screen medium a contributing factor to the "artistic nihilism" that pervaded a contemporary landscape populated by "insecure, illiterate, television-educated audiences."

The power of Chrissy, the seemingly ditzy blonde who Somers played on *Three's Company*, is seen in all her ambiguous glory in

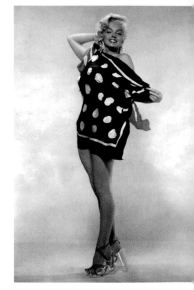

★ TOP:
Louise Brooks, 1928:
The Jazz Age pin-up.

★ ABOVE:
Marilyn Monroe, 1953:
The high-water mark.

this book's final image. She's simultaneously a goofball (by means of facial expression), an alluring sex bomb (the cling and shape of the hot pants), and a modern emblem of speed and strength (roller skates and muscle tone). As such, she paved the way for the present post-pin-up day, a time in which representations like these, once deemed solely objectifying and degrading, are regarded with substantially more nuance. It's important to remember that Somers is part of a tradition present at Hollywood's birth: Just like Mary Pickford before her, Somers capitalized on her starpower to become a shrewd business executive. Not only the author of self-help books (practically a requirement for any celebrity), she created her own multimillion-dollar brand of health and beauty products, and continues to be a mover on the female self-empowerment front (not to mention her spokesperson gig for Thighmaster).

The pin-up was severed from the star-and-studio system just as that system (at least in the "classical" sense) collapsed. Nevertheless, there are still stars everywhere; and they're much closer to home than they've ever been. In more recent years, the interface between technological expertise and human desire finally gave birth to the Internet, and all its attendant YouTubes, MySpaces, FaceBooks, and other related blogo-theatrics. No longer content to gaze upon the image of cinematic untouchables—from Greta to Farrah and beyond—the audience (us) became its own subject matter. (No one will ever be Clark Gable or Vivien Leigh, but just about anyone can imagine *Dancing with the Stars*.)

And while we may not possess the same magic Hollywood magnetism of pin-ups past, we still have the examples (i.e., the pin-ups) they left behind for inspiration. At this point, these photos may seem undeniably arcane. But the idea suggested here is this: Embrace the cliché that says "They Don't Make 'Em Like They Used To" because, like all clichés, it's somehow true. Feel the intoxicating power of the shifting, unstable roles and identities, tap into it, and then head off into your own starstruck future—Va-Va Voom! But be sure to bring along that mini-HD camera. (You didn't realize this was a self-help book—did you?)

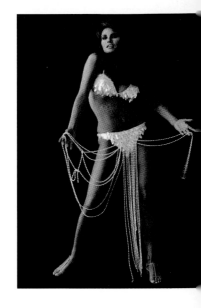

★ Raquel Welch, 1967: The pin-up near the end of an era.

INDEX

PHOTOGRAPHY CREDITS

All the images that appear in this volume are from the archives of The Kobal Collection, which seeks to collect, organize, preserve, and make available the publicity images issued by the film production and distribution companies to promote their films. We apologize in advance for any unintentional omissions or errors and will be pleased to insert the appropriate acknowledgment to any companies or individuals in any subsequent printing of this work.

All images courtesy of The Kobal Collection; additional photo credits below.

p.ii Columbia/Bob Coburn; p.vi RKO/George Hurrell; p.1 MGM/Laszlo Willinger; p.2 Columbia/Bob Coburn; p.3 Paramount; p.6 Universal; p.8 Mack Sennett/Nelson Evans; p.11 Bruce Mc-Broom; p.12 Nelson Evans; p.16 Paramount; p.17 MGM/Ruth Harriet Louise; p.18 Paramount; p.23 Paramount/E.R. Richee; p.24 Paramount/E.R. Richee; p.25 Paramount/George Hommel; p.27 Paramount; p.28 MGM/George Hurrell; p.29 MGM/George Hurrell; p.30 Gene Kornman; p.31 RKO/Ernest Bachrach; p.32 Paramount; p.33 Paramount; p.34 Paramount; p.35 Paramount; p.36 MGM; p.37 MGM; p.39 Paramount; p.41 RKO; p.42 Columbia; p.43 MGM; p.44 MGM; p.46 20th Century Fox; p.47 20th Century Fox/George Hurrell; p.48 Paramount; p.49 Paramount; p.50 Paramount; p.52 Warner Bros.; p.54 United Artists; p.55 United Artists; p.56 MGM/Laszlo Willinger; p.57 MGM; p.58 First National/Warner Bros.; p.59 First National/Warner Bros.; p.61 Columbia; p.62 MGM; p.63 Warner Bros./A.L. "Whitey" Schafer; p.64 Edwin Bower Hesser; p.66 MGM; p.67 MGM/George Hurrell; p.68 Paramount; p.69 Paramount/E.R. Richee; p.70 Paramount; p.71 Paramount; p.72 MGM/Ruth Harriet Louise; p.73 MGM; p.74 MGM; p.75 MGM/George Hurrell; p.76 Paramount; p.77 Universal; p.78 Paramount; p.79 United Artists; p.80 MGM/Laszlo Willinger; p.81 United Artists/George Shurrell; p.82 Columbia; p.83 RKO/Bob Coburn; p.85 Paramount; p.86 Columbia; p.87 Columbia; p.88 Paramount; p.90 MGM/George Hurrell; p.91 20th Century Fox; p.92 Warner Bros.; p.93 Paramount/A.L. "Whitey" Schafer; p.94 Paramount; p.95 Paramount; p.96 Warner Bros.; p.99 MGM/Clarence Sinclair Bull; p.100 RKO; p.101 MGM; p.102 MGM;

p.103 Universal; p.104 Columbia/Bob Coburn; p.105 Columbia/Ned Scott; p.106 Columbia/George Hurrell; p.107 Columbia; p.108 20th Century Fox/Fran Powolny; p.109 20th Century Fox; p.110 MGM; p.111 20th Century Fox; p.112 MGM; p.113 Paramount/William Walling Jr.; p.114 MGM; p.115 Columbia; p.116 George Hurrell; p.117 Paramount; p.118 Columbia; p.119 MGM/Clarence Sinclair Bull; p.120 MGM/Laszlo Willinger; p.121 MGM; p.122 MGM; p.123 MGM; p.125 MGM; p.126 20th Century Fox; p.127 20th Century Fox; p.128 Paramount; p.129 Columbia; p.131 RKO, 20th Century Fox; p.132 MGM; p.133 Universal/Ed Estabrook; p.134 Warner Bros.; p.135 Paramount; p.137 Paramount; p.138 Columbia; p.140 MGM; p.141 MGM; p.142 MGM/Eric Carpenter; p. 143 MGM /Virgil Apger; p.144 MGM; p.145 20th Century Fox, RKO/George Hurrell, Paramount; p.146 RKO/George Hurrell; p.148 20th Century Fox/Jack Albin; p.149 20th Century Fox; p.150 Columbia/Bob Coburn; p.151 Columbia/Bob Coburn; p.152 United Artists/Al St. Hilaire; p.153 Paramount; p.154 MGM; p.155 Warner Bros.; p.156 Universal; p.157 Universal; p.159 MGM; p.160 Universal; p.165 RKO; p.166 MGM; p.167 20th Century Fox; p.168 Paramount; p.169 20th Century Fox; p.171 20th Century Fox/Bert Reisfeld; p.172 Columbia/Bob Coburn; p.173 20th Century Fox; p.174 Warner Bros.; p.175 20th Century Fox; p.176 Warner Bros.; p.177 Warner Bros.; p.178 Universal; p.179 20th Century Fox; p.180 MGM/Eric Carpenter; p.181 Columbia/Ned Scott; p.182 20th Century Fox/Frank Powolny; p.183 20th Century Fox/Frank Powolny; p.184 Universal/Ray Jones, Universal; p.185 Universal; p.187 Warner Bros./Elmer Fryer; p.188 MGM;

p.189 20th Century Fox; p.190 20th Century Fox; p.191 MGM/Eric Carpenter; p.192 MGM; p.193 MGM; p.194 United Artists; p.195 Columbia; p.196 Warner Bros.; p.197 MGM; p.198 20th Century Fox/Bert Reisfeld; p.199 Warner Bros.; p.200 20th Century Fox, MGM; p.202 Rank/Lucas Cornel; p.203 Rank; p.204 Paramount; p.206 MGM; p.207 Columbia/Bob Coburn; p.208 Columbia; p.209 Columbia; p.210 20th Century Fox; p.211 20th Century Fox; p.212 MGM; p.213 United Artists; p.214 Paramount; p.215 Paramount; p.216 RKO; p.217 20th Century Fox; p.218 Warner Bros.; p.219 Universal; p.222 Columbia; p.224 Universal; p.225 Hammer; p.226 20th Century Fox; p.227 Paramount; p.228 MGM; p.229 MGM/Virgil Apger; p.230 Walt Disney; p.231 Paramount/Bud Fraker; p.234 MGM; p.235 Columbia; p.236 RKO, MGM; p.237 MGM; p.238 Columbia/Glenn Adams; p.239 20th Century Fox; p.240 Columbia; p.241 Danjac/Eon/United Artists; p.242 Paramount; p.243 Paramount; p.244 Columbia; p.245 Paramount; p.246 Hammer; p.248 Warner Bros.; p.249 MGM; p.250 MGM; p.251 MGM; p.252 MGM; p.254 Universal; p.256 Paramount; p.257 20th Century Fox/Greenway; p.258 Columbia; p.259 MGM/Virgil Apger; p.260 Paramount; p.262 20th Century Fox; p.264 MGM; p.265 MGM; p.266 Hemdale/Bind; p.268 Orion/Warner Bros./Bruce McBroom; p.273 Warner Bros. TV/DC Comics; p.274 Spelling-Goldberg; p.276 Paramount/E.R. Richee, 20th Century Fox/Bert Reisfeld; p.277 20th Century Fox